In the Image of Tibet
Tibetan Painting after 1959

ENVISIONING ASIA

Series Editors: Homi Bhabha, Norman Bryson, Wu Hung

In the same series

Fruitful Sites
Garden Culture in Ming Dynasty China
Craig Clunas

Camera Indica
The Social Life of Indian Photographs
Christopher Pinney

China into Film
Frames of Reference in Contemporary Chinese Cinema
Jerome Silbergeld

IN THE IMAGE OF TIBET

Tibetan Painting after 1959

CLARE HARRIS

REAKTION BOOKS

For my parents, Reg and Beth Harris

Published by Reaktion Books Ltd
79 Farringdon Road
London EC1M 3JU, UK

First published 1999

Series design by Ron Costley
Printed and bound in Italy by Giunti Industrie Grafiche, Prato

British Library Cataloguing in Publishing Data:
Harris, Clare
In the image of Tibet: Tibetan painting after 1959. –
(Envisioning Asia)
1.Painting, Tibetan 2.Painting, Modern – 20th century – Tibet
I.Title
759.9'515
ISBN 1 86189 039 7

Contents

Acknowledgements

Above all I would like to acknowledge the help of members of the Tibetan communities in Mussoorie, Dharamsala, Delhi, Manali, Leh, Kalimpong, Darjeeling, Kathmandu, Pokhara, Lhasa and London. They are too numerous to mention by name, but this book would not exist without their knowledge, hospitality and goodwill. My greatest thanks must be extended to the artists I worked with: Nawang Choepel, Tenpa Choepel, Tsering Dhondup, Dorje, Gonpo, Gongkar Gyatso, Dorje Josama, Chamba Kelsang, Dharamsala Kalsang, Kathmandu Kalsang, Jamyang Losal, Lobsang Ngodup, Nawang Tsering, Sonam Tenzin, Sonam Wangdu, Tsultrim Tenzin, Pema Namdol Thaye, Migmar Tsering, Nawang Tsering, Tsering Wangdu and Sangay Yeshi.

Financial assistance for the research for this book was provided by the School of Oriental and African Studies, the Research Committee of the University of London, the British Academy and the University of East Anglia, Norwich. The finished product has benefited from the advice and expertise of a number of individuals: Monisha Ahmed, Robbie Barnett, Peter Bishop, Michael Brandon-Jones, Richard Cocke, Philip Denwood, Gongkar Gyatso, Ludmilla Jordanova, P. Christiaan Klieger, Frank Korom, Erberto Lo Bue, Karl-Einar Löfquist, Donald Lopez, Jamyang Norbu, Michael O'Hanlon, Maria Phylactou, John Picton, Christopher Pinney, Veronica Ronge, Tsering Shakya, Jane Singer, Giles Tillotson, Wang Tao and Tashi Tsering. For all kinds of support and much more, I would like to thank my family, friends and Rupert Gill.

Introduction

A certain sterility is now apparent in Tibetan crafts, art-forms, literature, imagery and all the rest. But as the various things produced continue to be true to traditional form and always beautiful in themselves one hesitates to make adverse comment on this score. But the question arises: what now becomes of Tibetan civilization?
– Snellgrove and Richardson, *The Cultural Heritage of Tibet*

It could be argued that Tibet no longer exists – or that if it does, it is only as a utopian vision in a virtual world. Tibet does not exist as a place or nation in the nomenclature of contemporary world politics; there is no geopolitically bounded space that we can designate as the territory of a Tibetan homeland. Although the majority of ethnic Tibetans currently reside in a part of the People's Republic of China (PRC) designated by the Chinese government, apparently without irony, as the Tibet Autonomous Region (TAR), it is the smaller community of exiles now dispossessed and dispersed throughout the world who dominate the global view of Tibet as a concept. These refugees, led by the Dalai Lama and his 'government in exile', are sitting tenants in the homes of others. Some hold passports of host nations, but most are still defined by the 'yellow card' of the Indian government, a certificate issued to refugees and people with a criminal record. For Tibetans, the yellow document that the Indian government calls an 'identity certificate' can only confirm the opposite: it defines their statelessness and lack of powers. Instead, though the original Tibet from which they departed in or after 1959 is now denied to them as a direct source of national self-definition, the idea of Tibet functions as a profound signifier of identity. The 100,000-strong diasporic community see themselves as the perpetuators of the heritage of this abandoned place and the custodians of a 'true' image of Tibet.

Tibet also continues to exist as an apparently unproblematic and identifiable unit for the growing global community of Tibetophiles. Publications, films, exhibitions and organizations employ the linguistic marker 'Tibet' with justifiable confidence in its powers of signification. It is even possible for viewers of 'Wisdom and Compassion: The Sacred Art of Tibet' (an exhibition that began a world tour in San Francisco in 1992), who may be members of the Tibet Support Group or some similarly named organization, to take *The Tibet Guide* as their

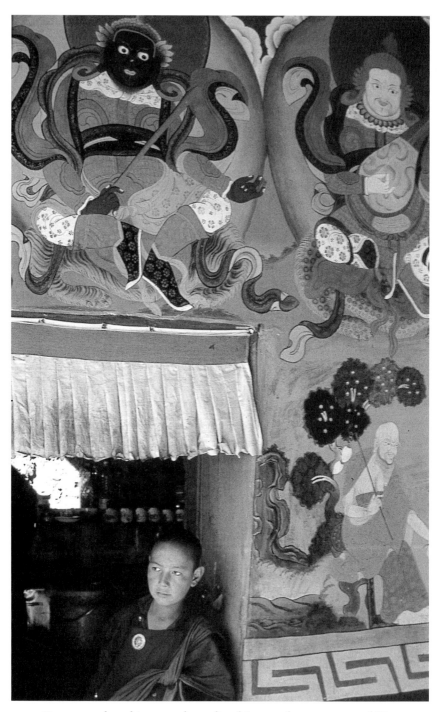

1 Young monk and images of guardian kings at the monastery of Rizong, Ladakh, 1994.

instruction manual on a tour of the 'Tibet' Autonomous Region. There, the fact that Tibet did exist is verifiable, for some physical markers of Tibetan Buddhism remain, despite the ravages of the Chinese invasion and the Cultural Revolution. Having won the battle (in both a political and a military sense) the Chinese could afford to meet the entreaties of the Panchen Lama and others and retain some major buildings, such as the Kumbum at Gyantse, the Jokhang and Potala in Lhasa, the seat of the Tibetan oracle at Nechung and so on within a 'museumizing' process, which generally plays down the religious and political contexts for which these structures were intended. During the 1970s and 1980s other monasteries damaged in the preceding decades were reconstructed, primarily for the benefit of tourists, who have been allowed into Tibet since 1985. It is perhaps only then, Chinese visa in hand, on the pilgrimage to the Potala in Lhasa, that they will inhale the scent of a home(land) that has become a mausoleum.

This book therefore takes up Snellgrove and Richardson's challenge and asks 'What has become of Tibetan civilization?' In the years following the Dalai Lama's departure, it has clearly been threatened with extinction. Alongside the ransacking and demolition of monastic buildings, the Tibetan populace were forced to cast their household icons and religious books into bonfires and to renounce their faith in Tibetan Buddhism. The artists, writers and religious figures who were at the forefront of Tibetan cultural practice either escaped into exile or had to give up their activities. Some died in the famines and battles which befell Tibet at the hands of the Chinese or perished in the attempt to escape. Clearly the colonizers intended to extinguish all material traces of what it meant to be Tibetan. But their attempt did not succeed, for 'culture' (or civilization) does not only reside in the artefactual and the monumental. It encompasses many activities – intellectual, spiritual, aesthetic and ideological – which contribute to a process (or processes) by means of which an understanding of life beyond the merely utilitarian or substantive is formulated. In these terms, Tibetan culture after 1959 is by no means extinct. It is animated by the actions of Tibetans who live as exiles throughout the world or who still reside in the Tibet Autonomous Region of the People's Republic.

But above all the idea of Tibet exists in the imagination, though the way in which it is to be imagined is contested by a number of parties. Since 1959, Tibet has been captured in a series of images of itself which have established a set of what I shall call 'representational fields'. These fields are produced by groups with an interest in filling the void left by the obliteration of the old Tibet from the world's cultural and political

map. There is the Chinese image of Tibet, a Western image of Tibet, an exilic Tibet and the Tibet imagined by the Tibetan residents of the TAR. These four fields bisect and intersect at various points: none is entirely separate and none is uninfluenced by another. As in a Venn diagram, they converge at the point of a shared interest in the issue of what is 'Tibetan'. However, each of the groups has produced different answers to this question, with exiles, for example, claiming a closer relationship to the facts of the Tibetan past than even those Tibetans who still live in the Tibet Autonomous Region.

This book is concerned with just one aspect of cultural activity, the production and use of images, but its title, *In the Image of Tibet*, alludes to two potential readings of the word 'image'. Firstly it is a reference to the more conventional usage in which an image is thought of as a representation or likeness which is visually apprehensible. Though I am not interested in providing an art history of Tibet after 1959, it is important to acknowledge what is literally in images made by and for Tibetans and to explore debates that inform these representational surfaces. I have not attempted to produce a comprehensive survey for the purposes of connoisseurs, nor do I consider those images I do include to be simply diagrams of social organization. My intention is to try to avoid the unhappy separation between the aesthetic, the social and the political which has hampered so much of the literature of art history and the anthropology of art. My solution is to emphasize a second definition of the word 'image', in which its conceptual connotations are emphasized. Hence the phrasing 'In the image of . . .' reveals the wider issues of this discussion and suggests the space which exists between an object which is perceptible through the senses and the idea beyond it. Just as artists worldwide have struggled to represent the intangible, such as the idea of god, so there are problems in recreating the idea of Tibet. The images analysed here refer to an imagined or remembered place, Tibet, which since 1959 has conjured very different associations for different audiences. Equally, the adjective 'Tibetan' has acquired a variety of meanings in different settings (and hence I have avoided referring to my subject as 'Tibetan art'). Owing to their sheer physicality images, perhaps more than other cultural objects such as books (not as readily consumable in one viewing) or theatrical performances (ephemeral), participate in debates about how nations or cultural entities (such as 'Tibetan' culture) can be represented. Western art history has traditionally employed the frame of national or ethnic boundaries in order to define its subject matter, hence the plethora of studies in which the idea of place is emphasized, such as the 'art of India', 'Chinese art' and so on. However, in cases where a homeland has

been vacated, a diaspora created or a nation colonized, the frame of national culture is patently problematic or even defunct. Those who make and view images produced since the Chinese invasion of Tibet are informed by histories and ideologies generated in locations which may be local (e.g. India) or distant (e.g. China), as well as global and imagined (i.e. pre-1959 Tibet). Consequently the concept of what is or could be Tibetan is in a state of flux.

The designation 'Tibetan' can encompass a number of historically constituted variations on the theme which are often assembled together for the sake of political or economic, rather than aesthetic, reasons. In Dharamsala contemporary paintings are recognized as 'New Menri' rather than simply 'Tibetan' by the members of an educated art world of Tibetans who support a particular vision of their history. In other contexts the desire for the label 'Tibetan' appears to increase in direct proportion to the audience perception of the 'otherness' embodied in artists' works. Thus for the non-Tibetan readers of *Chöyang* (the journal of the Department of Religious and Cultural Affairs in the capital in exile) or the viewers of 'Wisdom and Compassion', Tibetan designations of schools within Tibetan painting are deemed less useful than the overarching notion of a Tibetan Buddhist art (fixed in the word *thangka*, or religious painting). For the bureaucrats of the Indian state of Himachal Pradesh keen to expand their tourist revenue, the Tibetan sources (in this case the Karma Gadri style of painting) for the images exhibited by 'Spiti School' artists are played down in preference to a general idea of the exoticness of the Spiti region, a Tibetan Buddhist area in a largely Hindu state. In the bazaars of Kathmandu the apprehension of the saleability of anything labelled 'Tibetan', despite the fact that it may be produced by Tamangs or Newars, is driven by the ever burgeoning market for souvenirs of 'Shangri-La' (i.e. a 'Western' construct of Tibet).[1] Even in the capital of the TAR, Lhasa, the label 'Made in Tibet' has potency since art, tourism and the politics of colonization are inextricably fused together.

Perhaps it is this condition of hybridity and borderlessness which explains the lack of publications similar to this one. At a time when studies of twentieth-century visual culture in other parts of Asia are increasing, Tibet is in danger of being written out of the historical record. Substantial research has been conducted into colonial and post-colonial art in India. The arts of Japan and China have inspired numerous monographs, and a number of scholars are even attempting to produce pan-Asian surveys such as John Clark's *Modern Asian Art* (1998) (though neither 'Tibet' nor anything 'Tibetan' appears within its pages). This situation is very probably the result of the political status

of Tibet since the Chinese takeover. It now falls between the stools of two Asian superpowers. Within China, 'Tibet' has been absorbed into a larger entity which consigns Tibetans to the status of a 'minority nationality'. Within India, Tibetans are even more marginalized (owing to their small numbers) in the grander scheme of the culture of independent India. Hence when a work by a Tibetan does appear in a publication, it is likely to be designated as Chinese or as an example of the art of exile and somehow hovering in space unrelated to the country in which it was produced (such as India). Twentieth-century Tibetan 'art' is thus either ignored, subsumed within other nations or conceived as part of a culture held in suspended animation in exile and segregated from the activities of those Tibetans who live in the TAR and from the Indian artists who are their neighbours.

This book is designed to try to redress some of these mistakes and omissions and to counteract the absence of publications on contemporary 'Tibetan' visual culture. However, the reader will protest that there are many glossy books devoted to 'Tibetan art'. This contradiction is easily explained. The contents of these titles are uniformly concerned with the identification of objects and buildings created before the Chinese invasion of 1950 (and often from well before 1900). Many are based on the accessions of private and public collections in the West and focus on the 'beautiful' and 'traditional' objects which Snellgrove and Richardson describe. These ancient objects trigger the powerfully evocative 'remembrance of things past' which so dominates the Western image of Tibet. But even those studies which include research carried out in the Himalayas and on the Tibetan plateau rarely mention any evidence of cultural activity in the twentieth century. This denial of 'modernity' in Tibet threatens to fix it in a past state for perpetuity. The Western 'museumizing' process, by which the remains of distant civilizations attain the status of 'art', began to be applied to Tibetan material culture in the late nineteenth century and was part of an Orientalist project to explore and record the 'fixtures and fittings' of Tibet. Many of the sacred objects which now grace the museums of the West were removed from Tibet during the colonial period, but prior to 1950 they received relatively scant scholarly or popular attention. It was only following the emergence of a Tibetan diaspora in 1959 that the aesthetic and commercial value of Tibetan art increased exponentially. Ironically, the dispersal of Tibetan 'art' into Western markets was initially a by-product of exile and later the result of the extraction of objects from Tibetan homes and monasteries within Chinese-controlled Tibet. As mystified remnants of a lost world, these fragments of a broken cultural unit attracted huge symbolic capital and

now contribute to the marked discrepancy between the high status of Tibet as a concept with global appeal and the low levels of awareness of the practices and experiences of 'modern' Tibetans in every area other than the religious. Must Tibet remain the beautiful but sterile culture that Snellgrove and Richardson were reluctant to interrogate? In order to answer their question – what now becomes of Tibetan civilization? – we must relinquish the idea that Tibet is an inaccessible utopia of esoteric religious practices and traditional culture. It is this notion of Shangri-La which ought to be extinct: Tibetan 'civilization' is not, otherwise why would objects like paintings still be so empowering? Why else would the visual remain so vital for Tibetans?

In order to elaborate on the ways in which Tibetan material culture has functioned within Western mythologies of Tibet, the first chapter of this book considers some examples of nineteenth- and twentieth-century collecting and exhibiting. Chapter 2 then focuses on the role of images in the Tibetan capital in exile after 1959. This, the year of the Dalai Lama's departure from Tibet, provides both a chronological marker for this book and an indication of its themes, for the images of exilic Tibet cannot be understood without acknowledgement of the political and cultural rupture which that date signifies. Artists who were born in Tibet prior to 1959 have been accorded special status in exile as a result of their access to 'authentic' memories and techniques for making images. However, a specific notion of what Tibetans currently construe to be authentic has evolved through debates about the way image-makers should work. Chapter 2 concentrates on the reification of the concept of tradition, whereas Chapter 3 acknowledges that beyond the boundaries of an official vision of Tibetan culture in exile, the rules of tradition have in fact been broken. This chapter explores the impact of the host community of India and of modern technologies, such as photography, on the ways in which image-makers work.

In the course of my research, it became clear to me that one of the ways in which exilic representations are generated is through a consciousness of what they are not; that is, Tibet, and what it is to be Tibetan, is imagined in opposition to China and Maoism and the images of exile were consciously produced to reject those of the colonizers. In Dharamsala an image which demonstrated any connection with the People's Republic of China would be deemed 'inappropriate' and ejected from the 'capital in exile'. In order to explain the source from which exiles' objections arise, I have charted the history of depictions of Tibet by Han Chinese artists during its annexation and

ideological takeover in Chapter 4. Chapter 5 then analyses the work of Tibetan artists living in the TAR as they tried to put themselves in the picture and respond to the colonization of their artistic space. Finally, Chapter 6 follows the biography of a painter who has moved between the representational fields of Chinese, Tibetan and Western images of Tibet, which provides some evidence for my concluding remarks on the future of Tibetan culture.

As Tibetan images and their makers are currently dispersed throughout the world, this study is by no means a conventional ethnography. In a sense the 'fieldwork' began when I spent six months working as a volunteer teacher in the Tibetan refugee community in Mussoorie, Uttar Pradesh, India, in 1984. Whilst there I met an elderly artist from Amdo who first introduced me to Tibetan painting. Thereafter I made repeated visits to Tibetan communities in South Asia and between 1991 and 1995 conducted interviews with practitioners of painting, observed them at work and took part in discussions with their audiences. Thus the observations made in this book are based on multi-locational fieldwork in Tibetan communities in Ladakh, Himachal Pradesh, Delhi, West Bengal and Sikkim in India, as well as in Kathmandu and Pokhara in Nepal and in the Tibet Autonomous Region of the PRC. Though I have not named them all within the text, this study would not have been possible without the generosity of many individuals who shared their work and ideas with me. Owing to the politics of exile and the PRC I have not flaunted my sources for some of the judgements made in the following pages. Ultimately, I am responsible for the interpretations and any mistakes are my own.

Note on Language Usage

In order to make this book accessible to readers who are unfamiliar with Asian languages I have kept the use of Tibetan and Sanskrit terms to a minimum. Where they do occur they are italicized, with a brief explanation in English. Tibetan has mainly been rendered in a phonetic form rather than in the Wylie transliteration. For Tibetan personal names and places I have used the form in which they are presented for English readers in publications produced by Tibetans. Buddhist terminology is given in Sanskrit rather than Tibetan (e.g. vajra instead of dorje) as the lingua franca of Indology is more widely known. Some Sanskrit terms which have entered common parlance, such as mandala and bodhisattva, are not italicized. I have avoided the use of diacritics.

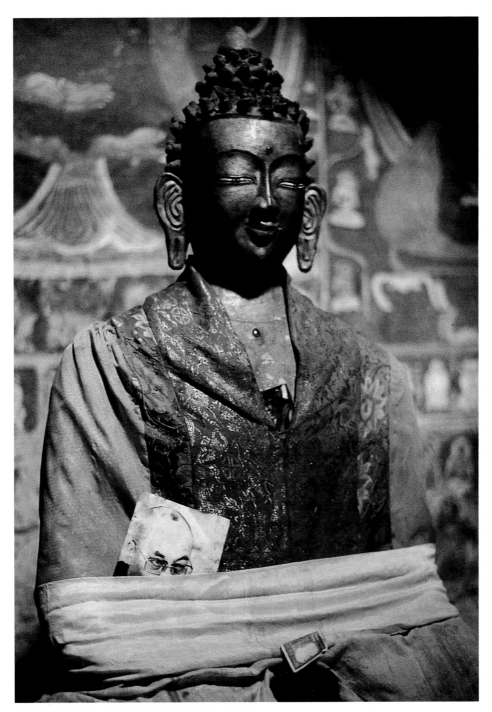

2 Clay Buddha accompanied by photo-offerings of the fourteenth Dalai
Lama, Alchi, Ladakh, 1994.

1 The Image of Tibet in the West

Although it is a fact that the older pieces usually differ from the younger by a rather more careful execution and, in the case of the paintings, by a more distinguished and mellow colouring, yet these differences are qualitatively too slight to refute the general principle that Tibetan art, taken as a whole, presents itself to us as an unchanging entity. One of its characteristics is its agelessness.
– P. H. Pott, *Introduction to the Tibetan Collection of the National Museum of Ethnology, Leiden*

In 1984, in the diesel-scented heat of the streets of Delhi, an Indian curio seller and an English woman had the following conversation about a grubby piece of cloth hanging outside his shop (illus. 3).

She: 'What is that?'
He: 'Very old . . .'
She: 'But what is it?' (trying to decipher blurred forms which appeared in a textile of uniformly tea-brown colour)
He: 'Very old . . . from Tibet . . . two hundred dollars.'

This encounter was one of the first in which I experienced the power of association which the word 'Tibet' has mustered in the minds of non-Tibetans for many centuries and which continues to gain purchase as the decades pass. The tripartite equation which the Delhi shopkeeper proffered confirmed one of the tropes of the dream of Shangri-La, that Tibet is imagined as an artefact of great age and beauty. But even on my first visit to India I wondered why the fabric which he spoke of with such reverence was dangling in the fumes of Janpath and whether its age and provenance were so authentic. I soon learnt that the murky coloration of the object he offered provided a clue to what it was – a tea-stained fabrication of a Tibetan *thangka* probably produced like thousands of others in Nepal or India only months before it was hung up for sale in Delhi. Dealers in things Tibetan could literally capitalize on the statement of the Leiden curator that 'Tibetan art, taken as a whole, presents itself to us as an unchanging entity. One of its characteristics is its agelessness.'[1] As culture brokers both Pott and the Indian dealer use 'Tibet' as a concept to conjure with. Just as Tibet has become an imagined locus of spirituality, an 'empty vessel' into which Western dreams could be poured, so its objects have become signs of a place

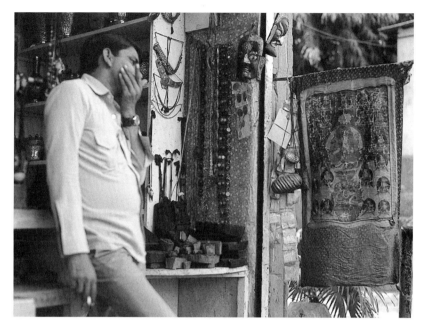

3 Indian curio seller, Janpath, New Delhi, 1984.

where time stands still.[2] Tibet and its objects have thus been forced to dance to the tune of allochronic discourse in which, as Fabian puts it: 'That which is past is remote, that which is remote is past.'[3] Tibet has been and continues to be imagined entirely in terms of great physical and temporal distance from the West, resulting in the denial of coevality and agency to those who live and create 'Tibet', that is, Tibetans. Hence Dr Pott could also claim in his catalogue that just as Tibetan art is 'timeless', so it is 'nameless'. Any acknowledgement of the makers of Tibetan things and their consumers, or of the textual sources in which aesthetic and technical matters were analysed by named Tibetans, is absent from his account. This omission reflects the Tibetological scholarship of a period when few had engaged in fieldwork or participant observation and in which the constructions of knowledge about 'the Orient' gave primacy to objects as representatives for their producers and their places. The place Tibet was embodied in artefactual ambassadors.

It is only in the last thirty years that Tibetan culture has begun to receive the attention of anthropologists who privilege indigenous conditions of production and use. But why have recent literary and museological presentations of Tibetan culture continued to emphasize the 'timeless' and the 'nameless'? Why has the material and visual

culture of exiled Tibetans and the inhabitants of the Tibet Autonomous Region of the PRC been ignored? I argue that the answers to these questions may be found in an analysis of the process of museological fixing which has been applied to Tibetan objects. The approach of collectors from the colonial period is by no means unique to the case of Tibet, but whereas the study and representation of, say, Indian material culture has been re-framed in the post-colonial era, recent exhibitions of Tibetan 'art' suggest that, as a category of investigation, Tibet remains locked into a series of Orientalist paradigms (such as timeless-ness and namelessness). This situation is partly the result of the Chinese takeover, which has meant that Tibet no longer exists as a political entity or a site for colonial-style exploration. Instead it remains most firmly fixed in the Western imagination through its objects, making the journey to the 'sacred land' on the 'roof of the world' redundant.

British Reactions to Tibetan Material Culture

It is therefore crucial to examine the ways in which the vast numbers of Tibetan artefacts held in Western collections have stimulated the imag-ination of their viewers over the last century or so and to historicize the production of the contemporary image of Tibet which presents it as a lost world of spirituality and traditionalism. British encounters with Tibetan things provide revealing source material for a preliminary discussion of this subject. Shortly after the Dalai Lama's departure from Tibet and the creation of the Tibetan diaspora, two British Tibetologists (Snellgrove and Richardson) reported that:

Until 1960 or so Tibetan art was known outside Tibet from scattered museum collections and those of the very few westerners who had visited the country on official missions or as travellers and scholars.[4]

This elite group of 'travellers and scholars' entered Tibet carrying many of the preoccupations of colonial explorers of other lands (though Tibet itself was never fully colonized by Europeans). Their observations and collections had the double force of confirming a personal history of adventure and access to first-hand specialist knowledge with the ability to encode an imagining of place. These early travellers played down the significance of individual objects in order to construct a grander narra-tive of a cultural unit. This tactic has remained powerful and perhaps inescapable owing to our 'entanglement' with colonial history.[5]

Although British involvement with Tibet was literally peripheral to

the larger project of ruling and knowing India, one of the aims of the Raj was to map the extent of Tibet, to discover exactly what lay beyond the Himalayan foothills where the colonial administrators lived in the monsoon months. At one of the British summer retreats, Simla, a marker stone indicating the number of imperial miles to Lhasa was still visible in the 1950s when my informant Balraj Khanna was a schoolboy there. Indians known to the British as 'Pandits' (such as Sarat Chandra Das, who wrote a Tibetan dictionary) were sent into Tibet disguised as Tibetans to count imperial miles on prayer beads and orient themselves with compasses concealed in prayer wheels so that, for the British, 'what in the end came to be its borders were colonially determined'.[6]

But the fascination with Tibet was not simply a matter of fathoming its landscape and territory (one of the defining features in the construction of the myth of Shangri-La). It also arose from a desire to acquire its objects. The void left by the failure to fully map and colonize Tibet was filled by a series of anticipated realities which were concrete embodiments of a projected myth of Tibet. These were the objects of Tibet's material culture, familiar to the British on the Indian sub-continent. The conclusions adduced by early collectors of Tibetan objects vary according to the state of concurrent knowledge about Tibet the place – a knowledge established through texts. It is possible to historicize some of the European attitudes towards Tibetan Buddhism between the eighteenth and twentieth centuries, highlighting visions ranging from the demonic to the benign,[7] but little account has yet been made of the ways in which Tibetan material culture has been 'read' and used to demonstrate some of the assumptions held about the land from which it originates. Publications that document Tibetan culture oscillate between an emphasis on the peaceful and spiritually uplifting, with titles such as *Lamaist Art: The Aesthetics of Harmony*[8] and *Wisdom and Compassion: The Sacred Art of Tibet*,[9] and the violent and disturbing, as in *Tibet's Terrifying Deities: Sex and Aggression in Religious Acculturation.*[10] The photographer Fosco Maraini, who accompanied Giuseppe Tucci on his 1938 expedition to Tibet, summarized this approach in a caption to some of his pictures of monastic sculpture ascribing to Tibetans 'the need for the horrible'[11] (illus. 4). We need to acknowledge the degree to which objects trigger received ideas rather than attempting to offer an 'objective' record of a society or culture. One dominant Orientalist trope concerns the intriguing difference of Asian objects, an exoticism further excited in the minds of the British in the eighteenth and nineteenth centuries when they came from 'inaccessible' and 'esoteric' Tibet.[12]

Following a skirmish between British and Bhutanese forces in 1774,

59. The need for the horrible

4 'The need for the horrible': Fosco Maraini's photographs of sculpted wrathful deities in Tibetan monasteries recorded during the Tucci expedition, 1938, from *Secret Tibet* (1952).

the Panchen Lama (the second highest ranking religious figure in Tibet) sent a letter to Warren Hastings (Governor of West Bengal) in Calcutta, inviting one of his representatives to visit Tibet. No British foot had heretofore been placed on Tibetan soil. George Bogle was the man charged with the unique task. Hastings' curiosity had been excited by a box of gifts that accompanied the Panchen Lama's letter and which included:

. . . gilded Russian leather stamped with the Czar's double headed eagle, and Chinese Silk, which suggested external commerce; small ingots of gold and silver, purses of gold dust, and bags of musk, which seemed evidence of internal wealth; and Tibetan wool cloth, which together with the well made chests in which the gifts had come, indicated a knowledge of the arts and industries.[13]

On the basis of these examples of material culture Hastings made judgements about the nature of the place from which they came and the people who lived there:

A simple, well disposed people, numerous and industrious, living under well-regulated government, having considerable intercourse with other nations, particularly with the Chinese and Northern tartars, and possessing at home the principle means of commerce, gold and silver in great abundance.[14]

Hastings clearly viewed Tibet as something of a treasure house and

recognized that the Tibetans were highly skilled traders with contacts stretching from the Black Sea to Beijing. Their ability to both acquire and produce objects of beauty and value made a great impression; the possibility of entering into trade relations with these industrious people, who were apparently also rather well disposed towards him, was tantalizing. Though sent by a religious leader, the Panchen Lama's box had presented Hastings with evidence of secular and commercial activities. Hence his image of Tibet was of a place ripe for exploration and exploitation. This vision of an unknown but jewel-filled Tibet continued to fuel British desires to know and engage with Tibet and Tibetans right through the nineteenth century.[15] Over a century later the Younghusband Expedition enacted British desires to control political and trade relations with a Tibet which they knew to be replete with mineral resources. As one of its members, L. Austine Waddell, commented, Tibet's goldmines were 'probably the richest in the world' though 'almost as inhospitable as the Klondyke'.[16] Waddell had spent almost twenty years among the Himalayas (a phrase he used as the title of his book) waiting for the chance to join a group of pioneers who could discover these riches, but he also saw Tibet as the repository of other kinds of goods: the beautiful products of its religious practices.

Over the course of many years spent on the periphery of Tibet, in the employ of the British Raj, Waddell could only dream of Lhasa. From 1885 to 1895 he laboured under the unglamorous title of Assistant Sanitary Commissioner for Sikkim and Darjeeling, but this vocation provided him with ample opportunity to examine the inhabitants of the Himalayas, including Tibetans whom he documented in the style of colonial records of ethnographic types (illus. 5). Darjeeling in the 1890s was in some ways not so different from Delhi in the 1980s. On his walks around the hill station Waddell found that:

. . . you can seldom go far without being pestered by pedlars to buy all sorts of things [. . .] jewellry, plaids, daggers and swords, carvings and the crudest of curios, including prayer wheels, amulets, skull-bowls and trumpets of human bones and 'genuine' antiquities from Tibet and China, most of which are of local manufacture, and made especially for sale to visitors.[17]

In order to acquire the authentic article rather than the merely 'genuine' of the Darjeeling bazaar, Waddell located his objects among those who practised Tibetan Buddhism. He outlined his collecting strategy at a Sikkimese monastery in the preface to the first edition (1894) of *The Buddhism of Tibet or Lamaism.*

. . . Realizing the rigid secrecy maintained by the lamas in regard of their

5 Tibetan curio sellers in Darjeeling in the 1890s, from L. A. Waddell, *Among the Himalayas* (1899).

seemingly chaotic rites and symbolism, I felt compelled to purchase a lamaist temple with all its fittings and prevailed on the officiating priests to explain to me in full detail the symbolism and rites as they proceeded. Perceiving how much I was interested, the lamas were so obliging as to interpret in my favour a prophetic account in their scriptures regarding a Buddhist incarnation in the West. They convinced themselves that I was a reflex of the Western Buddha Amitabha, and thus overcame their conscientious scruples and imparted information freely.[18]

With his Orientalist ambitions, Waddell could hardly have hoped for better luck. He acquired the entire contents of a temple, enough erudition to write a 570-page book and was deified in the process. Though Waddell enjoyed impressing his British readers with his assimilation into Tibetan culture as a new Amitabha, he 'adopted a posture of both control over and contempt for his informants and secured his authority by allowing the lamas to believe that he was ultimately one of them'.[19] While it is clear that Waddell sought to emphasize the superstitious and gullible nature of Tibetan monks, and his readers are assumed to share his enjoyment at playing a 'reflex' of the Buddha, it is highly unlikely that the Tibetans actually believed this English gentleman to have any connection with the Buddha or a bodhisattva. Rather they had little choice but to encode what was an equally confusing situation for them in a culture-specific manner. Whilst the English surgeon, sanitation commissioner, collector and amateur anthropologist/art historian employed dissection and description as his cultural tools, the Tibetans organized their thoughts within a world-view dominated by religious pronouncements. When Waddell, as a representative of the colonial authorities, felt 'compelled to purchase', it is also likely that the Tibetans felt compelled to oblige. This must rank as one of the first recorded moments when Tibetans enabled a European to go away with what he believed to be thoroughly authenticated goods.

Waddell's reaction to the confusing prospect presented to him by the imagery and ritual of Tibetan Buddhism was first to purchase and then to dissect and itemize his 'finds'. Thus page after page of *The Buddhism of Tibet or Lamaism* includes diagrams and tables of ritual implements and the 'insignia' of Tibetan Buddhism. Pages 340 and 341 demonstrate his working methods (illus. 6). On the right-hand page, a box includes illustrations of 29 'Insignia and Weapons of the Gods, etc.', each inscribed in Tibetan. On the left-hand page, a table provides a translation of the Tibetan into English in one column, in the second column transliterated Tibetan and in column three Sanskrit terms, where they apply. That Waddell based his model on similar studies of Indian objects is demonstrated by his inclusion of Sanskrit, the lingua franca of Indology and one which any scholar connected to either the British Museum's Oriental Department, the India Office Library or the Indian Museum in Calcutta (all institutions to which Waddell donated objects) would have studied.[20] Thus Waddell introduced Tibetan objects through a classificatory grid established for the documentation of Indian objects. Indian material culture had been a major feature of 'The Great Exhibition of the Industry of All Nations' at Hyde Park in London in 1851 and the Paris Exposition of 1877–8 and had inspired a

European taste for secular, decorative objects from the sub-continent as well as Hindu ritual implements and devotional images. Waddell selected mainly religious items for his representation of Tibet and his motivation was not dissimilar to those, described by Breckenridge, who collected Hinduism:

Such a collection created an illusion of control – in this case over the 'mysteries of the Hindu pantheon' with its endless 'curious and often grotesque' gods who belonged to a 'polluted faith'. Mastery over these multiarmed gods was brought about with Linnaean tenacity, if not obsessiveness. The collector collected them, grouped them, photographed them and even published them.[21]

Waddell aimed for a similar air of control through the use of classificatory tables and taxonomies which attempted to organize objects in a scientific manner akin to that used for specimens of flora and fauna. *The Gazetteer of Sikkim*,[22] in which he published diagrams of the positioning of ritual objects in a Sikkimese monastery, was part of the colonial project in which the regions of India were documented, and included sections on the plants and animals of the area, as well as

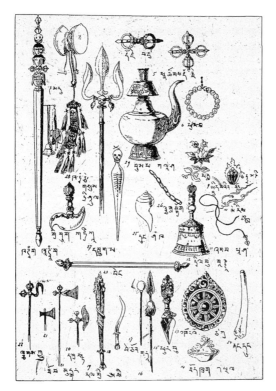

6 L. A. Waddell's scheme for arranging 'The Insignia and Weapons of the Gods, etc.', from *The Buddhism of Tibet or Lamaism* (1894).

24

classifications of ethnic types and their practices. A tension between what Waddell saw as the curious and grotesque appearance of Tibetan culture and his desire to organize it and make it knowable is resolved by the aestheticizing effect of the tables of illustrations, in which the diminished scale of the objects makes them both pleasingly miniature and manageable.[23] Waddell's study is firmly placed in the colonial framework of documenting the visible details of a culture even when his overall attitude towards that entity was fundamentally negative. He describes his magnum opus (my emphasis) thus:

The special characteristics of the book are its *detailed accounts of the external facts and curious symbolism of Buddhism*, and its analyses of the internal movements leading to Lamaism and its sects and cults.[24]

But he also states that:

. . . the bulk of the Lamaist cults comprise much deep-rooted devil worship and sorcery, which I describe with some fullness. For Lamaism is only thinly and imperfectly varnished over with Buddhist symbolism, beneath which the sinister growth of poly-demonist superstition darkly appears.[25]

Waddell's dim view of Tibetan Buddhism can be related to the techniques he utilized to produce his knowledge of Tibet. He suffered from what Fabian (1983) calls an excess of 'visualism', for it was those very 'external facts' of Tibetan life which had not impressed him. Though he collected them with alacrity, it was the things that he observed Tibetans using in daily life that exposed their superstitious nature, for, like other 'primitives', they had an irrational faith in their objects. In the text accompanying a studio portrait made in Calcutta of a woman from Tashilunpo, Tibet (illus. 7), the compiler of the second edition of *The People of India*, Herbert Hope Risley, cites Waddell as an authority on the 'Lama' people, remarking that:

Their inveterate craving for material protection against malignant gods and demons has caused them to pin their faith on charms and amulets which are to be seen everywhere dangling from the dress of every man, woman, and child.[26]

Despite this damning commentary Waddell collected amulets like those worn by the woman he arranged to have photographed in the studio of Johnston and Hoffmann and included a photograph of three alongside her picture in *The Buddhism of Tibet or Lamaism* (illus. 8). He also copied printed 'charms' against dog-bites, bullets, cholera and 'kitchen cooking smells offensive to the House-Gods' as further demonstration

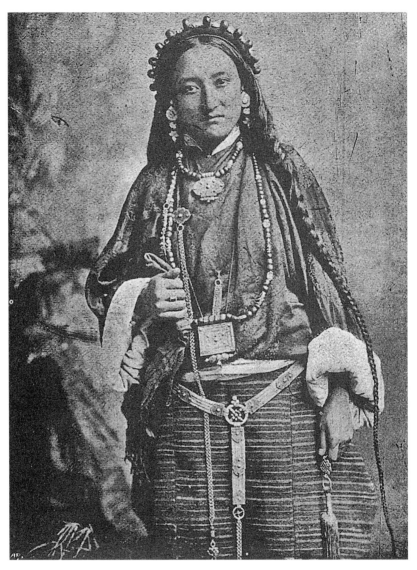

7 Woman from Tashilunpo, photographed in the studio of Johnston and Hoffmann, Calcutta, *c.* 1890, from Waddell, *The Buddhism of Tibet or Lamaism.*

that Tibetans lived in an 'atmosphere of the marvellous' in which 'no story is too absurd for them to credit, if only it be told by Lamas'.[27]

For nearly ten years after the publication of *The Buddhism of Tibet or Lamaism* Waddell continued to hope that he would have further opportunity to find evidence of the 'idolatory' of Tibet. That he had

been inspired by the idea of the 'unknown' Lhasa is suggested by his use of this quotation from Lord Curzon, Viceroy of India: 'In the heart of Asia lasts to this day the one mystery which the nineteenth century has still left to the twentieth to explore – the Tibetan oracle of Lhasa.'[28] In 1903 Waddell finally gained the opportunity to visit Tibet as chief medical officer to the Younghusband Expedition to Tibet. In his account of the campaign (*Lhasa and its Mysteries*) he presents this view of Colonel Younghusband's final destination, Lhasa:

Wreathed in the romance of centuries, Lhasa, the secret citadel of the 'undying' Grand Lama, has stood shrouded in impenetrable mystery on the Roof-of-the-World, alluring yet defying our most adventurous travellers to enter her closed gates. [. . .] But now, in the fateful Tibetan Year of the Wood Dragon, the fairy Prince of Civilisation has roused her from her slumbers, her closed doors are broken down, her dark veil of mystery is lifted up and the long sealed shrine with its grotesque cults and its idolised Grand Lama, shorn of his sham nimbus, have yielded up their secrets and lie disenchanted before our Western eyes. Thus, alas! inevitably, do our cherished romances of the old pagan world crumble at the touch of our modern hands![29]

Designed for an adventure-hungry British public and with the aim of legitimizing the Younghusband Expedition, Waddell begins his account in classic Orientalist mode. He encourages the (male) reader to join with him as an Asian city, defined as feminine and alluring yet chaste

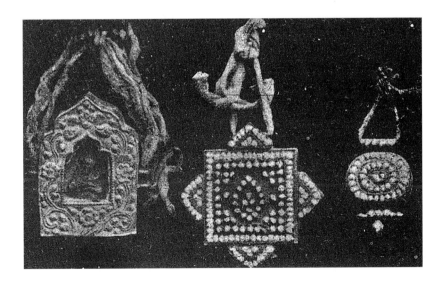

8 Three amulets from Waddell's collection 'reduced 1/3' in *The Buddhism of Tibet or Lamaism.*

and fortified, is penetrated by the 'fairy Prince' of European civilization. But in Waddell's romance, where he plays Prince Charming to a Tibetan Sleeping Beauty, the Princess Lhasa, once touched and unveiled, reveals herself to be something of a whore. Lhasa's tradition of 'pagan' cults and idolatry is exposed as a 'sham' which cannot withstand the interrogation of a rational, modern, Christian European. In the explicitly 'tradition versus modernity', 'ignorance versus Enlightenment' paradigms of many a colonialist before and since, Waddell is both enticed by dreams of the perpetuation of the 'old world' in a remote corner of the globe and repelled by its difference. He manages to blame Lhasa for failing to live up to his dream and somehow it is her fault that 'our Western eyes' are disappointed once the fortress has been assailed. This passage consists of an extended metaphor of the 'virgin culture' which has yet to be conquered but, once taken, can never be the same again. Waddell uses an idiom of decay to recuperate a presence which is most clearly glimpsed on the cusp of its destruction. Thus Tibet appears most vividly in the Western gaze at the moment of its disappearance.

Waddell's account attests to the privilege of having been physically present on the Tibetan plateau. Despite the fact that the dream crumbled under his 'Western eyes', he continued to use them during the expedition to collect specimens that presented Tibet as 'a fixed reality which (was) entirely knowable and visible'.[30] But on this occasion he was not obliged to purchase, as the dream also crumbled at the touch of Western bodies. The Younghusband Expedition was supported by a military force that engaged in battles with the Tibetans as they attempted to reach Lhasa. In a letter to his mother written after the capture of Gyantse Dzong in 1904, Lieutenant Colonel A. L. Hadow described how he and other soldiers looted the fort (dzong)'which was almost entirely in ruins' and how in one room they found 'a lot of images and other things connected with their religious ritual'.

Everything which appeared worth having was there, and after some things had been set aside for the British Museum, the remainder was divided among the officers. Three small images fell to my share, of no particular value beyond being curiosities . . .[31]

But Hadow was not satisfied with his 'curiosities' and went back at seven the next morning with only one other officer to look for more. This secret mission proved fruitful because:

. . . presently in a dark corner I discovered what appeared to be a cupboard with two doors [. . .] It was piled high with dust inside but the first thing I touched rattled, it being hung from the ceiling, and I recognised it as a

Lama's apron made of human bones and beautifully carved – knowing this to be of some value I seized it out at once.[32]

Hadow also found a large 'image of some deity' covered in silk, but it was evidently too big for him to take away so he settled on two smaller images, though he was 'disappointed to find no precious stones set in any of them as is often their custom'. However he remained concerned that:

... if the authorities heard of what I had got, some of the things would be appropriated for the British Museum, so I have packed up the best of them and they are leaving tomorrow. There is a Colonel in the Indian Medical Service who is 'Antiquarian to the Force' and whenever he sees anything nice, he says for the British Museum, but we are very doubtful as to how much will eventually reach the said museum![33]

Though Hadow does not name him, the 'Antiquarian to the Force' was their surgeon, L. A. Waddell. With the assistance of the Norfolk Regiment and their Maxim machine guns, the Younghusband Expedition successfully reached Lhasa and attempted to establish the much sought after trade relations between Tibet and British India. In the meantime Waddell did ensure that the majority of looted Tibetan objects were accessioned at both the British Museum and the Victoria & Albert Museum in London.[34] There they have performed honourable service to the static, religious vision of Tibet which still predominates one hundred years later. In the absence in these galleries of any narrative of Tibet's history in the twentieth century, they contribute to the process by which Tibetan culture continues to be viewed as 'timeless' and 'nameless'.

Hadow's collection on the other hand (now displayed in the Norfolk and Norwich Regimental Museum, Norwich) is presented in the context of a military museum whose entrance display includes a highly polished Maxim machine gun alongside a Tibetan gun collected at Gyantse. As artefacts of battle their labels also suggest a wider epistemological conflict. The Maxim is captioned as the 'very sophisticated' weapon which successfully suppressed the opposition, while the flint-triggered Tibetan weapon is described as a 'simple, slow, clumsy and inaccurate' implement of war. Like its users, it is construed as lower on the evolutionary scale by comparison to the British machine gun. The Younghusband Expedition had been one of the first tests for the newly designed Maxim, and (as the regimental museum informs us) Lt Hadow returned from Tibet 'a very enthusiastic advocate' of it. (However, he was unsuccessful in his attempts to introduce a machine-gun section to the All India Rifle competition.) In the Norwich display, the visitor

passes Hadow's human-bone apron en route to a case that reiterates the effectiveness of British weaponry and includes a photograph by Hadow of a Tibetan dying on the plain at Gyantse. Here lies Tibet as if in a perpetual state of rigor mortis. This impression is all the more poignant and problematic when the picture is accompanied by Tibetan bones in the form of a thigh-bone trumpet (again from Hadow's collection at Gyantse) and the 'apron'. This collection confirms an observation made by Susan Stewart that:

If the function of the souvenir proper is to create a continuous and personal narrative of the past, the function of such souvenirs of death is to disrupt and disclaim that continuity. Souvenirs of the mortal body are not so much a nostalgic celebration of the past as they are an erasure of the significance of history.[35]

Hadow's Tibetan souvenirs are not presented without reference to a particular moment in time (1903–4), but they deny the particularity of the politics of that moment and its future ramifications. The dying Tibetan fixes the British attitude to Tibet at a moment of defeat, of failure in the face of superior fire-power. This suggestion could equally be applied to Waddell's collection, for, as we have seen, Tibetan objects were read as symbols of failure, demonstrating the credulity of Tibetans and their inability to engage with modernity and technologies of civilization.

The early part of the twentieth century saw European, particularly British, 'princes of civilization' attempting to arouse Tibet from her slumbers and bring her into the domain of Western modernity. Waddell himself included a section in his preface to the second edition of *The Buddhism of Tibet or Lamaism* in which he describes 'The Hostility of Lamas to Western Civilization and Western Education'. However, the thirteenth Dalai Lama was an exception to the rule, and he is said to have hoped to 'assist the Tibetans towards acquiring some western civilization' by sending the sons of Tibetan 'lay land owners and merchants and nobles to receive western education on civilized lines'.[36] These lucky boys were sent via India to Harrow, Rugby and Sandhurst in England. But, Waddell complains,

it all proved a miserable and total failure, through the inveterate hostility of the all powerful and superstitious and intriguing lamas of the great monasteries in fear of losing their firm hold on the ignorant populace.[37]

According to him, the Tibetans had rejected those very influences from the outside world that could have redeemed them. Instead they persisted in their 'superstitious' religion, in perpetuating their

traditional but 'sterile' art forms and doggedly pursued an isolationism that the British deemed inappropriate for the modern world.

However, the Younghusband Expedition bequeathed a legacy of British connections with Tibet that remained close throughout the first half of the twentieth century. Political relations were complex and tense during this period, but trade and the gathering of intelligence remained defining features of the relationship. As the trade agent in Gyantse a decade after the expedition, David Macdonald was photographed with some of those who assisted him in his efforts: a group of Gurkha soldiers and 'Enchung', an itinerant Tibetan curio dealer who was 'one of his informants'.[38] Presumably, as Waddell had found, those who could overcome their 'conscientious scruples' and sell objects could also 'impart information freely'. Unfortunately, the objects that were collected and purchased did not always create a positive impression when displayed back in Britain and perpetuated the idea that Tibet's dislocation from the rest of the world and her bizarre religious practices were the cause of a condition of cultural stasis. Thus, when examining Tibetan artefacts from the eighteenth century, Snellgrove and Richardson could find very little evidence of progression and noted 'a certain sterility [. . .] in Tibetan crafts, art-forms, literature, imagery and all the rest'. It was this observation which led them to the larger question of the future of Tibetan civilization (my emphasis):

Does it continue to flourish always in the same stereotyped forms, contrary to all we observe elsewhere in the history of civilisations? *It is almost a general rule that when any culture becomes cut off from outside influences and ceases to develop new forms it is already moribund.*[39]

Since one of the authors of this comment (Richardson) had been British representative to Tibet between 1936 and 1950, the lament about Tibet's inability to change may reflect the British view that Tibet would have to modernize and open up or die. Shortly after Hugh Richardson left the country, Tibet was subsumed into China: an 'outside influence' certainly not of the sort the British or the majority of Tibetans had hoped for. The arrival of the People's Liberation Army (PLA) and a Maoist version of modernity is an event generally read as the death-knell to the traditions that gave rise to all that was finest about Tibet, particularly its religious culture. After this, objects collected from the monasteries of pre-invasion Tibet carry an even higher premium, as mementoes mori to a Tibet now deceased.

The vision of Tibet as a 'Lost World' whose religious practices meant that it was somehow outside of time was not restricted to British visitors prior to 1959. It was shared by the Italian Buddhologist and art

historian Giuseppe Tucci, who wrote: 'To enter Tibet was not only to find oneself in another world. After crossing the gap in space, one had the impression of having trailed many centuries back in time.'[40] Like Waddell he collected evidence of his visits to Tibet in the form of objects, though where Waddell's collecting should be described as ethnographic in intent, Tucci's was devoted to the pursuit of the artistic object. His *Tibetan Painted Scrolls* (1949) is usually referred to as the first art-historical study of Tibetan images (based on the collection of *thangka* he acquired in Tibet in 1948[41]) and has been the model to which many later authors have aspired. Its emphasis on iconographic analysis has bequeathed a powerful and rather rigid legacy. In other works Tucci reveals a broader agenda than the primarily connoisseurial concerns of *Tibetan Painted Scrolls*. For Waddell, Tibetan objects served as reminders of the 'external symbolism' of a religion which corrupted its followers and justified the implementation of a civilizing, Westernizing project. Tucci, on the other hand, saw his collection of paintings as emblems of an Oriental culture which could lead Europeans to deeper knowledge. For both men their response to the material culture of Tibet reflects the ways in which Western intellectuals projected the problems of the Occident through the lens of the Orient. In Tucci's case, his abhorrence of the industrialization and modernization of Europe charged his passion for 'Eastern' values. He had served in the Italian Army during the First World War, an experience which inclined him towards Fascism and the view that battle could be 'the antidote to the cold rationality and impersonality of the modern age'.[42] In a sense the idea of Tibet (and Asia in general) was equally immunizing for it was there, Tucci believed, that a magic no longer present in the West continued to reside. He set out to lead his fellow Europeans to an understanding of Eastern religions which would give them the 'inner vision' of Asia without actually going there. Since he was a conservative who believed that the twentieth century was creating increasing degrees of impersonality, the solution was to seek robust, philosophic self-absorption. To assist in this process, Tucci moved on from his cataloguing of Tibetan material (he also published a multi-volume survey of Indo-Tibetan objects and buildings) to produce *The Theory and Practice of the Mandala: With Special Reference to the Modern Psychology of the Subconscious* in 1961 in which he documented the uses of mandalas with a gloss influenced by Jung. The sense that Tibetan paintings were to be consumed by Westerners as manuals for religious and psychological development thereby became enshrined as one of the tropes of Tibetophilia, and esoteric Tibet became even more firmly located in the Western psyche.

Tibet Relocated

For a handful of exceptional individuals, such as Tucci and Waddell, Tibet was no longer the inaccessible and unobtainable virgin culture of their imagination. They had seen her disrobed and removed some of her more alluring attire to be displayed back in the Occident. Less privileged twentieth-century Europeans thereby came across Tibet in the permanent displays of Western museums where the explorers' collections fixed 'Tibet' as a clearly identifiable cultural unit in which tradition and religion were the defining characteristics. However, according to Dr Pott of the Leiden museum:

> . . . much of the material which has reached western collections in fact exemplifies nothing more than a skilled specialist ability which can lay no claim to be described as true artistry. [. . .] As [the objects] clearly have reference to a mysterious side of life they can certainly be of such interest to initiates that, despite all aesthetic inadequacies, they become desirable objects, but certainly not works of art.[43]

His comments were published in 1964 when a dramatic shift in the Western perception of Tibet was underway. Since the demolition of the country in the 1950s, Tibet's old clothes have been relocated and used to clothe mannequins in other kinds of exhibitions and the global marketplace. They have undoubtedly become highly 'desirable objects', their value increasing in inverse proportion to the political status of the place from which they came. Contrary to Pott's view, some collectors of things Tibetan do admire them for aesthetic reasons, but their capacity to signify 'Tibet' at a time when growing numbers of Westerners hope to be initiated into what Pott calls the 'mysterious side of life' is even more potent. The Tuccian vision of Tibetan images as didactic aids for Occidental seekers of Oriental truths has begun to eclipse Waddell's negative appraisal of Tibetan material culture. The evolution of this change of perspective parallels the history of the demise of Tibet: as Tibet was vacated so its fortunes in the West were revived. The diaspora of Tibetans and their objects allowed it to be relocated and reconstructed all over the globe, from South Asia to Staten Island.

The 'Potala of the West'

In the United States in the 1930s a Chinese 'Lamaist' temple featured in both the Chicago (1933) and New York (1939) World's Fairs. Among the thousands who marvelled at its golden roofs and exotic form was an

American dealer in Oriental art who had changed her name from Jacqueline Klauber to Jacques Marchais. Marchais had already fallen in love with the idea of Tibet when, as a child, she played dolls with a collection of Tibetan sculpture which her great-grandfather had acquired in Darjeeling. Or so goes the tale. According to Barbara Lipton, ten of the 'statuettes' had in fact been purchased in America in 1935.[44] We need not probe Marchais's mythologizing of her relative the 'British lord and sea-captain' too deeply, but the fable at least indicates that she was thoroughly capable of providing an authentic-sounding provenance for Tibetan objects. Her great-grandfather could well have walked the same pedlar-filled lanes in Darjeeling as Austine Waddell. Though she never visited the Himalayas or Tibet herself, Marchais was determined to bring Tibet to her. Inspired by the temple at the World's Fair, she resolved to build a 'miniature copy of the Potala in Lhasa' in her garden at Staten Island, New York, for her growing collection of Tibetan art. However, it seems that she had some competition to be the first to pursue such a plan, as a letter to her secretary records:

In the course of conversation, [the Count] lamented the fact that it was really a shame someone did not build a Lamaist temple to house his Tibetan art, and that he knew where one could buy the temple that was at the World's Fair for only $200,000![45]

But Marchais was not deterred by this and consoled herself with the knowledge that the World's Fair temple had 'lost its gold shingles anyway'. Above all the unnamed 'Count' should not bother acquiring a Chinese Lama temple for she was building 'a real Tibetan one!' By 1947 Marchais's 'Potala of the West', as she called it, was opened and officially titled the Jacques Marchais Collection of Tibetan Ritual Art (illus. 9). The buildings, including a sumptuous library, altar area and exhibiting galleries were designed by Marchais herself in order to ensure that it would have 'all those architectural details (in true Tibetan style) which make the difference between a perfect reproduction and only an indifferent copy'. Her efforts were apparently successful for even the Dalai Lama, on a visit to the museum in 1991, reportedly commented that 'it felt like being in Tibet'. For Jacques Marchais that feeling came from being surrounded by beautiful objects from the place which the Dalai Lama had been forced to flee. Whether the tragedy of this situation struck Marchais is unknown, but she must at least be acknowledged as one of the first who began the process by which Tibet came to be rebuilt in other people's backyards. (Her museum is now a public institution where sponsors can attend champagne brunches entitled 'Sunday in Shangri-La'.) Marchais had

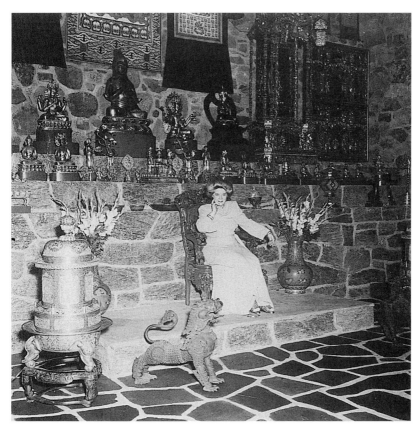

9 Jacques Marchais in her 'Potala of the West'.

set the ball rolling, and ever since Tibetan things have repeatedly been used to invent spiritually uplifting locations in other Western spaces.

The acquisition and enjoyment of Tibetan objects is no longer the prerogative of an elite as they have become, like those of many other cultures, 'symbolically appropriated, fragmented, and repackaged as variable features of mass-produced consumer goods: in brief as style'.[46] Tibetan art and artefacts are now commodities that can be purchased almost anywhere across the globe by almost anyone who desires to buy into that style. The wares laid out to entice tourists at the Buddhist monastery of Alchi in Ladakh, northern India, offer a typical range of Tibetan memorabilia: skull cups, prayer wheels, amulets, thigh-bone trumpets and so on, the very same types of things that Waddell stumbled over in Darjeeling a hundred years ago (illus. 10). The Tibetan bazaar may be timeless, but we need to historicize this objectification.

In the 1950s, Tibetan paintings could be purchased in India and Nepal

for a song, but twenty years later prices for similar items had increased a thousand fold.[47] Snellgrove and Richardson attribute the increased marketability of Tibetan paintings to a rise in knowledge about them and a revival of interest in the colonial collections in the West. However, they fail to mention that it was the very impact of the 'outside world' that forced a change in the market for Tibetan goods. From 1959 onwards, as refugees fled from the Chinese incursions into Tibetan territory and began to establish exile communities in India and Nepal, many were forced to sell possessions from the homeland in order to survive. The paintings and religious objects which they managed to escape with were eagerly purchased by those whose interest had been triggered by the collecting and documentation of Tibet carried out by such figures as Waddell. As we have seen, a taste for Tibetan material culture had already been created, but the events of 1959 attached further symbolic capital (as Bourdieu [1989] would have it) to exilic objects. Maoist policies of the Cultural Revolution period (1966–76) also fuelled the market, as the drive to eradicate all tangible traces of Tibetan Buddhism meant that the contents of thousands of Tibetan religious buildings passed to the galleries and dealerships in Hong Kong and further afield. Many of these objects were eventually placed in the holding cells of Western museums and private collections where they have since provided the source material for the majority of

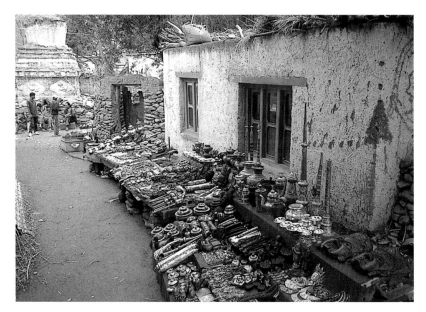

10 Sale of Tibetan curios at Alchi, Ladakh, 1995.

studies on Tibetan art produced in European languages in the second half of the twentieth century. But, like the refugees, they carry an identity certificate marking them as 'Tibetan' and are without powers of self-determination.

Only a relatively small number of artefacts remain in the hands of Tibetans. Tibet House (New Delhi) has staged a number of exhibitions using objects from refugee collections.[48] The 'capital in exile' in Dharamsala in India has a small museum at the Library of Tibetan Works and Archives, but the majority of Tibetan art and craft pieces are roving ambassadors representing Tibet without the intervention of Tibetans. As yet, there has been no concerted attempt to reclaim them. Unlike other groups of 'marginal' or dispossessed people, the Tibetans have made no claims to reappropriate these diasporic objects to become markers of their present identity. As we shall see in the following chapters, this may be due to the way in which their identity as exiles is part of an ongoing process of production in which the images of Tibet must be made anew.

Instead, over the last decade or so the task of curating and interpreting Tibetan material culture has been adopted by Western Tibetophiles. They have conjured meanings for objects disconnected from their original contexts and the people whose belief systems animate(d) them. In the 1990s a group of art historians, curators, collectors, Buddhologists and Tibetophiles (led by the actor Richard Gere) tried to resuscitate the myth of Tibet in the form of an exhibition entitled 'Wisdom and Compassion: The Sacred Art of Tibet'.[49] In it they attempted to re-create pre-1959 Tibet with a treasure trove of beautiful, dispossessed objects, which were mainly paintings on religious themes. Gere (the founding director of Tibet House, New York, which sponsored the show) stated in the catalogue that the exhibition and the 'Year of Tibet' festival that accompanied it were staged in order to 'bring the world's attention to the richness and uniqueness of Tibet's tragically endangered culture'.[50] No direct mention is made as to the source of the threat to Tibet's culture; it is simply understood that those visiting the exhibition will share the organizers' horror at the Chinese takeover. The entire project (and catalogue) sought to depoliticize the history of Tibet and replace it with a myth, as comments by the director of the Asian Art Museum reveal. He appealed to the memory of pre-1959 Tibet in his introduction to the exhibition:

In a Westerner's mind there is, perhaps, no place more distant from here, from now, than Tibet. Its very elevation makes it aloof – above even geography. We think only of mountain lofts and snow, bundled-up people moving slowly on the slopes of Everest.[51]

These imaginings echo the romance of the out-of-space and out-of-time Tibet of Waddell and Tucci in the spirit of what Lopez calls 'New Age Orientalism'. As we know, the Old Age Orientalist vision of Tibet focused on religious practices, hence at San Francisco the exhibition was organized according to the principles of the mandala, and Tucci's *Theory and Practice of the Mandala* was enacted by Western curators and a group of 'live' Tibetan practitioners. Four monks from the Tibetan capital in exile, Dharamsala, made sand mandalas throughout the course of the show. This was the closest the curators came to acknowledging that Tibet had a living culture. Within the display of over 160 works of art the curators did not (knowingly) include a single work painted by a Tibetan after 1920. When the show moved to the Kunsthalle in Bonn in 1996, a living Tibetan artist was allowed to enter the space but only in order to sell his wares as tourist curios on the periphery of the main display. The presence of Dharamsala monks at 'Wisdom and Compassion' (and the absence of contemporary artists and/or their work) suggests that for Western Tibetophiles the practice of Tibetan Buddhism is the only cultural expression through which exiles can perpetuate the dream of their lost paradise, as Tibetan historian Dawa Norbu notes with a hint of irony:

Tibet has no oil deposits like Kuwait to boast about or machines like the West. Her sole pride and contribution to the world is what she strove for and specialised in during the last 2000 years – Tibetan Buddhism.[52]

When 'Wisdom and Compassion' reached London, the President of the Royal Academy noted: 'that no work of art or artefact in this exhibition has been sent from Tibet itself must surely tell its own story'.[53] His comment does tell a story but not the one intended. The simple fact is that the 'Tibet' he refers to no longer exists. The exhibition 'Wisdom and Compassion' refers to the ageless, nameless and timeless Tibet that we encountered at the beginning of this discussion. Ultimately that Tibet is a re-presentation produced through objects collected in the past and when, as we have seen, particular historical and political factors came to bear on their collection and interpretation. Presumably the curators of 'Wisdom and Compassion' could not countenance the use of any object produced since 1959, that is, since Tibet became the Tibet Autonomous Region of China. The stance of these curators, dealers and collectors of art from Tibet is, like Tucci's, decidedly anti-modernist, preferring to dream of the solace of a different and traditional Tibetan past rather than face the realities of the Tibetan present. In attempting to bring the audience closer to understanding the 'inner vision' of

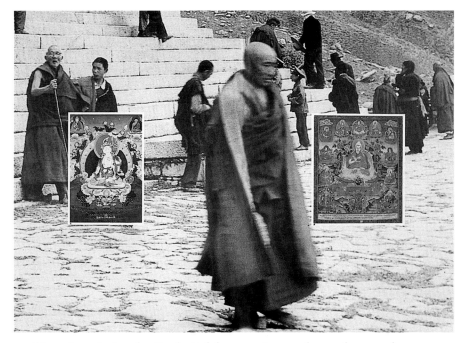

11 *Thangka* paintings by Temba Rabden superimposed on a photograph of a Tibetan monastery.

'the Tibetan mind' the legacy of Tucci is recalled. 'Wisdom and Compassion' was forged from the same longing for the pure sleeping beauty untainted by modernization that Waddell and Tucci so desired. Its unstated rationale is that whilst Tibet does not exist, the West will graciously preserve the treasures of Tibet from the ravages of expansionist and materialist Chinese modernity.

In 1989 another blockbuster exhibition, 'Magiciens de la Terre', at the Pompidou Centre in Paris included Tibet in its mapping of contemporary 'magicians of the earth'.[54] More specifically, it displayed two pieces by a painter (Temba Rabden) from Lhasa in the TAR which were then published in miniature in the catalogue and superimposed on a grainy actualité-style photograph of elderly monks leaving a Tibetan monastery (illus. 11). This exhibition sought to give equal billing to artist-magicians from the First to the 'Fourth' Worlds, so that work by Louise Bourgeois and Tony Cragg could appear in the same exhibition context as work by aboriginal Australians and even Tibetans. But whereas images produced by Western artists apparently needed no accompanying information, Rabden's did. The superimposition of his work on to a photograph of a monastery suggests that Tibet itself had to

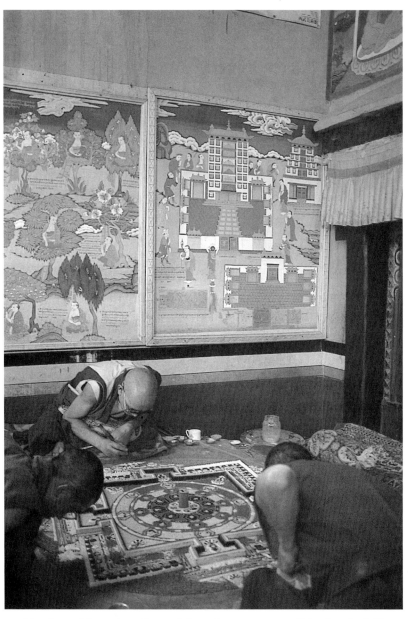

12 Monks making a 'sand' mandala at the monastery of Sankar, Ladakh, 1994.

come into the picture – as the place which created Tibetan Buddhism. Although Rabden's biographical details were also provided, defining him as an inhabitant of the Tibet Autonomous Region of China and his

nationality as Chinese, the curators clearly still wanted to imagine Tibet as it had been before 1959. That is, they played on the popular image of the place that no longer exists.

Further sections of 'Magiciens de la Terre' confirm that what replaced it, the TAR and the Tibetan diaspora, causes problems for those who want to display 'Tibetan art'. Three Tibetan monks were enlisted to help at the show by making a particle mandala (a strange number, since four makers are ritually required) (compare with illus. 12). They were defined as 'Nepalese' from 'Swayambhunath, Kathmandu'. Even more confusingly, two paintings by the Nepalese painter Nuche Kaji Bajracharya, described as a follower of the 'vie spirituelle' and the 'secret' traditions of painting, are direct copies of images that are usually identified as Tibetan. His *Arya Tara* appears in the catalogue as if it were an original authored product in the manner of Western-style painting. No reference is made to the fact that its thirteenth-century precursor, usually described as the Cleveland Green Tara, is one of the most famous images to have come to the West from the Tibetan plateau. It appears on the front cover of a well-known book on Tibetan paintings,[55] where the author acknowledges that, although Nepalese influence is visible, the painting is from 'Central Tibet, possibly Sakya'. Had the curators of 'Magiciens de la Terre' spent some time in the curio stalls of Kathmandu and Delhi they might have been aware that the streets are full of magicians who continue to fabricate Tibetan objects by dissolving the time which has elapsed between the thirteenth century and the present day in order to fulfil our desires for a mysterious authenticity.

However well intentioned, these recent exhibitions are really little different from the objectified fantasies of Tibet that have appeared in the West from the eighteenth century onwards and threaten to place Tibetan culture in a permanent bind of unchanging traditionalism, uninflected by 'outside influences'. In 'Tradition in Native American Art'[56] J. C. H. King suggested that the stereotype of Native American material culture was the result of a process of museological fixing which occurred in North America in the 1860s. He also noted that a static vision of tradition emerged at the moment of greatest change for Native Americans. For Tibetans, some changes were afoot at the time of Waddell, but the most drastic shifts in their fortunes have occurred since the mid-twentieth century and it is since then that the 'timeless' vision of Tibet has become most firmly entrenched in the Western imagination. The remainder of this book is devoted to an analysis of how Tibetans have responded to the changes brought about by the rupture of invasion and exile and to the question of how to go forward when pre-1959 'Tibet' is past.

2 The Image of Tibet in Exile

For the frontispiece to his manual for aspiring Tibetan painters the exiled artist Gega Lama designed an image of Tibet (illus. 13) that placed it at the centre of the world.[1] This depiction of the vacated homeland demonstrates the pride that Tibetan exiles derive from the global awareness of Tibetan culture and their hope that Tibetan Buddhist values, pre-eminently embodied in the figure of the fourteenth Dalai Lama, will spread far and wide. However, it also suggests the impact of the sense of loss and displacement that accompanies the 'virtual social identity' of refugees, an identity whose core element is 'the root of their troubles – they leave home because of who they are'.[2] Thinking about the Tibet they have been forced to abandon unifies Tibetan exiles in the face of challenges to their ethnic and political identity and confirms the idea of an originating source in which their cultural roots may be replenished. But the delineation of the historic Tibetan homeland which appears on many of the publications, T-shirts, posters and books of the community in exile also has a more explicitly political function as an icon of neo-nationhood. The shape of the land 'Tibet' has taken on an iconic status, instantly recognizable to exiled Tibetans and their supporters worldwide as confirmation that an independent Tibet existed and covered a section of the globe as large as Western Europe. It is essential that the exiles remember and depict the 'Tibet' that was taken over by the Chinese, beginning in 1950 and fully effected by 1959, and that they continue, despite the ravages of Chinese colonialism, to imagine it in a state of unity and boundedness.[3] Gega Lama has created an icon of the nation that Tibetans dream of whilst they are forced to make Tibet anew in other locations.

Creating exilic Tibet was initially a matter of dealing with the brute facts of physical survival in host countries, particularly India, which is given due prominence in Gega Lama's mapping of the Tibetan local-to-global nexus. The so-called 'capital in exile' at Dharamsala in Himachal Pradesh (India), which contains the exile government, monastic institutions and the home of the fourteenth Dalai Lama, Tenzin Gyatso, has been the primary location in and from which the self-conscious reconstruction of pre-1959 'traditions' has been executed. An exilic elite of religious figures and artists, writers, performers and musicians has been at the forefront of the promotion of what is in fact an invented tradition of what it means to be Tibetan after 1959: an invention defined in terms

ཏེན་གསུམ་གྱི་བྲེག་རིས།　　　　　ད་ང་རིའི་འགྲོ་ལ་མནད།

ཞེ་བུ་བད་ནོ་ཆེན་སྲུམ་བཟང་ཞེས་བྱུག་པ་བཤུགས་སོ།

13 Gega Lama's mapping of exilic Tibet, from *Principles of Tibetan Art* (1983).

of the imagined communities of Tibetan Buddhism and neo-national-
ism. Within and outside the elite, Tibetan exiles refer to themselves as
nangpa, or Buddhist 'insiders', a term which emphasizes their member-
ship of a community of Tibetan Buddhists and in which pre-exilic
regional and sectarian identities have been subsumed for the sake of
social and political survival. The *nangpa* sense of Tibetanness is
reflected in cultural style, and the dream of redrawing Tibetan nation-
hood is therefore depicted by Gega Lama in the hand of an artist grip-
ping a (Tibetan-style) brush whose point touches on the hem of the
seated Shakyamuni Buddha as he makes the earth-touching gesture.
The 'preservation in practice' ethos of the Dalai Lama and the exile
government has meant that the connection between the Tibetan home-
land and the global community into which the refugees have been
displaced is mediated through the Buddha and the Tibetan painter; a
religio-cultural definition of what it is to be Tibetan has been privi-
leged, and painting is recognized as one of the primary signifiers of
exilic identity.

In exile, *thangka* (religious) paintings remain empowering within Tibetan Buddhist practice and as markers of important life events. They continue to have a role when commissioned for the commemoration of the dead, to aid good rebirth, to tell tales of the Buddha and bodhisattvas, to gain merit, and occasionally to assist in meditation and visualization and so on as they did in pre-1959 Tibet. But images made by Tibetan exiles (and not just *thangka* paintings) also provide recognizable proof of Tibetan identity, the tangible evidence of difference and cultural distancing from the new local context. This is most markedly the case for public images such as murals in the new monasteries and temples of Dharamsala or government-sponsored buildings such as the Library of Tibetan Works and Archives (illus. 14), where the detailed painting of architectural features dresses the concrete frame in Tibetan style. As we shall see, portable images such as photographs and photo-collages have wider circulation in social, political and economic contexts and reflect more fluid ways in which Tibetans define themselves in relation to the perceptions of others.

There are three main aims behind the official agenda. First, it enables exiles to represent exilic Tibet within the host community of India and the wider world. The built environment is the primary focus for marking refugee spaces as Tibetan. Even in the first decade of exile, orphanages such as those at the Tibetan Homes Foundation in Mussoorie, UP, India, were designed according to the principles of Tibetan architecture. In the staging of 'authentic' Tibet in dance, opera and theatre productions, images of the homeland frequently provide the backdrop, with the Potala Palace the favoured imagined location. The second role for images refers to the need to educate the generations growing up in exile and to provide them with appropriate imagery for the new conditions. Some of these images are explicitly didactic, but the majority are designed to ensure that the visual world in which refugee children grow up informs them of their culture and religion. Hence at the Tibetan Homes Foundation each home was provided with a simple image of the Buddha for their communal space. Finally, there is a deep consciousness of recent history and the need to counteract the destruction of Buddhist images in Tibet and the Chinese depictions of Tibet that followed. As Gega Lama's mapping of exile shows, a sharp demarcation must be made between Tibet and China. For exiled image-makers, drawing the lines of difference has been an essential political task and making an image in 'Tibetan' style is thus a statement of resilience and resistance. The implementation of these three aims has meant that the image of Tibet which is reconstructed in exile is envisaged in terms of the past and the traditional.

14 The Library of Tibetan Works and Archives, Dharamsala, 1992.

Since for exiles 'tradition' refers to all that went before the disastrous break of 1959, its appeal is powerful within a process of psychological and cultural retrieval. The majority of exilic images appear to re-create traditional artistic styles and techniques, but an undifferentiated notion of tradition conceals the debates and dilemmas which underpin them. Works which for non-Tibetans may conform to a transparent category of traditional Tibetan art which has simply been preserved and relocated are often the result of a selectivity exercise in which a particular historic style has been accorded the equivalent of state patronage. In the following chapters I try to demonstrate how simple 'tradition versus modernity', 'consolidated past versus confused present' paradigms fail to do justice to Tibetan attempts to make sense of their post-1959 situation, but first let us explore an occasion in which the idea of tradition took precedence in exilic definitions of what can be Tibetan.

Though the contemporary visitor to the temples and monasteries of Dharamsala may be unaware of it, the visual culture of exile is by no means simply the result of unreflective or uninflected traditionalism. The images of exilic Tibet have been forged in the heat of debates in the Dharamsala 'art world'. An 'art world' refers to all of those who participate in making significant objects. This world includes those called artists (lha bris) as well as those who recognize what can constitute 'art'. In our case this includes all members of the Dharamsala community. For Danto (who coined the term) an 'art world' can only exist when its inhabitants have a consciousness of a history of art which enables them to recognize and place new images in a reflexive relationship with those of the past.[4] Although Tibetans have no discipline that is directly comparable to Western art history, the emphasis on a 'historically tutored memory' in exile means that refugees have a strong sense of what constitutes appropriate imagery. Broadly speaking, the religious and preservative ethos of Dharamsala places high value on pre-1959 styles of painting, while the politics of representation in that place has meant that other aspects of the history of Tibetan culture have to be negated. Hence the question of exactly how Tibetan exilic images should be designed, that is, in which style, is a matter of consequence, not merely of connoisseurship, in the Dharamsala art world. The debate over an important public commission demonstrates that in their adoption or rejection of certain styles refugee painters are seen to inscribe a political narrative; for just as there is no such thing as an 'innocent eye', there is no innocent brush. Those who wield the brush are required to demonstrate, both in their works and in their lives, that their Tibetanness is legitimate and authentic.

The Namgyal Temple

From the seventeenth century until 1959 one building in Tibet provided the setting for the many roles enacted by a Dalai Lama. The Potala Palace in Lhasa was his residence for at least half the year (the rest being spent in the Norbulingka), as well as the seat of government and the head-quarters of the Geluk religious order to which the Dalai Lamas adhered. Namgyal Dratsang, the Gelukpa monastic community founded in the sixteenth century by the third Dalai Lama, was also housed in the Potala upon its completion. In the course of the reconstruction process in the capital in exile, there has been some attempt to separate the government from religious institutions, with the Dalai Lama's home, the Namgyal monastery and its main temple adjacent to one another in Macleod Ganj, while government buildings are sited some distance away in Gangchen Kyishong. However, both governmental and religious buildings are used to encourage solidarity among the exiles and the Namgyal temple, also known as the Dalai Lama's temple, is pre-eminent in this regard. According to Von Furer-Haimendorf the new building was, from its inception, 'characterised by its catholicity, which allows prayers and rites of all Tibetan sects to take place within its walls'.[5] The fourteenth Dalai Lama himself promoted the notion of an ecumenical space and,

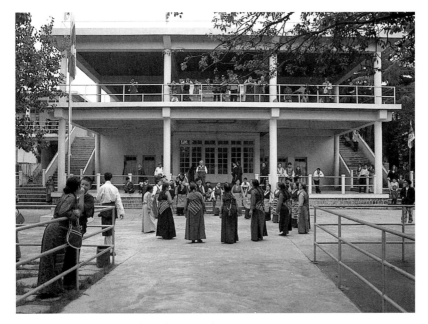

15 The Namgyal temple, Dharamsala, 1995.

16 Gelukpa monk in the circumambulation area of Namgyal monastery, Dharamsala, 1998.

according to his biographer, suggested that it should be built 'in a modern idiom'.[6] Consequently the temple became a two-storey concrete construction in post-Le Corbusier Indian modernist style, with no distinctively Tibetan features externally (illus. 15). Piloti support covered walkways around the assembly chamber, allowing devotees to circumambulate, and large steel and glass windows bring light into the chamber (illus. 16). The use of a modern (non-Tibetan) architectural idiom which would emphasize the accessibility of the space appears to have been successful, for the building is used by all members of the exile community, irrespective of sectarian and regional affiliations, particularly on days when the Dalai Lama appears as leader of the neo-nation. In 1995, his safe return from travel abroad was celebrated in front of the temple with dances from the different regions of the homeland beneath the unifying banner of the Tibetan flag. As one of the primary refugee sites visited by an external audience of devotees and tourists from all over India and the wider world, the Namgyal temple is also a key location for the 'presentation' of Tibetan culture.

In contrast to its international modernist exterior, the interior of the temple is filled with objects of specifically Tibetan origin and design, but the most revered of these, three large-scale sculpted images, have again been chosen for their 'catholicity'. Figures of the Buddha, Padmasambhava and Avalokitesvara are situated behind the throne used by the Dalai Lama when he addresses congregants in the assembly chamber and, since they do not represent bodhisattvas or deities favoured solely by Gelukpas, are acceptable to all. Though the images were sculpted in exile, the Avalokitesvara has special status as cultural repository and embodiment of the homeland, for it incorporates heads removed from the Avalokitesvara in the Jokhang in Lhasa which was damaged during the Cultural Revolution. The remnants of this figure were smuggled into exile and encased in the new silver image when it was consecrated in 1970.

Alongside these three-dimensional icons is another potent object in which imaginings of the past, present and future of Tibet are encoded – a painted representation of the 'Three Kings' of Tibetan Buddhism. However, this image attracts less attention, as it hangs above the entrance to the area circumambulated by visitors when they view and make offerings to the sculpted manifestations of Buddhahood. The *Three Kings* is thus behind them after entry, occupying a position usually reserved for wrathful, protective deities. In pre-1959 Tibet the liminal spaces of religious buildings were marked by guardian kings of the four quarters externally and wrathful, usually sect-specific protectors inside. Because of the Dalai Lama's desire to avoid sectarianism, a single Gelukpa wrathful deity was not selected for the space. Instead, in a novelty of exile, three major historical figures – Songtsen Gampo, Trisong Detsen and Tri Ralpachen[7] (who are also considered to be manifestations of the bodhisattva Avalokitesvara) – are presented as protectors of the faith and the nation in exile. The iconography of the three rulers of the first avowedly Buddhist kingdom in Tibet, with its capital in the Yarlung Valley, has been revived in consciously nationalist vein. The three kings are described in Dharamsala as 'specially revered and loved by the Tibetans for the tremendous contribution they made to spread the teachings of the Buddha as well as to unify and strengthen the country'.[8] This dual agenda, of dispersing Buddhist principles whilst creating solidarity among Tibetans, has clear parallels with the exilic project in which the Dalai Lama assumes the role of leader, if not king, of all Tibetans. Thus the content of the *Three Kings* image was an entirely appropriate addition to a key edifice of neo-nationhood, but its form became a matter of debate in Dharamsala in the late 1970s. For many Dharamsala viewers, the image of Tibet in exile had to be drawn in an appropriate style.

Jampa Tseten and the *Three Kings*

Jampa Tseten was the only 'state' *thangka* painter who managed to escape from Tibet immediately after the fourteenth Dalai Lama's departure in 1959. His official status as an artist had been accorded by the Dalai Lama in Lhasa, and Jampa remained 'a personal friend' of his patron when he followed him into exile. Once in Dharamsala, the Dalai Lama entrusted him with many commissions for new religious buildings and it was therefore no surprise that he should be requested to produce a painting of the Three Kings for use in the Namgyal temple. Jampa's rendering of these famous historical figures presents them as distinct individuals, solemnly returning the viewer's gaze and surrounded by the accoutrements of religious and regal power (illus. 17). The space which the three inhabit is readable, if not fully perspectival, showing them seated on a composite throne before a backdrop of trees and a mountainous vista. A light source from the left of the frame casts shadows around the kings and objects, such as the offerings placed before them, have a convincing chiaroscuro-like three-dimensionality. The only elements which do not conform to a Western notion of realism

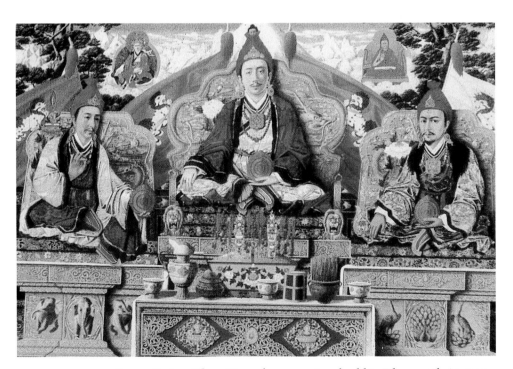

17 Jampa Tseten, *Three Kings*, from a postcard sold in Dharamsala in 1992.

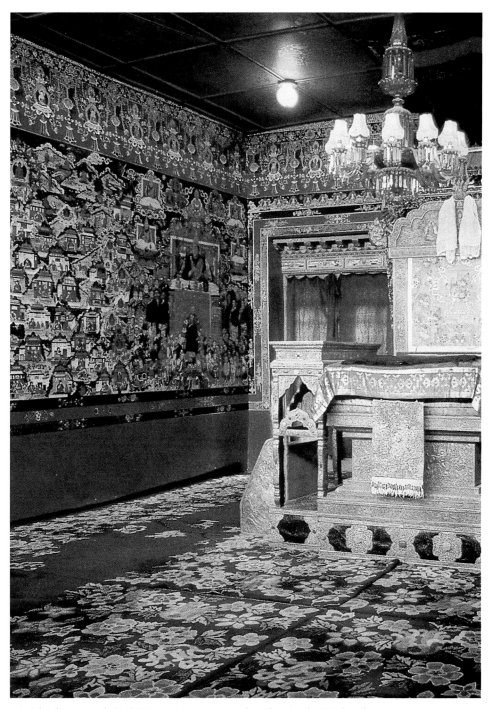

18 The fourteenth Dalai Lama's reception chamber in the Traktrak
Migyur, Norbulingka, Lhasa.

are the hovering figures of the great Buddhist adepts Padmasambhava and Shantarakshita (on the left and right respectively). Their appearance here recalls the assistance they provided in bringing Buddhism to Tibet. (In the eighth century Padmasambhava had been summoned by Shantarakshita and King Trisong Detsen to help to quell anti-Buddhist spirits and found the monastery of Samye.) These features, coupled with two flags of the snow lion, emblem of Tibet since the time of the thirteenth Dalai Lama, indicate that Jampa Tseten expected his audience to view his *Three Kings* as a neo-nationalist piece which was aesthetically and ideologically 'Tibetan'.

However, soon after its completion Jampa's work for the Namgyal temple was rejected and a replacement sought. The problem arose from his use of a style which was deemed un-Tibetan in its realism and, more pertinently, the realism he employed was associated with the Socialist Realism of the People's Republic of China. For some members of the exilic art world of the 1970s, mimesis of this sort suggested a transparent relationship between style and Maoist ideology, an equation which was patently anathema to those who had sought to escape the Chinese invasion. As we shall see later, Tibetan exiles had good cause to associate Socialist Realism with colonization and cultural imperialism, but they appeared keen to forget that, prior to 1959, elite members of Tibetan society had embraced other forms of realism which, though informed by non-Tibetan sources, were by no means Socialist. In fact Jampa Tseten had been in the vanguard of the development of new ways of depiction in pre-invasion Tibet.

Jampa Tseten began his career as an artist in Lhasa by training in the traditional styles of *thangka* painting under the Dalai Lama's 'most Senior State Artist', Sonam Rinchen. His credentials as a producer of religious images were thus well established when he moved to India and he continued to produce paintings in the old style for the Dalai Lama there. However, back in Lhasa in the mid-1950s he had completed a remarkable set of murals in the reception chamber of the Dalai Lama's palace, the Traktrak Migyur at the Norbulingka (illus. 18). These highly realistic portraits of leading figures of the Tibetan government, the Scotsman Hugh Richardson and the Dalai Lama have generated some speculation among historians of Tibetan art as a result of their dramatic deviation from historic Tibetan styles. Lo Bue, for example, suspects that, in order to achieve a heightened sense of realism, the artist had abandoned the use of xylographs as the model for his portrayal of the Dalai Lama in preference for 'an actual photograph of him as a young man'. But he is uncertain about the authorship of the murals.

This may be an isolated example, due to the originality of the artist (one wonders if this may not be a work by the famous dGe-'dun-'chos'phel [Gendun Chöpel]), but it is conceivable that photographs of Tibetan lamas and dignitaries taken and printed by Western travellers in Tibet were occasionally used for reference by artists commissioned to paint portraits of important lamas.[9]

As we shall see, a Western photographic source need not be assumed, as the camera had been in use among Tibetans, both in India and Tibet, well before the 1950s. Lo Bue's tentative attribution to Gendun Chöpel, a radical figure who included artistic endeavours among his many achievements (and who is discussed later), is also unlikely, given that he was under surveillance by the Tibetan government at this time and died in 1951. Heather Stoddard's biography of Chöpel, *Le Mendiant de l'Amdo*, informs us that it was a student of Chöpel, Jampa Tseten, who was responsible for the Norbulingka realist paintings. By seeking the tuition of Chöpel, renowned for the accuracy of his portraits of friends, Jampa had clearly sought to expand his repertoire of styles. In pursuit of this goal he also travelled outside of Tibet, as Norbu reports (referring to Jampa according to the region of his birth, Amdo):

Beginning with the Dalai Lama's previous court painter Amdo Champa, quite a number of young Tibetans with artistic talents were trained in the fifties, sixties and seventies in art schools in Beijing and other parts of China.[10]

But Norbu's additional comment is telling. He suggests that 'essentially these artists were to be used as propagandists'. Norbu's objection arises from the fact that some of his fellow Tibetans adopted the Socialist Realism which had been propagated in Beijing from the 1940s onwards. Certainly, in the first decades following the invasion, Tibetan artists were compelled to observe the ideological and stylistic imperatives of the People's Republic, but the situation in Tibet prior to 1959 was somewhat different. The Traktrak Migyur commission suggests that in the 1950s some Tibetans had no difficulty in accepting Jampa's iconic realism. On the contrary, approval for it came from the top. Jampa's murals for the Dalai Lama were situated alongside his throne in a reception chamber, that is, in a public room explicitly designed for visibility and conferring pomp and circumstance on its occupants. The second highest ranking religious figure in Tibet, the Panchen Lama, also seemed to approve of Jampa's technique, for he allowed his portrait to be made by the artist (illus. 19). Such vivid mimesis only served to accentuate the charisma of a powerful figure.

Hence when Jampa was asked to produce an image of the Three Kings

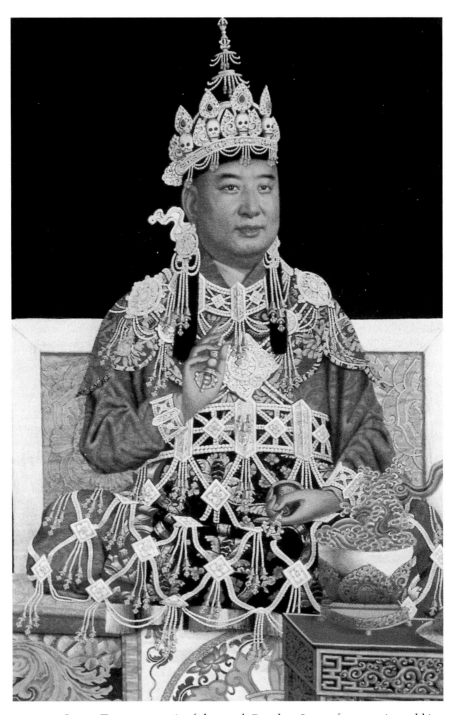

19 Jampa Tseten, portrait of the tenth Panchen Lama, from a print sold in Leh, Ladakh, 1992

in exile he selected the realist style that had proved so effective for his portrayal of eminent religious figures in Tibet. Neither the Dalai nor Panchen Lama had suggested that this style was un-Tibetan, so why was it rejected in Dharamsala? The judgement reflects the politics of the exile situation. In Dharamsala, any involvement with Maoist China can be viewed as suspect and deviation from 'traditional' styles implies a kind of cultural treachery. Jampa's mistake was that he had both studied in China and painted in a style which was not recognized by the exilic audience as part of the remembered traditions of Tibet. However, though he may well have been exposed to Socialist Realism in Beijing, Jampa did not become an adherent of its credo. According to Mao Zedong and his followers, Socialist Realism was a device to be used to create art for the people, by the people, about the people and ultimately, we might argue, to coerce the people. But Jampa Tseten had become a realist painter without becoming a socialist. With the Dalai Lama as a patron, he had no reason to believe that this was beyond the realm of possibility for a Tibetan.

Rigzin Peljor and the *Three Kings*

Once Jampa's *Three Kings* had been rejected, a replacement had to be found for the Namgyal temple. The painting which appears in the building today is an image which fulfils three of the requirements for authenticity that have taken precedence in exile since the 1970s. It is the work of an artist born in Tibet who hailed from a lineage of master painters and who had some knowledge of texts and manuals produced prior to 1959. Perhaps most importantly, the image is designed according to the principles of a particular historic style which has official approval. Its author, Rigzin Peljor (1933–91), had been a Junior State Artist in Tibet prior to his departure to Dharamsala and was the son of Jampa's teacher, the Senior State Artist Sonam Rinchen. Peljor's artistic pedigree stretched back to the time of the fifth Dalai Lama when his ancestor, Lamo Kunga, was one of those summoned to work on the Potala Palace in 1645 and taught at the Great Fifth's 'Marvellous *Thangka* Painting School'. In exile Peljor re-enacted this precedent by teaching *thangka* painting at the Centre for Tibetan Arts and Crafts and painting 'numerous much needed *thangkas*' for the exiled fourteenth Dalai Lama. But unlike Jampa, Peljor did not deviate from the style his father taught and thus produced a far more 'traditional' version of the Three Kings. His figures are highly regularized with virtually identical dress, drapery, crowns and thrones (illus. 20). Facially there is little to distinguish the three individuals and the only hint of variation occurs

20 The 'Three Kings' by Jampa Tseten and Rigzin Peljor.

in the scale of the figures where the 'first king', Songtsen Gampo, appears as the larger and greater of the three. This follows the principles of composition for *thangka* painting, where the primary deity dwarfs attendant figures. Proportion is determined according to a hierarchy of sanctity rather than from any naturalistic logic. Equally, since deities are imagined to have occasional presence in the world but are not a material part of it, Tibetan religious painting rarely incorporates a realistic presentation of space. Hence there are no attempts at perspective, recession or modelling in Peljor's *Three Kings*, despite the fact that the subjects were historic persons. His flattened figures bear comparison with an eighteenth-century monastic mural in Tibet which displays a similar figural treatment (illus. 21). The possibility of reproducing the forms of an image manufactured two centuries earlier and sited in a land no longer accessible to an exiled painter has been assisted in this case by the use of iconographic manuals such as the *Bhadrakalpika Sutra* and the *Astasahasrika Pantheon*. Copies of these two collections of images (in which the kings are depicted individually) survived the journey into exile, where they were consulted by artists, and when published together by Lokesh Chandra in 1991 were even more widely used.

We will return to the importance of the textual transmission of knowledge below but must first emphasize that the perceived authenticity of Peljor's work is not only derived from accurate copying. His connections with the past are affirmed in the use of a particular style for the *Three Kings*. He was a dexterous exponent of the Menri, a style which is recognizable to those who know the history of Tibetan painting and can compare it to other styles, such as the Karma Gadri. Noticeably Menri elements in his *Three Kings* are the densely packed composition with figures occupying most of the space (whereas in the

Karma Gadri style large areas of open space are usually left around the central figures) and the colour range, with intense orange hues juxtaposed to turquoise blue in the background. (Karma Gadri backgrounds are usually paler with large amounts of green.) Jampa, on the other hand, had employed a more realist palette in his work, with colours much more closely emulating the visible world. Thanks to the absence of any hint of realism (whether Socialist or not), Peljor's painting successfully eclipsed Jampa's and gained official and popular approval, but the use of the Menri style for this high-profile commission reveals the degree of invention behind the 'tradition' of Dharamsala visual culture. The Menri has been chosen to become the 'house style' of Dharamsala in preference to all other styles from the history of Tibetan painting and key individuals, such as Rigzin Peljor, have been entrusted with the task of ensuring that the use of this style is preserved and proliferated.

The removal of Jampa's *Three Kings* from the iconography of exile points to the larger question of which image of Tibet has been promoted and what kind of Tibetan culture has gained ascendancy since 1959. Jampa's work was replaced by a painting which conformed to the traditions of the Tibetan past and which the guardians of Tibetan heritage in the capital of the neo-nation in exile could sanction. In contemporary English the word 'tradition' refers to the transmission of beliefs, customs and practices from generation to generation, but earlier usage was closer to the Latin source (*traditio*) meaning to 'hand over' or 'deliver'. When applied to the transfer of objects, 'tradition' had legal connotations, and hence it shares a root with the word for betrayal or breach of trust: treason. In fourteenth-century English, 'treason' was

21 An 18th-century mural painting of the Three Kings.

construed as the violation of allegiance to a sovereign or state, which could include simply imagining the death of the king. The close association between 'tradition' and 'treason' has resonance in the Tibetan exile situation, where to deviate from tradition can lead to the accusation of forging a terrible breach with the trusted past: of breaking the bond with Tibet. Those who dare to remake the image of Tibet in any way other than the traditional must risk the opprobrium meted out on the treasonous. Just as imagining the death of the king was a treasonous offence, outlawed by Edward III in England, so envisaging a different Tibetan world can be a dangerous undertaking for an artist in exile.

Fixing Style in Dharamsala: Textual Transmission

From the eighteenth century onwards, Tibetan patrons had been able to ensure the accuracy of religious icons by sponsoring sets of wood-block or xylographed prints to be consulted by artists. The use of illustrated texts was thus a well established practice among painters in pre-1959 Tibet and a habit which has been consciously revived and continued by 'traditionalist' artists and their patrons in exile. Texts of Indian authorship, such as the *silpasastras*, *puranas* and *tantras*, were also influential in the production of art on the Tibetan plateau, though Lo Bue doubts 'whether all artists were sufficiently educated to read' them.[11] It is more likely that religious figures who could read these texts used them to specify the images they wished to commission. However, such books provide little information of a technical or stylistic nature. Tibetan artists therefore relied on training and practice with an established 'master'. Occasionally such a figure would produce a manual to assist in the transmission of his mode of painting. As was the case with the fifteenth-century artist Menla Dhondrup, whose *The Wish-granting Gem: A Treatise on the Proportions of Images of the Sugatas*[12] is probably the earliest example of a Tibetan artist's manual. He appears to have been one of those rare artists who could both read and write (or had access to someone who could write for him) and provides his own account of the motivation behind his book:

As for the Treatise on the proportions of images, which explains how the intentions of the tantric sources may be easily carried out, these present writings were earnestly undertaken at the request of my pupils coming from dBus and gTsang. I, the artist sMan bla don grub who have absorbed all the artistic systems of India, China, Tibet, Nepal and so forth, [. . .] formed the intention to write it at a place in Nyang stod in gTsang.[13]

Menla was clearly a popular teacher with students coming from

some distance to seek his tuition, hence within his lifetime the distinctiveness of his style (with its eclectic range of influences from neighbouring regions of Asia) had been recognized and the Menri style was named after him. It is impossible to ascertain how many painters used his manual over the centuries, but it undoubtedly inspired debate in high circles (particularly regarding iconometric specifications) and was referred to in the seventeenth century by the fifth Dalai Lama, in the eighteenth century by the encyclopedist Longdol Lama and in the present century by Mipham.

In exile, Menla's manual is by far the earliest source in use among contemporary artists, but it only became available to them through the efforts of Jampa Tseten and Rigzin Peljor. In a cameo of the exile narrative a young refugee and would-be painter, Tsering Dhundup, told me how a version of Menla's text arrived in India. In 1961 his father (Jampa) and a number of others managed to escape from Tibet via Nepal and took with them a collection of drawings which they feared would be destroyed if left behind. They recognized that these images could be used to perpetuate artistic knowledge in India, but perhaps more importantly they also brought an old palm-leaf-format edition of Menla's text with them. Both Jampa Tseten and later Rigzin Peljor had used this book to teach Tsering *thangka* painting until his induction was curtailed when first his father and then Peljor died. Fortunately Peljor had published a manuscript based on the Menla text entitled *Illustrations and Explanations of Buddhist Iconography and Iconometry according to the Old Menri School of Central Tibet* before his death. Like his fifteenth-century predecessor Menla, Peljor intended it to be used by students and to ensure that knowledge of the Menri style would be available to future generations. But, as Tsering had discovered, the use of texts alone could not ensure the completion of a training in *thangka* painting. The oral delivery of knowledge and ideas had been a key component of many cultural activities of pre-1959 Tibet, as Giuseppe Tucci noted when translating an early Tibetan text on style. Commenting that the author's main strokes of originality consisted of muddling or omitting sections from a work by another author, Padma Karpo, he concluded:

Nothing prevents the surmise that the author drew not only from books but also from the oral tradition handed down from father to son in some of the most important artisan centres of Tibet.[14]

It is this oral lineage system which the Dalai Lama and the Tibetan government in exile seek to re-create in Dharamsala.

Fixing Style: Institutions and Artists as Cultural Repositories

As we saw in the case of the *Three Kings*, Dharamsala viewers demanded the removal of a work executed in an alien and politically inappropriate style. Preference has since been given to styles which correspond more closely to exilic recollections of paintings of the past or which are embodied within a lineage of 'master' painters exported into India. The continuation of Tibetan cultural practices in exile has largely been entrusted to those born in Tibet and who had firmly established reputations prior to making the journey into exile. The artists within this group are viewed by other Tibetan exiles as an endangered, and therefore extremely precious, species. Their knowledge, determined by years of physical presence in Tibet, means that they are perceived as cultural repositories with an embodied authenticity which the younger generation can only hope to emulate.

Institutions

The importance of conveying the knowledge of individuals before their demise has been acknowledged at an institutional level in Dharamsala. The Library of Tibetan Works and Archives (LTWA) is a primary location where memories of Tibet can be passed on to those born in India (see illus. 14). The romancing of home is realized in the very fabric of this building, with elements of 'traditional' Tibetan architecture prominently displayed on its facade. Designed by the Indian modernist architect Romi Khosla and the Tibetan politician Jigme Taring, its painted columns and beams have functioned as an appropriate backdrop for performances of Tibetan theatre and opera and for exilic ceremonies. These architectural features and the presence of religious texts and objects which refugees secreted from Tibet give the building a religio-cultural significance which inspires some to circumambulate it on a daily basis. The library has thus accrued the symbolic significance of a building such as the Jokhang in Lhasa, which lies at the centre of three *khor* or circumambulation routes whose contours define the city as a sacred space. Just as pilgrims and residents of Lhasa are empowered by the knowledge that this building contains the most important icon in Tibet, the Jowo Shakyamuni, so for exiles the artefactual remains of the homeland animate memories of pre-invasion Tibet. The exilic objects are presented within the library in a museum-style display, but their function is by no means static. The entire building was sponsored by the Dalai Lama and participates in his 'preservation in practice' ethos. Its material contents are brought to life by staff members with

extensive knowledge of pre-1959 Tibet and the library has its own imprint, publishing works on religious and cultural matters by exiled authors. Texts, both old and new, are consulted by Tibetans and non-Tibetans alike in order to pursue the practice of Tibetan Buddhism, with some classes led by monks held in the building itself. Publications on *thangka* painting are also among its accessions and, like the religious texts, these are not treated solely as documents of history. The library has a satellite organization, the Library School of *thangka* Painting, in which the oral transmission of the techniques of Tibetan painting are actualized. Connected to the library and thus to the current Dalai Lama, the Library Art School is a modest exilic recreation of the seventeenth-century 'Marvellous *Thangka* Painting School' which supplied art and artists for the fifth Dalai Lama.

The other primary cultural centre for tuition in the arts is an even more explicit re-creation of a historic institution just outside Dharamsala. Named after the Dalai Lama's summer palace (the Norbulingka) in Lhasa, the neo-Norbulingka was sponsored by Western Tibetophiles (and inaugurated by Madame Mitterand of France) with the intention of providing accommodation and training areas for practitioners of Tibetan arts and crafts. Designed by a Japanese architect, the centre contains a temple closely modelled on pre-1959 Tibetan structures but with surrounding buildings in more post-modern vein, in which 'traditional'

22 The neo-Norbulingka outside Dharamsala, 1998.

Tibetan architectural motifs are quoted on substructures of less conventional form, such as semi-circular office blocks (illus. 22).

The original Norbulingka ('Jewel Park') on the outskirts of Lhasa was founded in the eighteenth century by the eighth Dalai Lama and was the summer residence to which much of the essential business of state was annually transferred when the Dalai Lamas left the 'winter palace' of the Potala. This Norbulingka was also the site of a number of significant events in twentieth-century Tibetan history. In 1932, the thirteenth Dalai Lama wrote his prophetic statement about the future of Tibet there. In 1959, rumours that the fourteenth Dalai Lama was about to be kidnapped spread so rapidly around Lhasa that, by 10 March, around thirty thousand people had gathered outside the main gates of the Norbulingka where he was residing. That night he escaped through a side gate of the Norbulingka complex and began his flight to India. After his departure, the Chinese converted the Norbulingka into a prison with thousands of Tibetan inmates. By 1972, it had been revamped as the People's Park and became the site of the annual Communist Youth picnic. Today it is a tourist complex (illus. 23).

Hence making the Norbulingka anew in India allows exiles some ability to reappropriate their history. The fact that cultural values are emphasized at this institution reiterates the sense in which exiles attempt to eclipse the 'bastardized' culture of the TAR in the promotion and practice of tradition.

23 Offices and accommodation buildings at the neo-Norbulingka, 1998.

Artists

The teachers of painting at both the new Norbulingka and the Library Art School are exponents of the Menri style and, though from different generations, share the distinction of having been born in Tibet. The Library Art School teacher, Sangay Yeshi (b. 1929), entered a monastery at the age of seven and began to study *thangka* painting at the age of

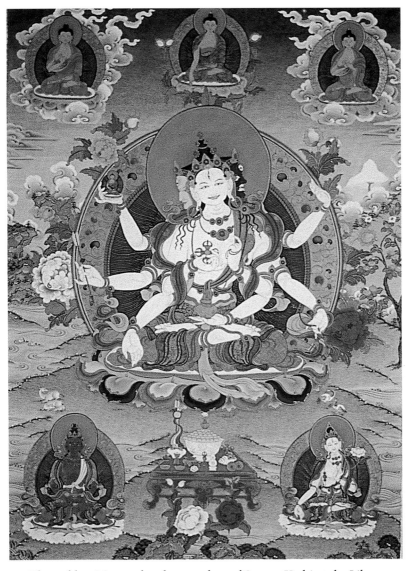

24 The goddess Namgyalma by a student of Sangay Yeshi at the Library Art School, Dharamsala, 1992.

25 Tenpa Choepel, *Avalokitesvara*, Norbulingka, 1992.

fourteen with 'the best painter of Kham'.[15] He continued his studies, both artistic and religious, at the Gelukpa monastery of Drepung but left in 1959 to follow the Dalai Lama into exile. In 1977 the Dalai Lama asked him to teach students who had been sponsored to become *thangka* painters at the Library Art School. Since then Yeshi has trained more than thirty artists and has himself completed many *thangka*, some of which hang in the Dalai Lama's private apartments. Tenpa Choepel, the master painter at the Norbulingka, was born in Tibet in 1959 and undertook artistic training with a painter in Lhasa in the early 1970s but became 'depressed at the limitations placed on cultural and religious practice'.[16] He finally managed to flee to India in 1984 and, with youth on his side, is now increasingly responsible for training the next generation of *thangka* painters in the 'authentic' style and imagery of pre-1959 Tibet. He can safely assume Yeshi's mantle, for like him he is a Gelukpa and a Menri-style painter (illus. 25). The students of both men are trained over several years in the Menri style until they have mastered the iconography and iconometry for a wide range of deities and are then free to set up their own studios, selling their work and training others (illus. 24). Hence all future generations of Dharamsala painters will be Menri painters and all *thangka* purchased in Dharamsala will conform to this style.

But what exactly is the Menri? Exilic artists are keen to emphasize the historic roots of their style and Sangay Yeshi states that he was asked to teach 'the oldest style' of Tibetan painting by the Dalai Lama

himself.[17] As we have seen, some textual and biographic information about its founder, Menla Dhondrup, allows Tibetans to demonstrate that a named individual created the 'first school of Tibetan Buddhist art',[18] but none of his paintings survive.[19] 'Menri' thus refers to the legacy of Menla as it developed over several centuries of interpretation by later generations of artists. Sangay Yeshi himself admits:

My painting was influenced by Menla Dhondrup but with changes. There were many variations on the original text and certain aspects were made clearer. I follow the new form. Chöying Dorje was one of the main ministers during the fifth Dalai Lama's time. He clarified Menla Dhondrup's style and ideas.[20]

The exiled painter and author Gega Lama also cites Chöying Dorje (1604–74) as the source of a new Menri, but Jackson proposes that the new style of the fifth Dalai Lama's reign (seventeenth century) was created by Chöying Gyatso, an artist who completed paintings in both the Potala Palace and the monastery of Tashilunpo.[21] His further comments may explain the discrepancy between Tibetan and Western accounts:

Indeed, it was probably not the rich, almost baroque style of Chos-dbyings-rgya-mtsho and the subsequent Tashilunpo court painters that developed later into what some have called the 'international style'. Rather, it was the lighter, simpler but at the same time more conservative style that gained widespread patronage and approval among the clergy of the great Lhasa monasteries and which thus became the official style propagated elsewhere. The latter was also an easier style, and thus better suited for widespread adoption than either of the high court styles of Lhasa or Tashilunpo.[22]

There can be little doubt that the new Menri of exile needed to be a 'conservative' style which could be easily taught and replicated by many artists, though Sangay Yeshi claims that his style 'looks very simple but if you try to draw it yourself you find it is very difficult'. Since many of the key figures of the Dharamsala art world were trained in Lhasa, it was the 'light' style which had been so popular at 'the great Lhasa monasteries' that was exported into exile. This is apparent in Rigzin Peljor's *Illustrations and Explanations of Buddhist Iconography and Iconometry according to the Old Menri School of Central Tibet* (which was edited by Yeshi). Here the Menri is defined as the style of central Tibet, although its founder Menla was actually from Lhobrag, southern Tibet.[23] Further differences in the interpretation of Tibetan

'art history' emerge in other exiled artists' manuals. The 'traditional' paintings of Dharamsala are thus more accurately described as images which emerge from a lineage that dates back to the fifteenth century but which are stylistically close to the new Menri of the Tibetan capital Lhasa. Hence in the late 1980s when the Dalai Lama decided to commission a new building next door to the Namgyal temple for his teachings on the *Kalachakra Tantra*, a painter was summoned from Lhasa. By this time the two most eminent Dharamsala artists who might have worked on such a project, Rigzin Peljor and Jampa Tseten,

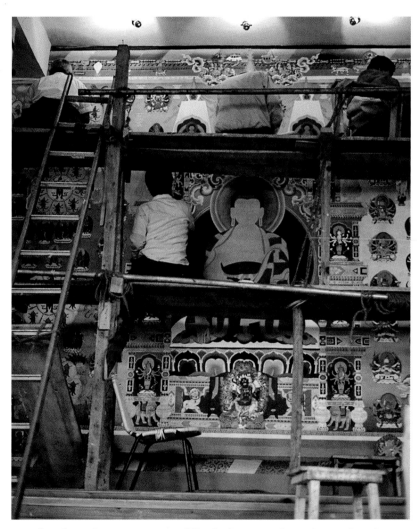

26 Chamba Kelsang, *'Gaya' Buddha* (before completion), mural in the Kalachakra Assembly Hall, Namgyal monastery, Dharamsala, 1991.

were nearing the end of their careers. (Jampa died in 1987 and Peljor in 1991.) The Dalai Lama therefore called upon Chamba Kelsang, an elderly painter still living in Lhasa, to ensure that the Kalachakra murals were of the highest quality and in an appropriate style. The entire cycle of images for this new chamber was approved by the Dalai Lama who, according to Chamba Kelsang, also asked that even the colour range for the richly painted 'Gaya' Buddha should meet with his approval (illus. 26). The Kalachakra temple now stands next door to the Namgyal temple and Peljor's *Three Kings* as another prominent example of the Lhasa New Menri style so favoured by officialdom in Dharamsala.

The resilience of the conservative Menri style was demonstrated when, in 1992, Chamba Kelsang returned to Lhasa having only completed one wall of the Kalachakra building. A new 'master' painter had to be found to complete the project. The post was filled by Kalsang, who was born in the Kham province of Tibet but left to live in Bhutan in 1960. He was first taught to paint by his father in Tibet, but his skills developed further in the consciously 'traditionalist' environment of Bhutan and in commissions at a number of monasteries in exile in India. Consequently Kalsang was well versed in a number of styles but was requested to work in the new Menri style for the Kalachakra temple, apparently at the behest of the patron, the Dalai Lama. The use of the house style ensured that the transition between Chamba's and Kalsang's sections was seamless, but, unlike the Lhasa painter who worked entirely from memory, Kalsang surrounded himself with photographs of other artists' work. Chandra's *Buddhist Iconography* and a number of Western publications with colour plates were consulted, and the artist admitted that his inspiration for an image of the deity Heruka was taken from a print of a *thangka* 'by a painter from down south called Nawang'.[24]

Kalsang was by no means the only exiled artist I encountered to incorporate the photographic record of Tibetan heritage into his practice. Those artists with sufficient financial resources frequently acquired glossy tomes on Tibetan art by Western scholars. Many found that access to the world of mechanical reproduction and global circulation of products could only benefit their work, as it dissolved the boundaries between exile and what remains of Tibetan material culture, whether it be housed in Western museums or sealed in an inaccessible homeland. However, the virtual Tibet of illustrated books presents a more diverse history of the artistic heritage of the country and a variety of traditions which are not reproduced in the visual culture of Dharamsala.

Since Kalsang was trained in neither Lhasa nor Dharamsala, his repertoire of styles was far more varied than the majority of Dharamsala painters and his patrons could choose their style of preference. Beyond Dharamsala many exiled artists claim to be able to produce styles on demand and state that this was often the case in pre-1959 Tibet. Some of the most successful of them concentrate on non-Menri styles. In the Indian Himalayan town of Manali a small group of painters, led by Nawang Dorje from a village north of Lhasa, are followers of the Karma Gadri style (although their work is marketed by the Himachal Pradesh Tourist Board as 'Spiti School', referring to the Spiti Valley north of Manali which they promote as an area of 'exotic' Tibeto-Buddhist culture). In Kalimpong, West Bengal, Pema Namdol Thaye and his uncle have developed what they consider to be a fusion of Menri and Karma Gadri styles. In Ladakh, Yeshe Jamyang was able to describe the characteristics of six major schools of Tibetan art: the Gyari – Chinese style; Khamri – from the Kham region; Driri – from the Drigung region (Drigung also refers to a sub-order of the Kargyupas); Uri – from Lhasa; Tsangri – from Tsang (particularly strong at the monastery of Tashilunpo); and Tsuri – from Tsurphu and the Karmapa sect of Tibetan Buddhism. His explanation of how these styles could be distinguished consisted of a poetic evocation of their qualities of light. Gyari, for example, should be 'like a rainbow in the sky, all colours equally positive'. The style in which Jamyang trained – the Driri – should also have brilliant colours radiating 'the full light of day', with an all pervasive blue in the background of each composition. Tibetan literature includes few examples of such commentary on style, but contemporary practitioners of painting do have a vocabulary which indicates aesthetic concerns, a topic which has received virtually no attention from Western scholars.

Once artists are consulted, it becomes increasingly apparent that what Western commentators and Dharamsala guardians of culture refer to as the New Menri style is a misnomer that obscures what are in fact a number of styles which evolved with regional differences, though they took their inspiration from the original Menri. Outside Dharamsala these regional styles have been continued through the oral transmission system and transmitted across borders. Jamyang, for example, became a Driri painter when he left Ladakh and studied in Drigung, Tibet. His contemporary, Tsering Wangdu, on the other hand, became a Tsangri painter in Ladakh. He was the student of Dawa Pasang, the master painter at the Panchen Lama's monastery, Tashilunpo (Tsang Province), who left Tibet at the time of the Dalai Lama's departure and worked in the Ladakhi monastery of Spituk.

Hence the Ladakhis have perpetuated versions of the Menri which were originally associated with two Tibetan monasteries (Drigung and Tashilunpo). According to Jamyang's scheme, the style selected from the numerous strands of the old Menri which currently finds official patronage in Dharamsala should be labelled 'Uri', that is, the New Menri style as propagated in Lhasa in the region of U (central Tibet).

It seems that the further away a contemporary *thangka* painter is from the capital of Tibetan culture in exile, the more he may deviate from the version of the Menri style endorsed there. For non-Dharamsala-based artists, cross-fertilization between Tibet and India has had beneficial effects as those who travelled across frontiers introduced new styles or inspired the regeneration of old ones. Working well away from Dharamsala gives them the freedom to look to other aspects of the history of Tibetan image-making and to break the rules of the 'authentic' Tibet of exile. But why should this variety and hybridity be denied in Dharamsala?

Purity or Hybridity?

The *Three Kings* debacle marked a turning point in the evolution of the image of Tibet, as the Menri was confirmed as the official style of exile. Since that time, four major exilic institutions have continued to promote it: the Library of Tibetan Works and Archives, the Library Art School, the Norbulingka cultural centre and the Namgyal monastery. As we have seen, the choice of the Menri was not simply due to the privileging of the past which Dharamsala demands, but because style cannot be construed as politically neutral. If an image is to be displayed in a prominent position within institutions of the neo-nation with explicit connections to religion, 'realism' of any kind must be avoided in preference to a more consciously Tibetan *thangka* style. The delineation of a distinctive, authentic Tibetan style in the visual arts (as in so much else) is considered essential for self-determination. However the 'pure' Tibetan culture presented in Dharamsala is in fact a series of re-inventions, some of which have been produced to counteract 'external' influences and others which comply with a vision of old Tibet made anew. As Clifford has remarked:

Questionable acts of purification are involved in any attainment of a promised land, return to original sources, or gathering up of a true tradition. Such claims to purity are in any event always subverted by the need to stage authenticity in opposition to external, often dominating alternatives. [. . .] If authenticity is relational, there can be no essence except as a political, cultural invention, a local tactic.[25]

The Tibet of exile in Dharamsala has tended towards a self-induced essentialization in opposition to the image of Tibet generated in two powerful external loci: China and the West. In the process of asserting its 'true tradition', exilic Tibet has clearly had to excise any Chinese impurities, but its relationship with the West remains entangled, as is demonstrated in an incident from the life of Sangay Yeshi.

Dharamsala *thangka* painters, such as those mentioned above, share the fear of the loss of tradition with custodians of texts and history at the library and guardians of Tibetan religion at the Namgyal monastery (headed by the Dalai Lama) and therefore willingly participate in the attempt to stabilize and fix the style in which they work. But things were not always so. In the 1960s the recently exiled Sangay Yeshi (of the Library Art School) had a formative experience which led him to come to some conclusions about appropriate style for Tibetans. Yeshi met an American in Delhi who had suggested that he could support himself as an artist by experimenting with new, non-religious, but eminently 'Tibetan' subjects such as yaks and nomads. (The American was perhaps unaware that a kind of secular Tibetan realism already existed and was used for domestic wall murals and painted furniture in pre-1959 Tibet. Yeshi later extracted scenes from his memories of those images for a series of postcards, with subjects such as kings and queens of Tibet, folk heroes or titles like *Long Life Image, High Incarnations of Tibetan Lamas Travelling to Kham* and *Tibetan Musicians*, which were sold in the bazaar in Dharamsala (illus. 27).) Unfortunately, when Yeshi started to 'collect styles' which presented novel ways of depicting the natural world, his American advisor was displeased with the results and told him to abandon his efforts as 'there were plenty of Western artists who could draw a tree as it looks in reality'. Instead 'The American said I should concentrate on producing images in the style I know best. This was a very good lesson.'[26] As we know, the monk–artist later devoted himself to *thangka* painting in a distinctly non-realist style, the Menri, but his story has parallels in the larger narrative of exile in which many Tibetans have received the same Western imperative: 'concentrate on the style by which we know you best'. Exiled Tibetans are required to replicate the 'unique' and primarily 'spiritual' style of culture which the word Tibet conjures in the Western imagination. The narrative of exile has been enscripted by many Western observers as a purgative rite in which 'impurities' of the past such as the superstitious and 'non-Buddhist' aspects of Tibetan culture (identified with some disgust by the likes of Waddell and other colonial authors) have been excised. Equally, the Tibet which rises phoenix-like from the flames of expurgation cannot be secular, modern or hybrid.

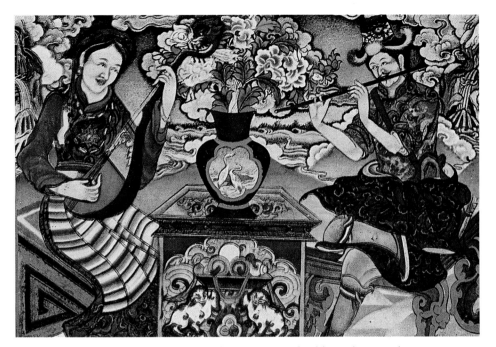

27 Sangay Yeshi, *Tibetan Musicians*, from a postcard sold in Dharamsala, 1992.

This is apparent in Von Furer-Haimendorf's study of exilic Tibet, *The Renaissance of Tibetan Civilisation*. He writes (my emphasis):

Under the inspiring leadership of their traditional ruler and spiritual head, His Holiness the Dalai Lama, Tibetans of all classes who had succeeded in escaping from the Chinese grip set about reconstructing the culture which had unfolded over centuries in Tibet, and *aroused the admiration of all those* aware of its aesthetic and spiritual uniqueness.[27]

The admiring gaze of increasingly large numbers of foreigners has undoubtedly impacted on Tibetans as they sought to revive and promote their 'unique' cultural style. In fact exiled Tibetans and Western Tibetophiles articulate their concern for the future of Tibet in a common language of the 'salvage paradigm' in which key characteristics of a culture become most clearly visible at moments when it is threatened with extinction and in need of recuperation. In 1982 an exiled artist introduced his painting manual (in English) in such terms:

During the course of my service, I realised the importance of preserving Tibet's unique painting for which I felt there was need of producing a

scientific work [. . .] [I] [. . .] have laboured hard to bring this work with the sincere hope that Tibetan tradition of painting will not decline but will spread far and wide. [. . .] I have shared with all the lovers of Tibetan art, the best and the ultimate knowledge I have of Tibetan painting.[28]

By the time these comments were published the numbers of 'lovers' of an entity called 'Tibetan art' had grown and spread around the globe, hence when Dharamsala painters re-created 'traditional' Tibetan paintings from compositional models dating back no earlier than the seventeenth century (a period from which the majority of paintings held in Western museums are dated), they happily appeared very like the image(s) of Tibet held in the Western imagination. Outsiders saw this as confirmation that, despite the dangerous rupture of the Chinese invasion, the tradition of Tibet remained unbroken and might even flourish, as two European scholars of painting in exile commented:

When we began this study eleven years ago we thought that we were recording and preserving a dying tradition. Now however, it seems clear that *thangka* painting on the whole is in no danger of becoming extinct. Although traditional art is today moribund in Tibet proper, it is flourishing in the Tibetan settlements of South Asia on a scale that nobody could have predicted two decades ago. Some of the younger painters are even showing promise of one day reaching the high levels attained by the early masters.[29]

For many 'lovers of Tibetan art', the greatest achievement of an artist in exile would be the ability to reproduce the products of his forefathers. This is a dream which puts a highly conservative pressure on the younger generation. However, according to a prominent Tibetan scholar based in Dharamsala, the move into exile, the demolition of Tibetan heritage in the homeland and developments in the Tibet Autonomous Region thereafter 'created an atmosphere in which Tibetan artists and their audience alike, suffered a crisis of identity'. This crisis affects the production of paintings and is exacerbated by the issue of memory:

Amongst the artists here in Dharamsala there are some who spent most of their lives in Tibet, but who have forgotten much of what they knew, or who no longer observe the conventions for fine details in thangkas. There are also young artists who have come from Tibet recently and are painting in a post-Invasion style with modern paints and rough and ready shapes. They never knew the fine work of the pre-1959 era.[30]

For those who grew up in the host environment of India the problems are compounded by a lack of knowledge of the details of pre-1959

Tibetan life. When asked to draw a Tibetan kitchen, the artist born in exile 'would probably include a Chinese thermos flask instead of a traditional butter-tea churn'.[31] However, Chinese-manufactured items are a fact of life for many Tibetans, in both the TAR and the Tibetan communities of the Himalayas, and the thermos has replaced the wooden churn in many exilic homes. Butter tea is no longer a staple in the diet of many exiled Tibetans, though it may be served on occasions when 'tradition' demands it such as weddings, funerals and religious ceremonies. The Indian-born artists are thus requested to imagine a different world from the one in which they live and to censor their knowledge of that reality in preference to the memories of their elders. This demand has a rather uncomfortable echo with an account of a Western tour group's visit to Tibet. On encountering a group of nomads 'the photographer among us, who had an interest in ethnic minorities [. . .] insisted on removing the huge multicoloured Chinese Thermos flask which was displayed at the entrance to the main tent (before taking any photos)'.[32] In pursuit of the 'primitive' and the exotic, the photographer insisted on manipulating the reality he observed 'in favour of the ethnic dream [. . .] in the form of a Tibet without telegraph wires and trucks'. The desire to remove such rogue elements in the photographer's composition is reflected in the exilic aspiration to depict and manufacture 'pure products' which are free of the taint of the foreign and the modern.

Even in the early decades of exile, the elision between the Western 'Shangri-la' dream of Tibet and Tibetan attempts to preserve their culture was identified as a disquieting development by key exilic figures. In 1976 the editor of the Dharamsala journal *Rangzen* (independence) had complained that the impact of the host nation, India, and 'Dharma' tourism was threatening to lead to a 'dilution' of Tibetan culture in the capital in exile.[33] Foreigners were increasingly buying into the 'spiritual' and 'aesthetic' experience of Tibet, now transposed into the more readily accessible location of India, and though many of those on the 'Dharma trail' were motivated by a desire to emulate the best features of what they understood to be Tibetan, their presence began to pose a new threat of commodification. It was perhaps inevitable that portable products such as *thangka*, made by Tibetans and in which Tibetan Buddhism appeared to be embodied, should be the first to perform the function of a souvenir, and Dharamsala painters responded to this new market. But by the 1990s, when this trade had become extensive, an article in *Chöyang*, the journal of the Department of Religious and Cultural Affairs (part of the government in exile), expressed disgust at the sale of mass-produced *thangka*:

The inferior paintings available at present are of little or no artistic value as most are of crude workmanship and resemble a mosaic of Buddhist symbols, deities, entourage and environments rather than a properly constructed painting. These paintings certainly have no value because of the lack of religious intent by the artist and as His Holiness the Dalai Lama has frequently pointed out it benefits neither Tibetans nor Tibetan art and culture for this trade to continue.[34]

Since *thangka* are part of the larger category of objects (*rten*) which are viewed as physical representations of the speech, body or mind of the Buddha and many are ritually consecrated in a ceremony (*rab gnas*) in which a deity descends into the image, their manufacture must conform to religious specifications. As makers of *rten*, artists therefore have a special responsibility in the religio-cultural project and are exhorted to avoid the temptations of commercialism. The majority of their fellow exiles expect them to continue to use the iconographic and iconometric schemes of pre-1959 Tibet and to keep their intentions pure. But members of the external audience for *thangka* paintings are generally unaware of the elements which prepare an image for consecration and worship. Their expectations are governed by the parameters of a history in which objects from Asia have been removed from their originating communities and transformed through the museumizing process into 'art'. This situation has been exacerbated by the fact that few Western publications on 'Tibetan Art' reference the conditions of reception and use for which *thangka* were designed, thereby positioning them as documents of history or as the subjects of aesthetic contemplation. The authenticity of exilic products is partly determined by their closeness or otherwise to the 'art' of the past, a purity which fulfils both outsider and insider desires. This quest for the authentic extends to the makers of images, who are themselves 'exhibited' as part of the cultural tour made by visitors to Dharamsala. Just as living Indian craftspeople and their handiwork have been displayed for Western audiences who dream of an anti-modern and non-industrial world, so Tibetan painters are seen to embody the romance of 'spiritual' Tibet. However, where Orientalist readings of India have been framed within the paradigm of craft and the rural idyll, a representation mediated through the essentializing traditionalism of Ruskin, Morris and Coomaraswamy, Tibet has been understood through the authenticating device of religion.

Hence when a project to manufacture a more appropriate Tibetan commodity for foreign consumption was devised in Dharamsala, the authenticity of the product was derived from the labour of monks. The Losel Project was established by a Western woman with official

sponsorship from the Department for Religious and Cultural Affairs. The project produces dolls which act as miniature ambassadors for a particular vision of exilic Tibet in Western displays (illus. 28).[35] Kim Yeshi describes the project's inception thus:

Losel dolls were born out of the imagination and talents of a group of Tibetan monks living in exile in India. They represent an alternative use of traditional skills in creating dolls which preserve an aspect of Tibetan life that has been lost forever, while passing down age old skills to a new generation of artists.[36]

Though the Losel idea is initially ascribed to the 'imagination' of monks, the remainder of the account makes it clear that it was Yeshi (a Frenchwoman married to a Tibetan government minister) who organized the materials and workers on the project. More crucially, it was she who selected the subjects for their labours, in consultation with 'natives and former government officials and consulting our growing photo archive'.[37] The costumes were copied from regional styles of aristocratic dress (such as a Lhasa lady and an Amdo lady) or outfits of the

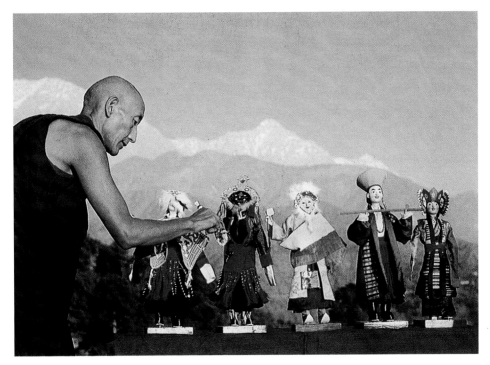

28 Monk arranging dolls made for the Losel Project, Dharamsala, 1991.

religious hierarchy (such as a monk official). These Tibetan 'types' reflect the social groups of the 'natives' interviewed for the project, who were Dharamsala government officials and monks, many of whom came from the aristocratic families of pre-1959 Tibet. The buyers of the dolls were apparently 'delighted by the authenticity of the figures, reminders of a way of life that is now gone forever'. But Yeshi admits that the dolls were made by adapting techniques used in pre-1959 Tibet:

I knew Tibetan tailors made beautiful clothes for statues of deities and fashioned appliqué wall hangings out of brocade, that they embroidered beautifully, and sculpted figures out of coloured butter for the New Year celebrations.[38]

However, though they worked for religious patrons, the tailors of pre-1959 Tibet were rarely monks, and so the authenticity of the Losel dolls lies in the status of their makers, the exilic monks, and in the miniaturized and attractive invocation of pre-1959 Tibet. The selectivity behind this vision became clear when one of the Tibetans employed on the project devised a figure from his memories of the 'lost way of life'. He dressed one of the prototype dolls as a 'policeman, wearing a black chuba and a stick'. According to Yeshi the doll 'looked so unpleasant that no one liked him enough to buy him', but the policeman surely stands metonymically for an ugly feature of Tibetan life which does not conform with the exilic presentation of culture. Apparently, no one, but especially non-Tibetans, wanted to remember that pre-1959 Tibet did have its less than attractive side with punishment meted out by monks and laymen alike. The Losel Project thus commodifies a selective vision of pre-1959 Tibet in a memorialization of class and power deemed desirable for foreign consumers.

Von Furer-Haimendorf's *The Renaissance of Tibetan Civilisation* borrowed the language and conceptual frame of accounts of fifteenth-century Italy to analyse Tibetan endeavours to unearth the past in order to give birth to the present, but the 'renaissance' metaphor ignores the quotidian demands of exilic life and some brute facts. Tibetans could not partake in a *Renascimento*-style archaeology, exposing classical forms in their own soil and reinvigorating a Tibetan aesthetic. By definition exiles are separated from the land of their birth, hence the new geographic and socio-political conditions of exilic 'Tibet' have meant that all its post-1959 cultural forms are, of necessity, closer to 'invented traditions' which, as Hobsbawm noted, are normally designed 'to establish continuity with a suitable historic past'.[39] Hobsbawm's emphasis

on retrospective selection is pertinent for understanding key aspects of the Tibetan refugee situation, where a suitable and quite particular Buddhistic version of Tibetan history has been favoured. In the visual arts, Dharamsala has also chosen to replicate the style of a 'suitable' period in Tibetan history, for the 'conservative' Menri style spread around Tibet from the eighteenth century onwards as the Gelukpas, the order led by the Dalai Lama, gained ascendancy in the country. Over the following two centuries they established a cultural and political hegemony which some commentators suggest led to 'stagnation' in the visual arts.[40] Hence, the officially condoned painting of exile is hardly comparable to that of the Italian Renaissance: it is closer to a facsimile of pre-1959 Tibet. We might recall that what was momentous about the rediscovery of the art of the past in Florence and Rome was that it inspired dramatically new forms of depiction. As we have seen, radical deviations from tradition cannot be condoned for the official imagery of exilic Tibet. However, in the following chapter we explore beyond the institutional boundaries of monastic buildings and governmental organizations to areas in which Tibetan image-makers have engaged in adaptation and embraced change.

3 Beyond the Boundaries of Tradition

In 1988 an unsuspecting Westerner was arrested in Lhasa, the capital of the Tibet Autonomous Region. The story of this 'innocent abroad' made international news, but her crime was neither incitement to riot, theft of official secrets, nor even of straying into delimited territory. The offence: sporting a Phil Silvers T-shirt without due care and

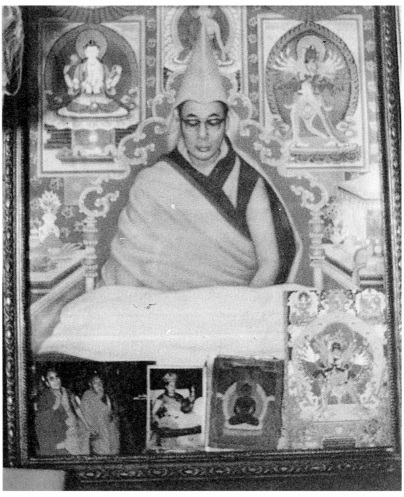

29 Photo-icon of the fourteenth Dalai Lama in the home of a Tibetan refugee at Spituk, Ladakh, 1992.

30 Photo-icon of the Dalai Lama at the Mussoorie temple, 1984.

attention. Though questions might be raised over the sartorial merits of such a get-up, few would suspect that this item of clothing could be viewed as a provocative political statement. Unfortunately, the felon had failed to notice the striking resemblance between the image of Phil Silvers, an American comic of the 1950s, and the Dalai Lama, incarnation of Avalokitesvara, bodhisattva of compassion, Nobel Peace Prize winner and exiled spiritual and political leader of the Tibetans. Nor did she realize that a ban on displaying his image was in force at the time of her visit to the TAR. As an emblem of Tibetan neo-nationalism and independence, depictions of the Dalai Lama have been repeatedly banned by the Chinese authorities in the forty years of their rule of Tibet. However, despite Draconian attempts at cultural control in the TAR, the image of the Dalai Lama remains the figurehead for a cultural currency which has yet to be devalued. Within the refugee 'black market' this coinage moves across borders, continues to have purchase and has been reinvented by contemporary artists.

The Dalai Lama Icon

The Dalai Lama carries a heavy burden of representation. For Tibetan Buddhists the hope of engaging with his personhood is the defining aspiration of their lives. Every new arrival in Dharamsala seeks an audience with the Dalai Lama as their first priority after the arduous journey into exile, a rite of passage which they undertake as he had done in 1959. Kalachakra ceremonies and other religious teachings given by him in Dharamsala and elsewhere are communal ritual occasions when the *nangpa* sense of identity is asserted in his presence. But, as a result of the dispersal of Tibetan bodies in various locations around the globe, an artefactual diaspora has also been generated. Since the first decade of exile (1960s) photographic reproductions of the Dalai Lama have been deployed to consecrate domestic shrines in which he may stand alone or among a selection of photographed 'root gurus' and other reincarnate Tibetan Buddhist teachers (illus. 29). When exchanged among *nangpa*, the Dalai Lama photo-icon accrues merit for the donor and recipient as long as the object is displayed respectfully in a prominent place. In more public contexts, the Dalai Lama icon is installed in thrones awaiting his actual physical presence. The construction of a shrine or chamber for the Dalai Lama had been a practice of the Geluk order prior to 1959, and it is now observed by all *nangpa* (i.e. irrespective of affiliations to other orders of Tibetan Buddhism) in refugee communities all over India. Religious festivals and ceremonies such as the 10 March Commemoration and New Year which bind the refugees, wherever they may be in the diaspora, are only conducted when at least the two-dimensional Dalai Lama is present (illus. 30). In India his image protects the service vehicles of the exile community as Tibetans insert their icon into a local symbolic structure (illus. 31), replacing Hindu deities with the Dalai Lama at the windscreens of auto-rickshaws and Tata trucks. But the Dalai Lama icon does not merely emulate the apotropaic function of the Hindu gods, nor even their role as signifiers of religious affiliation, but marks a bald political fact: the Dalai Lama is abroad in the world, literally and pictorially, owing to his ejection from Tibet. For *nangpa* this is a bitter memory which dominates the quotidian experience of life in exile, hence the display of the Dalai Lama icon is part of a strategy of cultural solidarity in the face of loss. The image also functions as a fixing and locating device that identifies Tibetans as different from outsiders (Indians and foreigners) and as insiders – i.e. *nangpa* – to other Tibetan Buddhists. This attempt to locate culture through a political/religious icon is a vital part of Tibetanizing spaces

31 Photo-icon of the Dalai Lama on a truck belonging to the Tibetan refugee community in Choglamsar, Ladakh, 1994.

(and bodies) at a simple, cheap and democratic level, which parallels the more public architectural statements of Tibetanness constructed by the monastic institutions and the government in exile. It is the Dalai Lama photo–icon which is most visible, present and active in *nangpa* lives rather than consecrated Buddha images and other 'traditionalist' icons which are often beyond the economic means of refugees. This is due in large part to the status of the fourteenth Dalai Lama, who is both

god-like (he is the incarnation of the bodhisattva of compassion) and an individual (Tenzin Gyatso) whose thoughts, actions and biography are received as a narrative of a nation in exile.

Politicization of the Dalai Lama Icon

The fact that the Dalai Lama photo-icon now presides over everything from the diners in Dharamsala restaurants to the private spaces of refugee homes is the result of adaptation to the host culture of India but also of ideological battles fought in the visual field during the 1960s and 1970s in Chinese-controlled Tibet. At that time the image of Chairman Mao was forcibly inserted into the homes and lives of Tibetans. Consciousness of this history inevitably runs deep among exiles, and the narrative of events which unfolded after 1959 is recalled through the oral and published accounts of later refugees such as Dhondup's account of the implementation of Cultural Revolutionary policy in a Tibetan commune. His story is just one of many circulating in exile which report on the introduction of the 'Four News' to replace the 'Four Olds' (old thoughts, old culture, old habits and old customs). According to Dhondup, 'The four olds are the things Tibetan and four news are whatever the Chinese say'.[1] Between 1966 and 1969 the 'old culture' was swiftly replaced as communist party workers 'came from house to house and forced every one to buy Mao's portraits and painted his sayings all over the walls'.[2] This activity was not restricted to private homes but extended to religious buildings, the streets and countryside of Tibet, as Norbu attests:

Before the sacred mantra 'Om Mani Padme Hum' was carved on rocks; the Red Guards now inscribed quotations from Mao's red book. In short, Mao replaced the Buddha in every respect during the Cultural Revolution.[3]

Chinese policy of this period also concentrated on the radical appropriation of ritual events which had previously been sanctified by the presence of the images of Buddhist deities (not Dalai Lamas) in Tibet, as we see in this propaganda image where a photographic portrait of Mao is carried at the front of a harvest ceremony by cheery Tibetan labourers (illus. 32). The reaping of harvest had traditionally been marked by Tibetan Buddhists through the actions not of the workers but monks, who processed through fields to the homes of farmers where textual recitation and offerings were performed to placate the spirits of the earth and the creatures destroyed in the scalping of the land. These ceremonies were replaced and renamed 'Lo-leg Du-chen (prosperous

32 Photographic portrait of Mao carried at harvest time by Tibetan labourers, *c.* 1970.

year festival) and we are made to carry Mao's portrait, sing Chinese songs and dance Chinese dances in expectation of a prosperous year'.[4]

No Tibetan exile would equate his use of the Dalai Lama icon with anything perpetrated by the Chinese, but the fact remains that it was the Chinese regime which first effectively manipulated the use of the political portrait in areas of Tibetan life that had previously been the domain of the religious icon. The Cultural Revolutionary regime consciously employed the Mao image within a system designed to equate the chairman with the incorruptible power of a deity and installed him in cultural spaces previously occupied, both for Tibetans and some Han Chinese, by apotheosized Buddhist figures.[5]

Additionally, Mao images could be deployed in many places that Buddhist images could not, such as work places and public, secular sites. The Chinese state had utilized the power of images in the process of controlling a vast populace and extended the use of the uniform and ubiquitous Mao portrait to help subjugate their colonized neighbours. In such conditions of cultural obliteration and Maoist 'organised forgetting' (Connerton, 1989) the Dalai Lama provided the agency to fight

33 Khampa guerrilla fighter with Dalai Lama amulet, bullets and knife.

back. During the 1960s and 1970s guerrilla fighters from the eastern region of Tibet (Khampa) attempted to do battle with the People's Liberation Army. Alongside guns and knives they wore *gau* (amulet boxes) containing photographs of the Dalai Lama (illus. 33). Prior to the Chinese takeover Buddha amulets had been worn in battle as the icon was believed to deflect arrows and bullets, just as the Buddha himself had diverted the weapons of his enemy Mara, but in the battle to reclaim the land he had been forced to abandon the Dalai Lama was enlisted for service. As a bodhisattva, the Dalai Lama exhibits a dual personality: he is both a god of compassion (Avalokitesvara) and a fierce protector of Buddhism (*tam drin*). Khampa guerrillas sought to embody the agency of a *tam drin* and transport the compassionate personhood of the Dalai Lama back to his rightful home, transforming the photo-icon into an ensign of the battle for the independence of Tibet. This process was assisted by the new technology of photography, a medium which proved equally useful in creating new images of exile.

Tibetan Images in the Age of Mechanical Reproduction

Before the Chinese invasion Dalai Lamas were portrayed by *lha bris* (makers of gods) in a similar style to that devised for the Buddha. (A

sixteenth-century *thangka* from Guge, western Tibet, for example, depicts the third Dalai Lama seated on a lotus throne and surrounded by scenes from his life [illus. 34].) They were iconized in the style of a deity, with little detail to distinguish an individual physiognomy but always with eyes open to receive and release the 'glancing' (Babb 1981) of the icon–devotee relationship. Since 1959, an exceptional phase in Tibetan history has generated conditions in which the visage of the fourteenth Dalai Lama has become highly recognizable to his followers and the power of the photographic index of the Dalai Lama could not be ignored by the 'makers of gods'. Hence when Sherap Palden Beru, a *thangka* painter trained in Tibet, attempted to make the first exilic depiction of the Dalai Lama, he incorporated a photograph and copied the resulting photo-icon for mass circulation in exile (illus. 35). In it the photographed Dalai Lama appears framed by Tibetan monastic architecture, with two dragon-entwined pillars and a multiple-layered pagoda-style roof. A subsidiary frame of a flat blue colour is then used to house the man himself, who is surrounded by four deities – Tara, Avalokitesvara and two gods of longevity. The slightly ungainly combination of painted and photographed components of the Dalai Lama's body exposes the artist's problem: how to represent a reincarnate bodhisattva who lives among you in the refugee community of Dharamsala and whose features are intimately known to people through his appearances and teachings or through photography. Palden's solution, employing a hybrid photo-painterly technique, constitutes a surprising departure for a Tibetan artist when we consider the strict regulations which in pre-1959 Tibet had been placed on the mastery of iconometric systems for the depiction of divine as well as not so divine figures. Deviation from these rules was a risky business, both for producer and viewer. Any involvement with an ill-formed *thangka* could 'lead one to hell', as the painter Pema Namdol Thaye comments in his *Concise Tibetan Art Book*:

The image must be accurate. An erroneous image cannot be blessed and consecrated. Such images should be in remote and deserted places as they are more harm than benefit to Human society.[6]

When specifying exactly how human beings should be drawn, Thaye states that 'The general human measurement, according to the ancient artists is eight *thos.* (a measure based on the distance between extended thumb and tip of the middle finger) similar to the divine forms'. On the other hand, 'the religious heads and personal Root-Gurus who show the sentient beings the Vajrayana ways should be represented according to

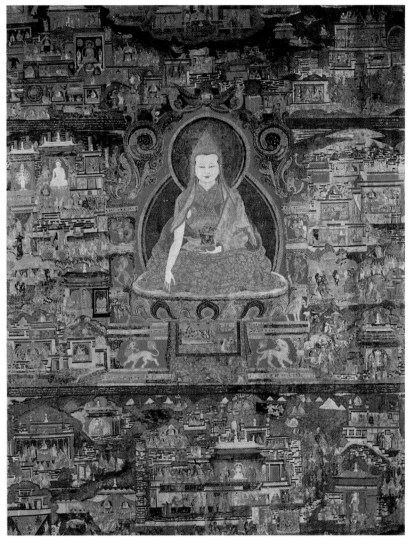

34 A 16th-century portrait of the third Dalai Lama with events from his life, made in Guge, western Tibet.

the measurements of Lord Buddha'.[7] Despite this, Thaye's own book includes an illustration of his personal guru (the head of the Nyingmapa school of Tibetan Buddhism, Mindroling Trichen Rinpoche) in photo-icon style (illus. 36). Iconometric codes are not adhered to. Instead the camera has been allowed to take on the responsibility of correctness previously ascribed to iconometry: that is, a device through which an object previously gained sanctity has been abandoned.

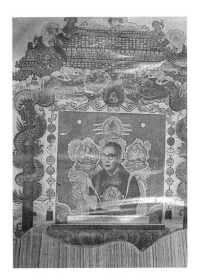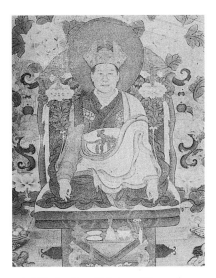

35 *The Fourteenth Dalai Lama* by Sherap Palden Beru, photographed in the home of Dharamsala artist Lobsang Ngodup, 1992.

36 Mindroling Trichen Rinpoche in photo-icon style.

The explanation for this departure derives in part from the assimilation of the 'modern' into the lives and work of Tibetan image-makers as they began to adopt influences from the host environment of India. Photography had played a part in Indian visual culture since the mid-nineteenth century and the camera had become increasingly accessible as a tool for studio portraiture by the mid-twentieth century when the exile community was established. An argument can be made that there were no grounds for a Tibetan objection to this particular technology of modernity. If not mechanically produced, identical copies of religious objects, from stamped clay *tsa tsa* (pilgrimage votives) to wood-block printed prayer flags, had been in common use in pre-1959 Tibet. In fact the *gtsagpar* (stencil copy) technique in which popular *thangka* designs were multiply replicated with a pin-prick stencil (while also ensuring iconometric correctness) shares an etymological connection with the neologism *par gyap*, meaning 'to take a photograph'. *Par* refers to a mould for making lettering or three-dimensional forms as well as that which was produced from it, such as a print. The verb *gyap* can mean a number of things, from 'build', 'shoot', to 'mark' or even 'bite'. But the question remains: what is the status of the image shot or marked by the camera? As 'an emanation of the referent' (Barthes[8]) whose radiance passes virtually unmediated to the viewer the photograph can function

very well in Tibetan contexts of seeing. Cardinal has demonstrated how nineteenth-century French photographers such as Félix Nadar were encouraged to produce photographic portraits by the 'contemporary ideology of the charismatic individual'.[9] In such a climate, filmic traces of the physical appearance of singular bodies were highly valued as the very physiognomy of the sitter was thought to reveal their distinguishing traits. Given that the current incarnation of the Dalai Lama is undoubtedly thought of as an exceptional and charismatic human being (as well as an incarnate deity), the privileging of photography in recording his image becomes increasingly explicable. In fact it was his pioneering and charismatic predecessor who created a precedent for the novel photo-icons of exile.

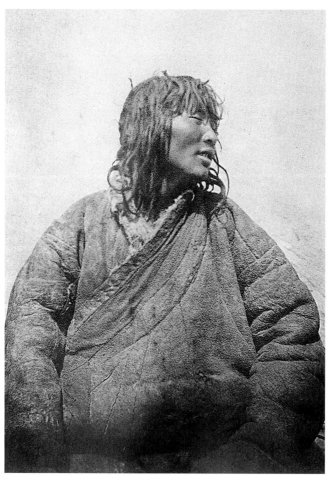

37 Henri d'Orleans, Photograph of an anonymous Tibetan, 1860s.

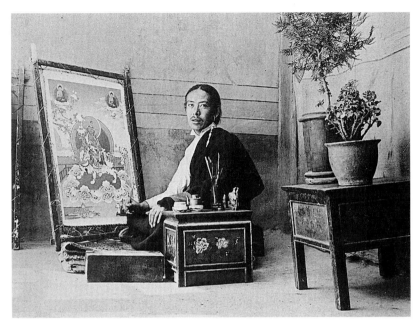

38 C. Suydam Cutting, The thirteenth Dalai Lama's senior *thangka* painter, 1937.

The Thirteenth Dalai Lama

Since the mid-nineteenth century Tibetans had been placed before the camera by Occidental visitors to the Tibetan plateau. In some of the earliest photographs taken in by Henri d'Orleans (illus. 37) they stand as anonymous figures embodying the romance of the explorer's encounters.[10] The thirteenth Dalai Lama overturned the anti-individualism of the ethnographic lens and initiated the process by which Tibetans presented themselves for self-portraiture and began to wield the camera themselves. (The first recorded Tibetan to take photographs was a member of the thirteenth Dalai Lama's retinue, Sonam Wangfel Laden.) In the 1930s the Dalai Lama's senior *thangka* painter was photographed at work by C. Suydam Cutting (illus. 38), and in 1936 the Tsarong family were pictured in their home (illus. 39) seated at a Western-style table with other valuable possessions, including Chinese scroll paintings and a framed photograph hung in European style, at an angle to the wall. By the 1950s, studio photography had become popular among Lhasa aristocrats as a means of recording the likeness of family members, whereby the myth of the ethereal and anti-materialistic Tibetan is sorely challenged. In his 1957 portrait (illus. 40) Sakya

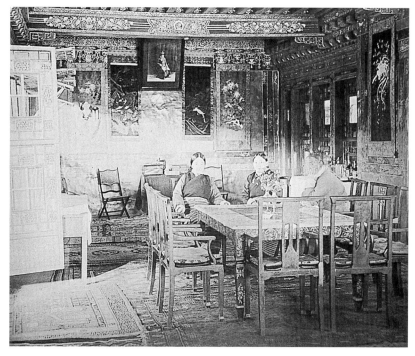

39 F. Spencer-Chapman, The Tsarong family in their home in Lhasa in the 1930s.

Dagchen Jigdal Rinpoche sits astride his motorcycle clad in full monastic robes before a painted studio backdrop of a lake-side pagoda. His pride at being depicted as the purchaser of exotic foreign goods and consumer of pleasurable pastimes clearly emerges from the sepia. The concept of mimetic reproduction of the appearance of individuals had become fashionable in elite circles well before the rupture of exile.

However, the inception of this development in Tibetan visual culture took place not in Tibet but in India. In 1910 the thirteenth Dalai Lama had taken refuge in Darjeeling after the Chinese sent four hundred troops to Lhasa, an act he and his government interpreted as the beginnings of a mission to kidnap him. Whilst in temporary exile in British-run India, he established a close relationship with Sir Charles Bell, the British representative for Tibet, Bhutan and Sikkim. Under Bell's guidance the Thirteenth was the first Tibetan to encounter some of the more sophisticated technologies of Empire, including photography. He even asked Bell to make an indexical record of his form. For a Christian European, recording the impression of a living body was an acceptable part of the process by which an image functioned in the 'cult

of remembrance of loved ones, absent or dead' (Benjamin[11]), hence he perhaps unwittingly (but at the Thirteenth's instigation) overturned a Tibetan taboo. In pre-1959 Tibet, portraits of religious figures were only made after their death. So that:

When So-nam Gya-tso, the Dalai Lama who introduced Tibetan Buddhism among the Mongols, died, 'In memory of his body his portrait was painted on cloth, in memory of his speech one copy of the Kan-gyur was printed in gold letters, and in memory of his mind a silver tomb thirteen cubits in length was built by the people'.[12]

A picture of the deceased was also used by Tibetan families during *bardo* ceremonies over the 49-day period when the spirit of the corpse was encouraged to move to its next incarnation. Hence Tibetans had good reason to express concern about the production of an index. As Bell reports: 'In November, 1933, the Dalai Lama, summoned one of the Nepalese photographers in Lhasa to take his photograph. This alarmed the people of Lhasa, who took it as a sign that he intended to die soon.'[13]

40 Photographic portrait of Sakya Dagchen Jigdal Rinpoche taken in Lhasa, 1957.

Unfortunately their collective premonition proved true. By mid-December the Thirteenth was dead. However, he had been having his picture taken since 1910 and Bell describes how his first portrait was quickly converted into an object of veneration by Tibetans:

This was, I believe the first photograph of him seated in the Tibetan style. I gave him a large number of copies, and these proved useful to him; he used to give them to monasteries and to deserving people. These all used the photograph instead of an image, rendering to it the worship they gave to images of Buddhas and deities.[14]

Bell comments that thereafter he saw thousands of these icons in circulation throughout the Tibetan communities of the Himalayas. But how had the taboo been overcome, allowing a photographic portrait of the living Dalai Lama to become an object of sanctity? The process was instigated through the collaboration of three agents: the thirteenth Dalai Lama, Sir Charles Bell and an anonymous Tibetan painter.

Bell's account of his relationship with the Thirteenth (appropriately entitled *Portrait of the Dalai Lama*) includes a copy of the photograph he had taken but with accretions (illus. 42). His picture was presented to him with both the seal and signature of the Thirteenth, emphasizing the sense of direct – indexical – contact with its subject, and had been tinted by a member of the Thirteenth's retinue in Darjeeling. Bell notes that the artist had used 'the appropriate colours for his hat, his robes, his throne, the religious implements [. . .] and the silk pictures of Buddha which formed the suitable background of it all'. That is, the areas surrounding the Thirteenth had been Tibetanized through the agency of a Tibetan artist. However, Bell fails to mention that the undressed parts of the Thirteenth's body, his head, arm and hands remained in unt(a)inted monochrome: the primary features which expose an individual identity were left undisturbed by pigment. The Tibetan painter, still wary of proscriptions against portraiture, allowed the camera to produce the simulacra of a religious body, just as, according to Tibetan accounts, the living Buddha could only be depicted from a reflection in water or an imprint in cloth. (Looking closely into the eyes of the divine therefore remains an occupational hazard which Tibetan artists must avoid at all costs.) In this sense the Dalai Lama photograph can function as an icon, but the camera has also been used to capture the 'aura' of an exceptional individual. The thirteenth Dalai Lama seems to have deliberately encouraged an 'ideology of the charismatic individual' and selected Bell to be his Félix Nadar. For him the photo-icon provided the possibility of making Barthesian 'certificates of presence', attesting that what is seen has existed and that his very

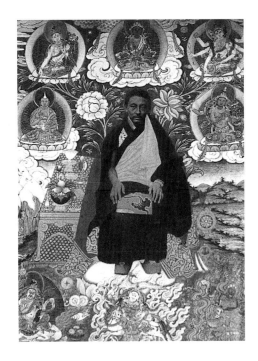

41 Photo-icon of the ninth
Panchen Lama at Likir
monastery, Ladakh, 1994.

particular body had housed the incarnate godliness of a bodhisattva.

In 1930 Bell took further photographs of the thirteenth Dalai Lama as well as of the ninth Panchen Lama which he published in 1946. Copies of these pictures evidently found their way across the Himalayas and became the subject of photo-icons, as is evident in one displayed in the Ladakhi monastery of Likir (illus. 41). Again, as in the 'certificate' of the Thirteenth, the body of a divine individual is replicated in monochrome, but the painter has ventured further than mere tinting. The ninth Panchen Lama is seated alongside a table set with offerings in a landscape painted in the manner of *thangka* paintings, with heavily stylized mountains, rivers and lakes. Peaceful and wrathful deities at top and bottom respectively are also painted and positioned as they are in *thangka*. However, the attempt to place the Panchen in a readable (there is even a degree of perspectivalism in the treatment of the offering table), if idealized, space is extremely novel. This tinted zone surrounding the photographic 'certificate' increasingly became an area of artistic innovation.

Exiled artists such as Sherap Palden Beru have taken this model and expanded its referential possibilities to acknowledge the social and political facts of relocation. By incorporating the Dalai Lama image into a wider field they began to use photography within an aesthetic

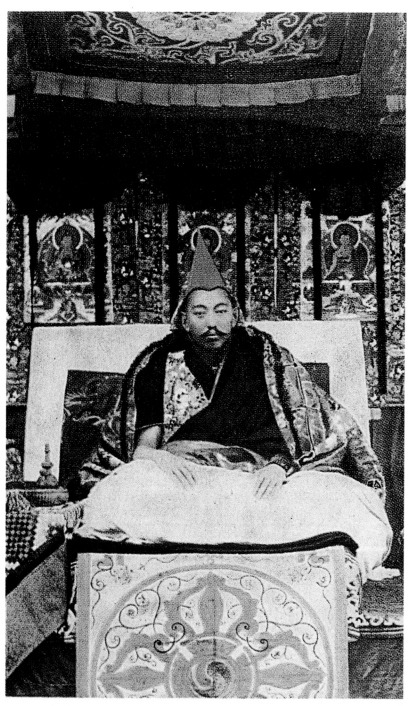

42 Sir Charles Bell, Photograph of the thirteenth Dalai Lama (with accretions), 1910, from *Portrait of the Dalai Lama*.

43 Photo-collage of the Dalai Lama at Bodh Gaya, India, from a postcard sold in Leh, Ladakh, 1992.

44 Photo-collage of the Dalai Lama at the Potala, Tibet, from a postcard sold on the Barkhhor, Lhasa, 1993.

dialogue which, contra Barthes, could in fact 'restore what has been abolished (by time, by distance)' and imagine their leader returned to his rightful home, the Potala, or locate him in the environment of the host country India. In a 1990s icon the camera enables the artist to show the fourteenth Dalai Lama occupying the same time and space as his followers (illus. 43). Like them, he can stand in Indian locations such as Bodh Gaya (a favoured exilic site and scene of Kalachakra initiations given by the Dalai Lama), though his status as a sacred person is demonstrated by the image-maker in lines of irradiating light (emitted from his body as they had from the Buddha-body). Proportion, which presents the Dalai Lama as larger than the photographed life around him, also suggests that he eclipses the architectonic embodiments of the Buddha and those who perform *pradakshina* (circumambulation) around the base of the Bodhi stupa. Here the Dalai Lama's status as bodhisattva of compassion (rather than *tam drin* or protector) and representative of pan-Asian Buddhism is privileged, acknowledging that he and his followers take solace in the fact that their 'home from home' locates them in a wider community of Buddhists. In contrast to the imagined space of Tibet, this 'home' is observable and subject to different systems of viewing and representing: the camera shoots India, while the brush remembers Tibet.

Fundamentally the possession and viewing of such images also relates to a condition of aspiration and expectation that both the Dalai Lama and the independent nation of Tibet will be reincarnated. This principle has been activated by monks at Likir, where the photo-icon of the thirteenth Dalai Lama hangs in the *Du khang* (assembly hall) as an object of veneration but also a record of history and future expectations. They make reference to the reincarnatory lineage of Dalai Lamas by attaching two images of Tenzin Gyatso outside the Potala and surrounded by a crowd displaying the Tibetan flag to that of his predecessor. The Thirteenth had designed this, the first ensign of the Tibetan nation, and predicted the calamitous events that would occur in the lifetime of the Fourteenth, though he did not foresee that both flag and icon of the Fourteenth would be banned on Tibetan soil.[15] For Tibetans the vulnerability and ephemerality of images and bodies is counteracted by the indestructible (eternal?) concept of transmigration of 'souls', a concept which allows them to imagine a return to the place absented, Tibet.

This politicized conception of reincarnation is also powerful within the TAR, and in recent years photo-icons have been utilized in a restorative process in which absent persons are returned to their rightful places. Young reincarnates, discovered in exile, are imagined at their

monastery in the 'homeland'. The Dalai Lama revisits his seat of power, the Potala Palace, accompanied by an iconic representation of Avalokitesvara and the tenth Panchen Lama (illus. 44), and the Potala is located in a landscapeless blue void – the tourist facilities, parades of shops, karaoke bars and other monuments to Chinese consumerism which currently surround it are obliterated. This image was available in Lhasa in 1993 during a period when the prohibition against the production and sale of images was relaxed. In the summer of that year the Barkhor, the ancient trading centre of the Tibetan capital and also a circumambulation zone around the most important temple in Tibet, the Jokhang, was filled with stalls selling photo-icons. Such images were bought by pilgrims, many of whom were en route to Tashilunpo, the Panchen's monastery thirty miles south-east of Lhasa, where his remains were to be placed in a commemorative stupa. As the second highest ranking figure in Tibetan Buddhism, the Panchen Lama had not followed the Dalai Lama into exile but stayed on during the Chinese takeover to attempt to negotiate with PRC leaders. For his pains he spent much of his life in prison, hence it was undoubtedly politic that his death (which some suspected was not from natural causes) should not lead to unrest. It should also be noted that the point of sale for his image, the Barkhor, had also been the primary zone for expressions of dissent during the 1989 riots in which monks and nuns were shot and killed by Chinese police. Hence for a brief period in the TAR, Tibetans were allowed to remember their dead and perhaps to dream of a different future in which the impact of China had been erased. Given the history of battles fought over images in Chinese-occupied Tibet, it appears rather surprising that this activity was condoned by the Chinese authorities in Lhasa. PRC officials apparently saw no danger in Panchen photo-icons because for them they were mere memorials to the dead, certificates of presence without ongoing personhood, whereas for Tibetans such icons imply a lineage of individuals and a larger communal identity. Another Barkhor photo-icon of the same year illustrates this point (illus. 45). It depicts three figures who no longer had physical presence in the TAR: the Dalai Lama (absent), the Panchen Lama (recently deceased) and the Buddha (long deceased). Here all three are re-presented photographically: the two monks by portraits taken in different locations (India and Tibet) and the Buddha by a photographed *thangka*. The image condenses large expanses of time and geography in order for all three to appear in the same space which they occupy in the minds of Tibetans, that is as part of a lineage of Buddhist teachers whose physical forms may alter but whose spirits are part of a constant process of transmigration. An additional aspiration has been added to

45 Photo-icon of the Dalai Lama, Panchen Lama and Buddha, from a post-card sold on the Barkhor, Lhasa, 1993.

this belief, that an imagined place which currently does not exist will also reappear: an independent Tibetan Buddhist nation.

The history of Dalai Lama photo-icons demonstrates that some innovation is possible beyond the sphere of official public culture in Dharamsala. With the precedent of the thirteenth Dalai Lama and the availability of the reprographic technologies of India, exiled artists have devised a new type of object which can circulate throughout the community of *nangpa*. As the leader of this group, the Dalai Lama pre-eminently carries the burden of representing Tibetan exilic identity for his story is a script with which the biography of each exile coheres. His image is a reference to this sense of communality and depicts an identification between himself and his followers in which 'Tibetanness' is reflected back. The Dalai Lama as a subject is supremely Tibetan, but exiled artists have also attempted to expand the repertoire of 'Tibetan' visual idioms in order to translate the narrative of the host environment into images which can be perceived as culturally, if not ethnically, Tibetan. When touched by the Tibetan brush, India can become

part of the *nangpa* world and culture-specific depiction can allow an 'outsider' (such as Mohandas Karamchand Gandhi), to become an 'insider'. In this case, taking inspiration from the local suggests that Tibetan refugees are very much part of the global condition of hybridity of the second half of the twentieth century.

The Tibetan Image of Mahatma Gandhi

In 1969 the exilic commemoration of the March 10th Uprising (when in 1959 the residents of Lhasa, fearing for the Dalai Lama's life, were involved in violent demonstrations at the Norbulingka) also marked the passing of ten years in India. Thousands of Tibetans congregated in Delhi to recall the events which led to their departure from Tibet, but they also joined in a public acknowledgement of an Indian leader as they marched to Mahatma Gandhi's cremation site at Rajghat, where they 'reaffirmed their faith' in his teachings. However, this public demonstration of respect for the father of the Indian nation was not without complications. The enthusiasm for M. K. Gandhi among the first wave of Tibetan refugees was driven in part by the religious aspects of his teachings which had been adopted by the Dalai Lama. The Fourteenth encouraged the practice of *ahimsa* (non-violence) and *satyagraha* (holding on truth) and had taken a Gandhian stance in advocating pacifism in the face of Chinese aggression. However, for other Tibetans the political, anti-imperial aspects of Gandhi's biography had greater resonance. At the time of the Rajghat pilgrimage the Tibetan Youth Congress was agitating for a more violent response to the impact of the Cultural Revolution (1966–76) in their homeland. Young, militant Tibetans rejected Gandhian *ahimsa* and urged action in defence of a just cause.[16] Hence the 1969 Delhi gathering was a ritual designed to acknowledge the history of struggle in Tibet whilst quelling dissent through the adoption of the Dalai Lama's interpretation of Gandhi's legacy to Tibetans. It was an event when the lessons of a non-Tibetan's life were to be held up as exemplars, particularly for Tibetans born in India.

Indeed, only a year later Gandhi's biography was translated into Tibetan by Lobsang Phuntsok Lhalungpa (an important figure in the Dharamsala education system at that time) and published for distribution within the schools and homes of exile in India. *Jewel of Humanity: Life of Mahatma Gandhi and Light of Truth of His Teachings* was published in 'Western' format (rather than the traditional palm-leaf style) with illustrations by an artist known only as 'Master Topgay' (of the Tibetan Craft Community, Palumpur, Himachal Pradesh) to

commemorate the centennial anniversary of Gandhi's birth in 1869. Its cover illustrates major events from the Mahatma's life and presents him not merely as a political hero but as a Tibetanized saint. Episodes in Gandhi's life are presented by Topgay (illus. 46, 47) in the format of a Tibetan biographical painting, that is to say with a central iconic representation surrounded by a landscape filled with narrative events in smaller scale. This format had been used in pre-1959 Tibet to illustrate the life of the Buddha and both Indian and Tibetan Buddhist saints, such as Padmasambhava and Milarepa. However, the compositional structure of Topgay's Gandhi image is not only reminiscent of this genre of Tibetan painting but is cross-fertilized by influences from mass-produced Hindu devotional images made in India in the 1950s and 1960s. The interweaving of two visual schemes in the Gandhi illustrations demonstrates a kind of post-colonial (and post-exilic) hybridity in which pre-existing structures are negotiated and given novel realignments which reflect the political significance of an Indian adopted by some Tibetans into a canon of saints.

The front and back covers of *Jewel of Humanity* replicate Gandhi's life story from birth to death, with his most youthful representation appearing in the top left of the front cover and his death at the bottom right of the back, illustrated by a scene where his corpse lies draped with the Indian flag. Though his birth in Porbandar, Gujarat, in 1869 is not shown, the sequence begins on the front cover with Gandhi as a child. The first three scenes at the top of the page all focus on women in Gandhi's life: his mother Putlibai, who biographers insist first instilled a sense of the importance of abstinence and purity in Gandhi, and Kasturba, the woman he married as a teenager in 1883, who supported his campaigns and eventually died imprisoned in the Aga Khan Palace near Poona following a 'Quit India' demonstration. The two women become fused into one in the central image where the young Gandhi is shown prepared to face the trials of his life but still embraced by a sari-clad figure, highly reminiscent of the *Bharat Mata* (Mother India) feminine iconization of the nation begun by Abanindranath Tagore in 1905. This image is placed in a significant location for Tibetan viewers, as it rises above the head of the central image of the lotus-seated Gandhi in the position usually reserved for root gurus or a bodhisattva such as Avalokitesvara. Here the living man, Gandhi, is acknowledged to have emanated from a woman, but his saintly status is implied by the lotus beneath his throne, a device used in Tibetan imagery to indicate a person of exceptional qualities and of exceptional birth. In fact there is a suggestion that some Tibetans consider Gandhi to be an incarnation of Padmasambhava (the lotus-born), who came to Tibet from India and

subdued powerful spirits to establish the new order of Buddhism in Tibet.[17] Hence Gandhi was adopted into a lineage of non-Tibetan heroes.

On the second level of this cover, moving downwards as the chronology of events unfolds, we see Gandhi in three of his guises. At both a personal and political level, dress was a fundamental tool in his strategies for disrupting the marketing of English textiles and promotion of European sartorial modes during the British Raj. His appearance became part of the iconography of nationalism, as Tarlo suggests:

Gandhi, recognising that dress was a concrete symbol to which everybody could relate, portrayed his disillusionment with the British through his gradual shedding of Western garments. This was not merely a rejection of Western values, but also a reassertion of Indian values as morally superior, as well as being socially, politically and economically more appropriate to India.[18]

On the left of Topgay's painting Gandhi appears in a European-style suit, indicating his journey to England as a young man (where he studied law) and the attire he later also wore as a barrister in Johannesburg, South Africa. This image is contrasted with that on the right, showing Gandhi clad in a *kurta* (coat) and clutching a staff, implying his shift towards a more Indianized mode of dress. In the centre is the religious representation of Gandhi in the lotus *asana* (seated position), hands in a *mudra* (hand gesture) of peaceful contemplation, bareheaded and dressed in the simple white *dhoti* (loin-cloth) and shawl so familiar from photographs of his later years. The thin wire glasses also hint that this is the mature Gandhi of post-*satyagraha* and *ahimsa* campaigns whom we should view within the aesthetic of *darshan* (the ritualized viewing of religious images), for this is a man whose use of religious precepts for political ends should inspire veneration. We should also note that this central figure is outside the chronological sequence, as deities were in pre-1959 biographical images.

On the lowest register two formative events in Gandhi's life in South Africa are arranged. On the left he appears in the Durban court room (though we would hardly guess the location as the architectural features are highly Tibetanized) where in 1893 he was asked to remove his turban if he wanted to present his case. Gandhi wrote to the newspapers complaining of his mistreatment and subsequently acquired the racist epithet 'Coolie Barrister'. On the right, an even more blatant demonstration of the colour bar in operation is displayed as Gandhi is ejected from the first class carriage of a Durban to Pretoria train by railway officials at Maritzburg. These experiences are cited in Gandhi

46 Master Topgay, The early life of Mahatma Gandhi, front cover of
Lhalungpa, *Jewel of Humanity* (1970).

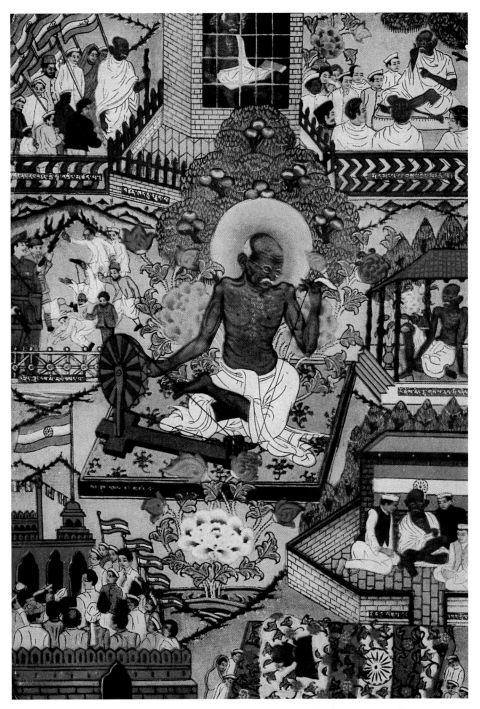

47 Master Topgay, The mature career of Mahatma Gandhi, back cover of
Lhalungpa, *Jewel of Humanity* (1970).

biographies as lessons through which he learnt the iniquities of colonialism. By 1913, Gandhi's activities defending the rights of Indians in South Africa had led to his third period of detention in jail and by 1914 he left the country for good. Thus the front cover of the publication moves geographically between India, England and South Africa, chronologically charting his evolution from childhood to adulthood and growing political awareness, but it also marks a number of other transitions which are placed in a dialectical relationship with one another. There are three major strands of transformation indicated as he moves from child (home) to man of the world (down the page) and from the protective embrace of others, specifically women, to man of many parts and guises. His constructed identity through dress, indicated from left to right in the central section, is sealed by a central iconic representation. The theme of movement from innocence to (painful) experience follows a downward diagonal trajectory. These patterns are replicated on the reverse cover.

Just as the image of supporting feminine figure(s) could be read as the root image from which the young Gandhi emerged, the reverse cover of the Gandhi biography is topped by a scene that embodies crucial values in his later life, where he appears as stoic prisoner. Here a deliberate parallelism between back and front covers is drawn, since we are told that it was from his mother (also the 'Mother of the Nation' and a representation of 'Indian' values) that Gandhi had learnt to observe a simple and virtuous life. These lessons were brought even more sharply into focus as he spent many periods of his life in jail. In the central iconic image, Gandhi the self-sufficient guru of the ashrams is shown at his spinning wheel, indicating a further reification of simplicity and purity. The implications of these values in terms of politics are demonstrated in the surrounding biographical scenes. The events covered follow his career back in India (1914) up until the assassination in 1948, a period of 34 years, in which Gandhi was involved in so many campaigns that the artist has had to select certain types of events to function as emblems of his major achievements. Broadly speaking the sequence begins (top left) with the representation of the Mahatma as leader of the Indian people as he marches followed by flag-carrying supporters. Here he appears as leader of the 'Quit India' movement (by 1920 he had been elected leader of the All India Home Rule League) in which non-cooperation was the dominant tactic employed, though when this led to violence at Chauri Chaura in 1922, Gandhi halted the campaign and personalized it by fasting for five days. This was to be a leitmotif of his mature career. In fact the dialectic of this image is constructed in an opposition between private and public, with Gandhi the figurehead of mass movements on

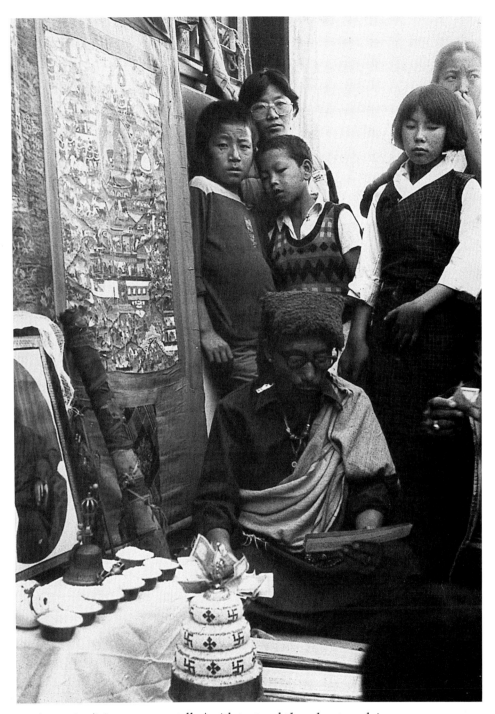

48 A *manipa* (itinerant story-teller) with text and *thangka* at work in Mussoorie, 1984.

the left-hand side and Gandhi the mo[...]
we have observed, these two principl[...]
operated ideologically and practica[...]
tension. At top right Gandhi the four[...]
Satyagraha Ashram was the first, esta[...]
shown in teaching mode, rather as[...]
thangkas (representations of tales of h[...]
disciples. The left-hand image of the[...]
indicate the battles which ensued du[...]
though Gandhi himself, appropriat[...]
violence, is absent. He appears oppos[...]
mode. Finally we see two scenes of n[...]
outside government buildings in Delhi, the Indian flag raised above
their ramparts, indicating the achievement of independence in 1947.
On the right, Gandhi as father of the nation is consulted by the new
country's leaders before a backdrop of the flag. His corpse, wrapped in
the flag of newly independent India and strewn with flowers, closes
the story.

As stated above, the trajectories of time and experience are indicated
on the reverse cover as on the front. On the left side a popular move-
ment of the people ultimately leads to the construction of the new
Indian nation, as agitation against the British colonialists, channelled
by Gandhi, leads to independence. On the right Gandhi's wisdom and
teachings lead to his valorization as father of the nation (if not leader) –
but also to his death at the hands of an extremist. The political narra-
tive is underpinned by the diagonal imperative of the image structure
that leads (from top left to bottom right) from leader of the masses to
assassination: from innocence to experience. This contrapuntal theme
demonstrates the moral core of the image and the implications to be
drawn from the biography – that a virtuous life lived for a cause may
lead to privations and the ultimate sacrifice. Causality is personalized,
though not without ethical and philosophical ramifications for the
collective. The inferences delineated in the structure of the Gandhi
image contain a powerful argument concerning the implications of the
actions of one individual employing knowledge informed by religious
precept – actions which gained him the title Mahatma, or great soul.
The iconization of Gandhi at the centre of these images illuminates a
figure whose actions give him heroic stature beyond that of ordinary
mortals and who thus is outside temporality. Like the fourteenth Dalai
Lama, the image of an apotheosized M. K. Gandhi summarizes the aspi-
rations not only of a single individual but of a larger group for whom he
symbolizes the embryonic nation of India. Equally similarly, Gandhi is

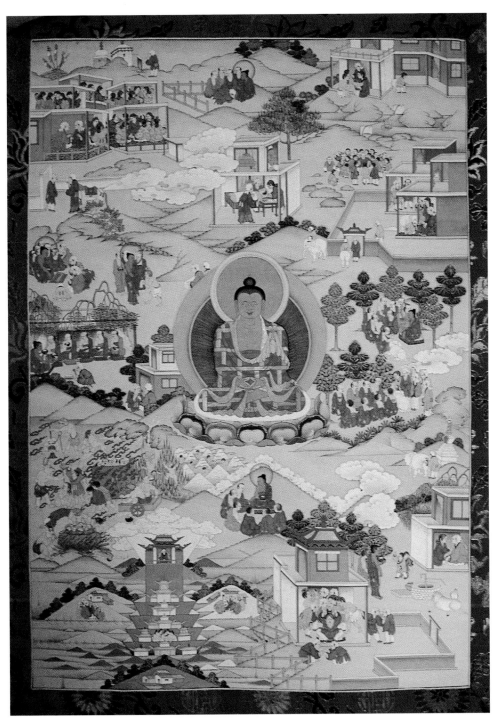

49 Sonam Tenzin, *Jataka thangka*, 1992.

a figure who, like the Dalai Lama, embodies the potential for transforming an imagined community into the reality of a nation.

The structural argument behind these Tibetanized images of Gandhi is a novel addition to the vocabulary of Tibetan image-making and one which demonstrates the impact of the Hindu oleographs of the host community. Although pre-1959 biographical *thangkas* incorporated sub-scenes which followed a sequential narrative and were interconnected by a zigzag or clockwise compositional movement, there was little sense of a chronological connection between each scene nor of causality in the actions of the subject (such as the Buddha). Landscape devices were utilized to confer the impression of a single space in which events took place, but they created a kind of empty time–space continuum. Moments from the tales of the Buddha's life, for example, often appear to have been randomly selected from versions of the Jatakamala text and no attempt is made to create parallels or draw dichotomies through the location of events within the 'frame'. Though the Buddha's biography documents the cumulative force of his actions, in which he accrued merit and was transformed from a bodhisattva into a buddha, in the past this evolution was not depicted by Tibetan painters as a sequence of logically or temporally interconnected events. Hindu oleographs on the other hand frequently compartmentalize key events and organize them into a left-right or top-down progression which demonstrates their relationship to one another. This approach to the surface of an image may have its roots in the sculpted narrative cycles on the walls of Hindu (and Buddhist) temples in India, where the viewer often saw the drama of Hindu epics unfold as they made their *pradakshina* (circumambulation) of a sacred building. Comparable narrative imagery was a rarity in the Tibetan cultural sphere.

The representational shifts apparent in Topgay's Gandhi images may also have been determined by the emergence of a different medium for story-telling which became prevalent in exile – the Western-style book. In pre-1959 Tibet biographical paintings were used by itinerant storytellers (*manipa*) who recited the accompanying text whilst pointing out relevant images on the *thangka* (illus. 48). In this oral system the impact of the text was enhanced for a primarily non-literate audience through a dynamic relationship between word and image. Topgay's illustrations, on the other hand, are reconstructions of a life as it had been presented chronologically within the pages of a book, to be read privately or on occasion publicly in a classroom. Though *manipa* still ply their trade in exile, the majority of Tibetan children experience story-telling in the school environment. There the old Tibetan didactic style, which was heavily reliant on repetition and recitation of religious

texts, has been replaced by guided reading which includes accounts of recent history and pertinent biographies.

Tibetanizing Elements

Topgay's Gandhi images reflect an epistemological shift in Tibetan culture under the influence of the host society. The new subject matter, in this case Gandhi, has been heavily 'Tibetanized', enabling the images to be received by Tibetan viewers and constraining the possible readings for that audience. This is achieved in a number of ways. Firstly the treatment of space is a deliberate fusion of the implications of Indian oleographs and some elements of pre-twentieth-century Tibetan landscape styles. As in oleographs, Topgay's images are highly symmetrical, with sharply subdivided scenes in cartoon-strip style, but the overall space is unified by the use of landscape devices familiar from Tibetan paintings from the sixteenth century onwards in which tufted triangular forms stand for hills or mountains. When buildings or compounds need to be marked out, diagonal lines cut into the space, not because 'the artist has perhaps tried too hard to incorporate perspective into each little scene, no doubt under Western influence'[19] but because this is a 'traditional' Tibetan system for treating space, especially popular in one of the few genres where landscape and architecture need to be amalgamated, the biographical painting (illus. 49). In such *jataka* images, each time the Buddha appears in an interior setting the walls of the temple/monastic compound suffer from the same drastic foreshortening as Topgay's. Neither achieve the supposed rationality of Western one-point perspective, but why should they? Both artists and audience are well aware that unity of space, time and action are hardly possible or desirable for this kind of subject. Generally Topgay simply uses the outline of his buildings to contain a scene and then moves on to the next. If there is any creeping 'Westernization' in Topgay's work, it has been filtered through the prism of Indian oleographs, which since the time of Raja Ravi Varma (1848–1906) have retained some influence from European Realist oil painting.

We have already noted the Tibetanization of the architecture of the South African courtroom which includes a golden 'pagoda'-type roof as found on many Tibetan religious buildings (such as the Potala and Jokhang in Lhasa) as well as other familiar Tibetan architectural details. Interestingly the rest of the buildings are rather generic and apparently brick-built. This appears to propose an inversion of Denwood's discussion of 'local colour' in a biographical painting by a Tibetan artist working in Dolpo, Nepal, in the 1970s, in which

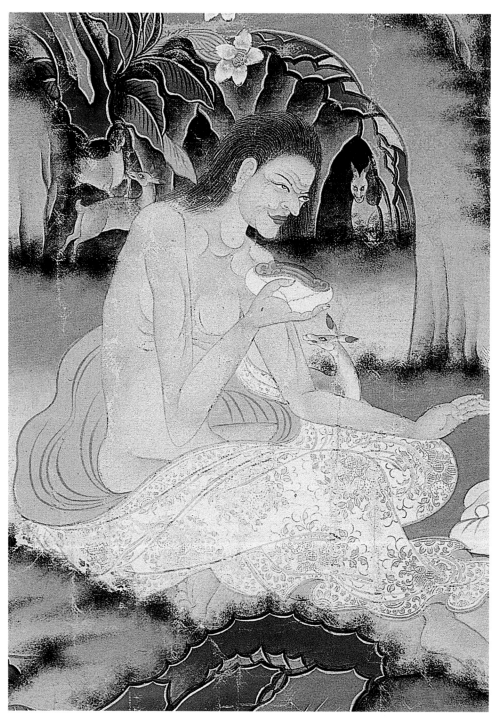

50 Detail of an 18th–19th-century painting of Milarepa's life story.

... if the story takes place in Tibet the buildings though simplified will be recognisably Tibetan; if in India, they will be recognisably 'foreign' (which usually means copied at some remove from a Chinese or occasionally Nepalese model).[20]

In Topgay's work the architecture surrounding the events of Gandhi's life in India is rendered in a series of neutral modernist boxes (with the exception of the Lutyens/Baker architecture of New Delhi on the reverse), but an official building in 'foreign' parts is represented by Tibetan architecture. What does this suggest about the iconography of exile? That things Tibetan have become the global, whilst things Indian are the local? Tibetan architecture appears to have become sufficiently exotic to refugees for it to function visually as a signifier of the strangeness of South Africa.

However, perhaps the most significant facet of these works is the manner in which Gandhi becomes Tibetanized, iconized and sanctified. Gandhi is by no means the first person born outside the Tibetan plateau to become an honorary Tibetan, but he was certainly the first to gain the accolade in this century. In the central image of the front cover of his biography he is seated and enthroned in a style and position reminiscent of the Buddha in *thangka* painting. The throne and tree canopy had been a popular design in Tibetan painting from at least the fourteenth century which has been continued in exile for portraits of high-ranking *rinpoche* (incarnate teachers). On the reverse cover the focal figure shows Gandhi clothed in his familiar white 'ascetic' attire and glasses (that is, familiar as a result of photography). For Tibetans this type of dress is less reminiscent of the Buddha than it is of one of the most popular Tibetan saints, Milarepa, who is also envisaged as thinly clad in white (Tibetans refer to him as the 'cotton-clad' Mila), indicating his distancing from materialistic, communal life (illus. 50). Milarepa's life story, including entertaining accounts of the effectiveness of his 'magical' powers, is recounted in the *Hundred Songs of Milarepa*, a biography which is well known to Tibetans and, like Gandhi's, provides tuition and inspiration. When represented iconographically, Milarepa can be differentiated from other figures through his more relaxed, asymmetrical posture (often with hand to ear indicating his love of poetry and song), just as Gandhi is shown in half-profile by Topgay, seated at his spinning wheel.

Topgay's book covers are an extraordinary example of what Nowak calls refugee 'creative sense making'. Gandhi becomes an insider (*nangpa*) as a result of a biography which is read as an example worthy of assimilation into Tibetan exilic life. The translator, Lhalungpa, and other exilic educators sought to represent a hero for Tibetan children in

exile and the artist, Topgay, rose to this challenge. By adapting lessons drawn from Indian representational techniques he devised a more rhetorical treatment of space than had previously existed in Tibetan painting. As we have seen, the plotting of Topgay's work makes the moral and political dimensions of Gandhi's story explicit and demonstrates that, though innocence may lead to painful experience, the journey is worth travelling if the true destination is achieved. Parallels are undoubtedly to be drawn with the Dalai Lama, who has publicly affirmed his debt to the Mahatma's example. The question remains whether his journey (and dream of nationhood) will prove as fruitful.

Painters of Modern Life

As this chapter has shown, India has been something of a locus of enchantment where key figures in Tibetan culture first encountered alien imagery and technologies. It was in India that the thirteenth Dalai Lama met Sir Charles Bell and discovered the camera and less than half a century later that the fourteenth Dalai Lama embraced the figure of Gandhi and his teachings. Though these encounters were created by the unhappy process of taking refuge in a neighbouring country, they led Tibetan culture into new domains. The legacy of these moments of cross-fertilization enables us to posit a counter-narrative to Snellgrove and Richardson's prediction that 'cut off from its roots' Tibetan culture would become 'moribund'. With the precedent set by their leaders, exiled Tibetan artists were thereafter at liberty to incorporate some of the imagery and visual codes of the host country, as long as their efforts were directed towards the 'ephemeral' and 'fugitive' objects of popular rather than elite culture. Topgay, Sherap Palden and a handful of anonymous artists became 'painters of modern life', as Baudelaire has it, and reflected the world as it appeared to them as Tibetan exiles living in India.[21]

However, their objectives were primarily descriptive and often couched in terms of historic precedent, as was the case for a mural project at the neo-Norbulingka where Indian Tata trucks are shown bringing cement and other building materials to the site. Back in Tibet, a famous eighteenth-century wall painting at the Potala Palace in Lhasa had shown the construction of the Jokhang temple. As an exiled artist notes, a kind of realism had long been a part of secular visual culture in Tibet:

Once an artist painted a beautiful flower, and a man, on seeing it complimented on its beauty. He wanted to grow that flower and so asked for its seed. The painter said, 'If you like this flower, then take it home'. The man felt happy and began to pick up the flower only to realise that it was not

real. He felt ashamed and felt it childish to take it home. It is amazing that even in those days something akin to modern art existed.[22]

The author of this account (Jamyang Losal) tellingly associates mimesis with modernity. However, in his paintings for the exile community he rigorously avoided both in order to fulfil the demand for 'authentic' Tibetan images. But even whilst making the commitment to the exilic presentation of Tibetan culture, many exiled artists are clearly aware of strands within both Tibetan and non-Tibetan art history which have been negated. Sangay Yeshi, for one, admired the work of Italian Renaissance painters he had seen in Western books, though he worried about the number of cracks in their surfaces! Another painter commented that he did not like 'modern art, where the artist tries to copy from nature and make it real or lifelike as in a photograph', but he did appreciate contemporary Indian painting, which is predominantly modernist in its disavowal of realism. It is therefore all the more surprising that no exiled artist with whom I spoke cited the example of a Tibetan whose inspiration for making images of Tibet had come from the art of twentieth-century India.

Gendun Chöpel was the first Tibetan to paint in ways which seriously deviated from tradition and presciently tangled with modernism. At the close of our discussion of exilic Tibet and prior to chapters on image-making in and about the TAR, Gendun Chöpel's story straddles both Tibetan worlds. Here is a figure who was born at the start of the century in pre-invasion Tibet but rebelled against its traditional orthodoxies. In the 1930s he left the country to travel to India and whilst there visited pilgrimage sites which had been on the itinerary of Buddhist devotees for over a thousand years – in the process being exposed to the vivid realities of modern India. Most pertinently for our discussion, he met a key figure in Indian modernist circles and began to experiment with styles of painting which fell well outside the traditional Tibetan canon. However, in a strange inversion, it is not in India that the successors to Chöpel's avant-garde speculations can be found. It is, as we shall see, among artists in the Tibet Autonomous Region that the radicalism of Chöpel finds its most sonorous echoes.

Gendun Chöpel

The poet, scholar and revolutionary Gendun Chöpel (1903–51) was by any standards an exceptional figure. In Tibet he wrote a treatise against Gelukpa doctrine and pursued a radical position on literary and political matters for which he was held in deep suspicion by the Tibetan

authorities. Among his many accomplishments he was also a trained artist who had perfected the iconography and techniques of *thangka* painting in Tibet. When Rahul Sankrityayana met Chöpel there in 1934 he noted that 'having studied and mastered traditional painting, he quickly learnt the new style'.[23] Unfortunately the Indian scholar does not specify what this 'new style' consisted of, but it may have been an early version of the realism which Chöpel's student Jampa later used at the Norbulingka. Clearly Chöpel had eclectic tastes and prided himself on his ability to absorb lessons from diverse sources. This was clearly the case when in 1935 he travelled to India and spent twelve years there pursuing a wide range of interests, including politics, translation and the visual arts.

Whilst visiting sites associated with the Buddha in India Chöpel absorbed 'artistic influences from the buddhas of Mathura and the cave painting of Ajanta to the luminous mystical Himalayan watercolours painted by Nicholas Roerich, and even to Russian icons'.[24] Few of Chöpel's works survive, but the flowing line drawings from his 1938 sketchbook provide some indication of the direction his work had taken after a few years in India. Karmay concludes that these drawings were 'inspired both by traditional Tibetan painting and a keen observation of the human figure',[25] but, according to an anecdote related by Fany Mukherjee (a photographer who travelled with Chöpel, Rahula Sankrityayana and the artist Kanwal Krishna to southern Tibet in 1938), life-class style 'observation' was not the only way in which he worked:

[. . .] dGe-'dun Chos-'phel said the most important thing is concentration. The mind must be totally absorbed in the subject. One day he said that he would show me what he meant. He went to the market and bought a bottle of arak, he started to drink. He drank and drank and kept asking whether his face had gone red yet. By the last drop he was quite inebriated. He stripped off stark naked and sat down and started to draw; he drew a perfect figure of a man starting off at one fingertip and going all round in one continuous line until he ended back up at the fingertip again.[26]

Chöpel was in fact demonstrating (and perhaps parodying) a Tibetan account of image-making when naked, described here by Lo Bue:

The author of the *Hevajra-Tantra*, for example, lays down rather impractical and purely ideal conditions for painting the image of Hevajra: in a lonely spot at midnight on the fourteenth day of the dark fortnight, in a ferocious state of mind from the drinking of wine, with one's body naked and together with one's female partner.[27]

But the idea of drawing the figure in one line is not a Tibetan conven-

tion. Chöpel may have come across the idea in the Japanese calligraphic techniques which had been adopted in some artistic circles in India. In fact, there is a strong possibility that the maverick Chöpel was the first Tibetan to engage with Asian modernism through the work of Indian artists. His sparse line drawings in the sketchbook are far removed from the 'tradition' of Tibet and closer to a modernist deconstruction of the human form.

While he was in India Chöpel met Rabindranath Tagore, who invited him to teach Tibetan at the Viswa Bharati University at Santiniketan (an offer he refused), but the meeting must have been an important one for a Tibetan interested in literature and the arts. Tagore was a Nobel Prize-winning author and, by the time he met Chöpel, had also become a painter. At the university he founded, Tagore had also established an art department which in the 1930s was at the forefront of exploring ways of making a new kind of Indian art for the twentieth century. Two major forces drove the development of art at Santiniketan, one from the West in the form of European modernisms such as Cubism and Expressionism, the other from further east in the guise of Japanese aesthetics. Okakura Kakuzo, a Japanese art theorist, visited India under the guidance of Sister Nivedita (Margaret Noble) in 1902 and two other Japanese artists had made an impact on Calcutta art circles in 1903 (Yokoyama Taikan and Hishida Shunso). In the same year Okakura published a pamphlet in Calcutta entitled *The Ideals of the East with Special Reference to the Art of Japan* which was taken up by the Calcutta elite as the manifesto of a pan-Asian aesthetic. By the 1920s, Santiniketan artists had put the Japanese concept of deep mental concentration, rather than empirical observation, into practice under the guidance of Nandalal Bose, head of the art school in Santiniketan. According to Bilimoria, Bose 'doubted the virtues of "similitude" and quantification (*pramanani*) that his master had taught him, and so developed alternative modes of composition and perspectivism'.[28] His boss at Santiniketan, Rabindranath Tagore, had also been inspired to take up painting following his visits to Japan (in 1916, 1924 and 1929) and by the Bauhaus School in Europe. In 1922 Tagore organized a Bauhaus exhibition in Calcutta and by the 1930s had begun to produce the brooding expressive images in which 'modern art was seen to have arrived in India'.[29] It was during this seminal period in Indian art history that Chöpel met Tagore. It seems unlikely that the supremely curious and highly creative Tibetan would have failed to notice the invention of modernist Indian art.

In 1992 evidence to support the suggestion that Gendun Chöpel was the first Tibetan modernist was still extant at a monastery in

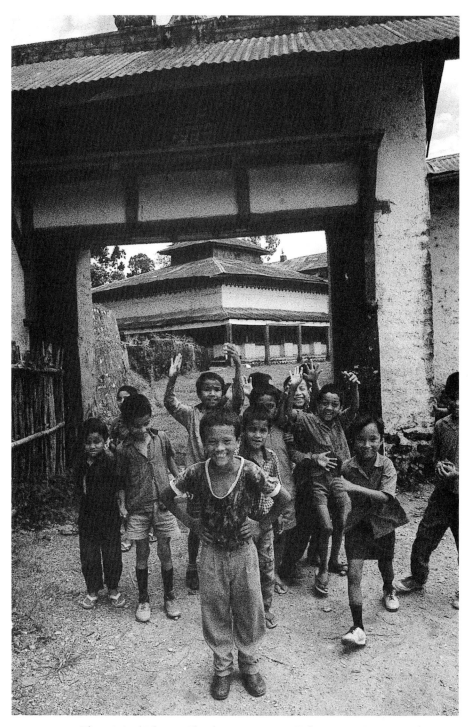

51 The original Tharpa Choeling monastery, Kalimpong, West Bengal, 1994.

Kalimpong, West Bengal. The single-storey monastery of Tharpa Choeling was completed in 1940 and served the minority Tibetan Buddhist community of the Himalayan town until 1995 when it was demolished and replaced by a new, more imposing concrete structure (illus. 51). In 1935 Gendun Chöpel had stayed at the Himalayan Buddhist Centre ('Bhutia Busty') in the nearby town of Darjeeling. He stayed for two years, spending much of his time studying English and Sanskrit. According to the testimony of a Tibetan woman who knew him during his stay in Darjeeling, he was also painting and completing work for private patrons. 'Once, shortly after his arrival in India, he painted a *thangka* of Namthöse (Vaisravana) in traditional style for us, which took about two or three weeks.'[30] Her emphasis on the use of a 'traditional style' suggests that Chöpel's patrons knew of other styles within his repertoire. A highly unusual mural at Tharpa Choeling suggested to me that Chöpel may have experimented with other styles during his stay in the Indian Himalayas.

On the right-hand wall of the entrance vestibule (a place traditionally reserved for didactic images) at the old Tharpa Choeling was a painted *khor lo* or 'wheel of existence'. The format of the image conformed with the basic components of the wheel: (1) the hub, containing the three sources of suffering, ignorance, lust and hatred, represented by pig, cock and snake; (2) the spokes, subdividing the six sensual realms of the universe; (3) the rim – the twelve stages of 'dependent arising'; (4) the figure of Shinje – holding the wheel and indicating the power of death and impermanence; and (5) the figure of the Buddha at one remove from the wheel but indicating a route away from the ceaseless cycle of suffering in various rebirths. However, within a conventional format, the artist responsible for this mural had deviated from the norm in a highly idiosyncratic manner.

In traditional wheels of existence the rim of the karmic wheel demonstrates the twelve stages or links of 'dependent arising'. This concept is illustrated with scenes from human life in which 'ignorance' is shown as the primary obfuscating factor in an individual's psychological and spiritual development. Stage six of this process depicts the idea of 'contact' between individuals in the form of a couple embracing or copulating. This subject is usually approached rather coyly by Tibetan artists, with a couple lying stiffly in bed together, their bodies concealed by covers. But at Tharpa Choeling the topic is represented by a scene of debauchery as a naked couple thrash around, tongues entwined, an abandoned bottle by their side. This animated depiction of a naked, non-divine couple has no parallels in pre-1959 Tibetan monastic art and the novelty of its style and content suggests an

attribution to an exceptional man. Gendun Chöpel was the author of a treatise on passion and a man who revelled in his sexual experiences, as his biographer makes clear. In one of his writings he

... admits to having known only the women of Kham and Tsang in Tibet. 'The Khammo are soft and passionate and the Tsang-mo have good technique and are active on top.' He left a blank space in the manuscript for his compatriots ('old men with yellowing bodies who have the experience of the country') to add their own commentary on the women of Tibet.[31]

Chöpel's interest in the subject matter of stage six of the *khor lo* is thus without doubt, but in arguing the case for his authorship of the Tharpa Choeling mural analysis of the formal signature is more conclusive. From a stylistic point of view, the Tharpa Choeling painting bears comparison with Chöpel's sketchbook which includes studies of naked couples drawn with an economical and vivid use of line.[32] Their simplicity is reminiscent of the modernist paintings by Santiniketan artists such as Nandalal Bose, who sought to expunge the heavy elaborateness of academic realism from his work. Chöpel's sketchbook also includes line drawings of shooting figures which may have been preparatory sketches for the realm of the battling demi-gods in the Tharpa Choeling wheel. This area of the wheel contains a unique fusion of tradition and modernity with some figures portrayed in ancient Tibetan warriors' dress and armed with bows and arrows alongside Spitfire-like aircraft, howitzers and the uniforms of twentieth-century warfare. These incursions from the modern world reflect the imagery of Indian newspaper photography and cartoons, sources readily available to an artist based in Kalimpong or Darjeeling. It seems plausible that just a few years before the Second World War, and only two decades after the First, Gendun Chöpel (or whoever was the designer of the Tharpa Choeling wheel) attempted to demonstrate the relevance of Buddhism in the modern world. According to Buddhist precepts, the demi-gods were doomed to be reborn to fight eternal battles in this section of the karmic cycle because they had envied the power of the gods in a previous life. In the Tibetan Buddhist scheme of things, Hitler and Mussolini would be justly consigned to this kind of hell. Could anyone other than a man who had read of the political turmoil of Europe (and who became a Communist sympathizer) have produced such a commentary? And who other than someone who had been exposed to the modernist imagery of India could have produced such a novel reworking of a 'traditional' Tibetan image? Such a figure would be a rarity in both pre- and post-1959 Tibet. Gendun Chöpel is one of the few who could fit the description.

Chöpel's radical pictorialization is linked with two strands of modernist art practice which can be broadly defined as stylistic and ideological. His treatment of the body demonstrates the formal lessons of modernism, with the essential components pared down and conceptualized, rather than naturalistically observed. On the other hand, the use of imagery drawn from photographic sources and the actualité of news media reflects a modernist desire to comment on contemporary political realities, as was the case in Picasso and Braque's newsprint collages at the time of the First World War. For Indian modernists, the production of a non-traditional art form was a means of expressing both political and aesthetic independence from the colonial past.

Gendun Chöpel's experiments, in which the bonds of tradition began to be dissolved, could have been the precursors for a gradual change bringing modernity into the images of Tibet. Instead the events of the 1950s have created a strange inversion in Tibetan visual culture. The official image of 'Tibet' in exile reifies tradition and ignores the legacy of Gendun Chöpel. Yet in the 'Tibet' of the Autonomous Region of the People's Republic of China, the potentiality of modernism has been grasped by Tibetan artists and activated as a tool of political and creative survival. It is this counter-narrative which we must now turn to.

4 The Chinese Image of Tibet

According to the narrative of exile, Tibetan painting (especially religious or *thangka*-style painting) was either totally banned or became an underground activity in Chinese-controlled Tibet after 1959. Instead, artists who remained in the country were forced to paint hundreds of portraits of Chairman Mao and other heroes of the Communist pantheon such as factory workers, farmers and members of the People's Liberation Army (PLA). A sub-genre of this imported iconography consisted of the portrayal of 'counter-revolutionaries' in which the 'splittist' Dalai Lama often featured. Depictions which portrayed the Tibetan leader as a captive enchained by PLA troops demonstrated the representational power of Socialist Realist aesthetics, in which the truth of the Dalai Lama's escape could be replaced with a fantasy of his capture. Propagandistic images such as these were designed to be viewed as cameos from the 'glorious battle' which would liberate the Tibetan people from feudalism and its equally oppressive bed-fellow, Tibetan Buddhism. Copies of these images have not survived, but other works by Han Chinese artists illustrating the physical and ideological takeover of Tibet continue to be published.

Shi Lu's *Chairman Mao Sends his Emissaries* (illus. 52) reflects this agenda. The still point at the centre of this whirling composition marks the moment of embrace between a Tibetan from Kham and a PLA soldier in the Tibetan capital, Lhasa. A reception committee of monks and lay-people gather around them in an excited throng, joyfully celebrating the arrival of the emissaries of Maoism. This image is clearly intended to function within a revisionist history of the invasion of Tibet, presenting the 'Liberation' of Lhasa as if it were conducted in a party atmosphere, when in actuality the city had been a zone of dissent and rebellion. (In 1959 the Norbulingka had been the site of a riot against the PLA and monks from the nearby monasteries of Sera and Drepung had repeatedly instigated anti-Chinese agitation.) *Chairman Mao sends his Emissaries* is a Socialist Realist confection which presents the arrival of an invading army as if it were a gift requested and gratefully received by the Tibetan people. The ideological strategy of Maoist image-makers is also reflected in the adaptation of a historic genre of Tibetan painting in which Tibetan leaders were shown receiving ambassadors from China. Perhaps the most famous of these, in which the fifth Dalai Lama welcomes the Qing emperor, was painted

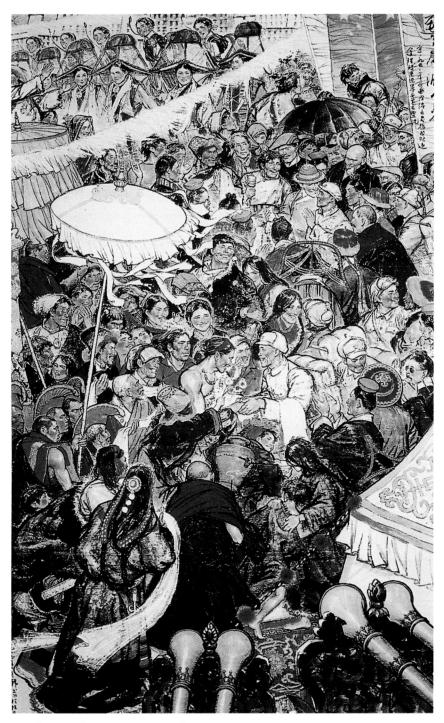

52 Shi Lu, *Chairman Mao Sends His Emissaries*, c. 1970.

on a wall of the Potala Palace. From the Tibetan point of view it commemorated a period of good relations between two independent parties. However, in the post-invasion period the same image has been used in Chinese propaganda publications as 'evidence' of Tibet's historic dependence on Chinese patronage and lack of self-determination. Hence for Maoist viewers *Chairman Mao Sends His Emissaries* represented only the most recent wave of ambassadors sent by China to administer Tibet. But this benevolent vision of the People's Liberation Army was clearly not shared by Tibetans, otherwise the need for such cheery representations would surely not exist. The fact remains that, from within the Maoist arsenal, images were tactically deployed in the battle to win Tibetan hearts and minds.

It is thus little wonder that 'post-invasion' styles of painting are held in contempt in Dharamsala. For Tibetan exiles they signify the incursion of an expansionist ideology and a dangerous alien aesthetic. These styles are associated with a representational invasion which was explicitly designed to eclipse 'traditional' Tibetan ways of seeing and depicting. Hence the desire for appropriate style in exile and the need to assert the 'uniqueness' and 'purity' of Tibetan culture preserved in the diaspora. Additionally, as we saw, the demand for similarity with the Tibetan past was forged from a requirement for explicit difference from China – past and present – as Jampa Tseten found to his cost. However, the history of Chinese images of Tibet is not readily available in Dharamsala or elsewhere in the exile community, and this vacuum has tended to be filled with an assumption that all 'post-invasion' imagery was Socialist Realist in style and content. Though it is not possible to pursue a comprehensive survey of Chinese paintings of Tibet here, I include an examination of some key examples from the period just preceding the Dalai Lama's departure up to the 1980s, in order to demonstrate that the Chinese image of Tibet has evolved from a concern with a colonizable territory to the depiction of an exoticized minority community.

Some may find the mere consideration of this topic unpalatable and politically suspect, but it seems to me that alongside the narrative of exile, the parallel history of image-making in and about the Tibet Autonomous Region (TAR) needs to be told. After all, this history inheres within the cultural landscape which the majority of Tibetans currently inhabit. For them it is impossible to avoid the impact of the aesthetic codes which Chinese artists brought to bear on them. The legacy of Socialist Realism is evident to this day, if in watered-down form, in the advertising hoardings and posters for governmental education campaigns on the streets of Lhasa (illus. 53). For TAR Tibetans it is

difficult to make an explicit bi-partite differentiation between China and Tibet and so, though my narrative begins with Chinese artists dominating the production of images of Tibet, it later includes the entanglement of TAR Tibetans with this imaginary locale. It is generally agreed among exiles that a TAR Tibetan who chooses to become a painter will, perforce, become a Socialist Realist. However, as the story of the image of the TAR illustrates, Tibetan artists have met the challenge of being a member of a 'minority' community of the People's Republic with varying degrees of acquiescence. Some have even attempted to turn the weapons of the Chinese artists' arsenal against them. In examining these gestures we must return to a key question. Are those who live in the TAR and their works to be denied the label 'Tibetan'? Must the use of an alien aesthetic always imply cultural treachery? In order to answer these questions we must first establish just what that alien aesthetic consisted of.

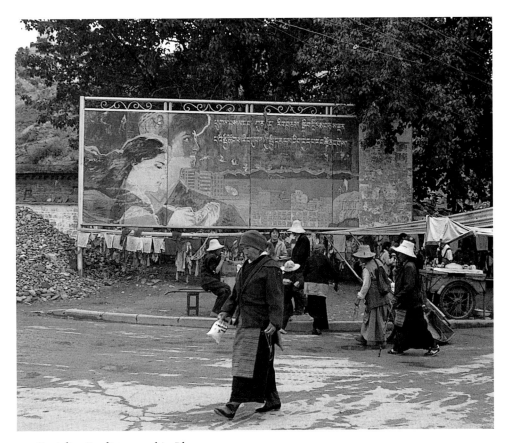

53 Socialist Realist mural in Lhasa, 1993.

Socialist Realist Tibet

To date very little documentation of the 'art world' of Tibet under Chinese rule has been published,[1] making it difficult to illustrate the attitudes of those who produced and consumed images. At least one fact can be asserted: the styles and subject matter of painting were abruptly, some would say brutally, altered beyond all recognition to those acculturated according to pre-1959 visual codes. It is no doubt true to say that the majority of images produced in Tibet prior to 1959 were designed for religious purposes and depicted religious subjects. What might be called more secular forms of art such as portraiture did exist, however, although this was reserved for high-ranking members of the religious community, royalty and aristocrats and was decidedly non-realist. Self-portraits, on the other hand, were unheard of. The life styles of ordinary people were rarely documented, with the exception of decorative panels in wall and furniture painting. Landscape, except in the form of topographic views of monasteries and backgrounds for *thangka*s, did not occur as a distinct genre for Tibetan painters. Yet when Han Chinese artists first started to represent Tibet, the two categories just described (the portrayal of 'ordinary' individuals and the land which they inhabited) were predominant. With the notable (and rare) exceptions of Jampa Tseten and Gendun Chöpel, Han Chinese artists were thus the first to depict Tibet and Tibetans in a modern, secular idiom though their choice of these topics was made for ideological as much as aesthetic reasons.

Therefore when exiled commentators on visual culture refer to 'post-invasion style' they have a specific type of image-making in mind. This is the Socialist Realism of Maoist China which for them was clearly designed to obliterate the fine traditions of Tibet. The roots of Socialist Realism lie in European history painting, from which artists in the Soviet Union devised an explicitly ideological type of realism. For the leaders of the Russian revolution, only a form of realism could truly fulfil the moral imperatives issued to artists 'to interpret, reflect and change reality'.[2] Hence a Socialist Realist work could be defined as one produced in order to create the 'reality' of a Socialist state with the didactic intention of liberating the masses. In 1934 Joseph Stalin conferred official status on the style and thereafter the Socialist Realist aesthetic was adopted by other nations as they embraced Communism. Mao Zedong's *Talks at the Yan'an Forum on Art and Literature* emphasized the need for popular art forms which would 'convey the positive aspects of life under the Communists'.[3] Hence when the Maoists came

to power in China in 1949, the Vice-Minister for Cultural Affairs, Zhou Yang, swiftly implemented policies which drew upon the example of Soviet Socialist Realism. His dedication to the Soviet Union was clear when he stated that the Chinese 'must learn from other countries and especially the Soviet Union. Socialist realistic literature and art [. . .] are the most beneficial spiritual food for the Chinese people and the broad ranks of the intelligentsia and youth'.[4] Henceforth artists throughout the People's Republic were to produce appropriate imagery for the proletariat in order to introduce a radical new code of personal and social ethics. Zhou Yang's policies were especially indebted to the Russian theorist Malenkov, for whom the worker as hero was to be the primary subject of Socialist Realist art.

But the political rhetoric did not specify the details of depiction. Revolutionary artists in China first learnt their trade by following the example of Russian artists such as Ilya Repin (1844–1930) and other members of the anti-Tsarist artists' group 'The Wanderers'. In the 1920s and 1930s, the critic Lu Xun promoted the work of Soviet Socialist Realist printmakers such as Vladimir Favorsky (1886–1964), Alexei Kravchenko (1889–1940) and Pavel Pavlinov (b. 1881). Their style was deemed to have brought a monumental and epic quality to the portrayal of contemporary proletarian life which Chinese painters and print-makers could emulate. On occasion the debt to the Soviets was great, as was the case when Kravchenko's *Sluice on the Dnieper River Dam* was employed as a prototype for *Searching in the Ruins* by Huang Yan (made between 1937 and 1945).[5] Style and ideology coalesced in the dramatic illustration of the urban and industrialized landscape peopled with an empowered proletariat. The primary responsibility of the Socialist Realist artist lay in recording the activities of their fellow workers in images which would help to bring a modern, Maoist state into being. Hence when 100,000 workers were deployed on the Ming Tombs Reservoir project in the late 1950s, a large group of artists accompanied them to depict the construction process. Their paintings were displayed at the reservoir site, to boost morale among the workers, as well as in Beijing, where paintings of this sort were exhibited in order to inculcate the unifying national ideology of Maoism. From 1950 onwards, as Tibetan territory became part of the People's Republic, Tibet and Tibetans were also absorbed into the iconography of the Maoist state.

Framing the Colonized: Maoist Depictions of Tibet

Socialist Realist paintings of Tibet were primarily designed to be consumed by the majority Han Chinese population of the People's

Republic of China (PRC) in urban centres such as Beijing. When displayed in the capital they brought the 'reality' of a community at the periphery of the Maoist empire into the consciousness of those at the centre. The first such images emerged during the period when control of the eastern regions of Tibet was assumed by the PLA (1950–55) and when the government had instituted a policy in which the population of the People's Republic was classified according to *minzu* or 'nationality'. Each 'nationality' was to be ascribed a place on a scale of greater or lesser degrees of 'civilization', emulating a 'scientific' model of social progress derived from the Soviet Union.[6] Lower-ranking 'nationalities' could then be led towards the higher plane of civility embodied in the Han Chinese, who by dint of being both modern and Maoist were at the top of the scale. According to these principles the peripheral Tibetan 'nationality' was in dire need of conversion to the standards of modernity 'enjoyed' by those at the centre (i.e. Han Chinese), and the skills of Han artists (to research, document and depict) could be used to chart progress towards this end. Depicting Tibetans as underlings in need of redemption for the audiences of Beijing and other cities helped to justify the physical and epistemological colonization of Tibet. Where Western explorers had used the indexicality of the camera to document the exotic inhabitants of the Tibetan plateau, expansionist China used the ideological apparatus of Socialist Realism to objectify its subjects.

The artist responsible for *Chairman Mao Sends His Emissaries*, Shi Lu (1918–1982), was clearly one of those engaged in the project of documenting the lives of the inferior 'nationalities' (a synonym for ethnic minorities). His 1954 painting *Outside the Great Wall* (illus. 54) depicts a clutch of bucolic characters revelling on a hillside in fur-lined coats (possibly *chuba*, traditional Tibetan robes) and admiring the landscape which unfolds before them. The Great Wall snakes across the scene, like a segment of the classical architecture so favoured in the history paintings which inspired Socialist Realism. But the contours of the People's Republic are also shown to be incised by the sharp trajectory of modernity in the form of a railway line. *Outside the Great Wall* is an illustration of the power of Maoist ideology and endeavour, for it refers to an inversion of the historic symbolism of the Great Wall as a monument to segregation, protecting the Han Chinese from marauding hordes. In Shi Lu's work those barbarian outsiders (such as Tibetans and other minorities) are to be brought in from the cold through the advances of Maoism, here represented by a railway building project. The image is an essay in pride at both past and present achievements. The Great Wall acts as an expression of long-standing Chinese skill in engineering, with the railway as its modern-day equivalent enabling

54 Shi Lu, *Outside the Great Wall*, 1954.

the triumph of culture over nature, as 'primitive' herders are assimilated into mainstream culture through a modern transportation system. The democratizing force of such technology is depicted as an event to be celebrated by the average man in the street or field. Be he Tibetan or Han Chinese he has, scored across the landscape, visible proof of the power of the People's Republic and of the engineering which underpinned the movement of people and goods from the centre to the peripheries of the Motherland.

Spring Comes to Tibet

This theme of an ideologically charged topography is also evident in one of a thousand works from the first wave of Socialist Realist painting under Mao's regime. Among the exhibits in the Second National Art Exhibition held in Beijing in 1955 was a work by Dong Xiwen (1914–73) entitled *Spring Comes to Tibet* (illus. 55). Completed in 1954, the painting depicts a group of women in Tibetan dress at work in the fields surrounded by blossoming apricot trees and a vista of a wide Tibetan valley. A road curves out of the middle distance with a convoy of vehicles

wending its way towards them. For Maoist viewers, elements of this composition would undoubtedly also be read as scenes from a political narrative in which the 'liberated serfs' move towards modernity. The fecundity of the land, and in particular the blossoming trees, functions as an emblem of the successful harvest to come – a harvest made possible by Communist farming methods. The inclusion of the road is no mere illustrative detail or compositional device, but a metaphor for the incursion of the Chinese revolution into Tibet. Roads of this calibre, capable of sustaining the weight of a convoy, were a decisive factor in the annexation of Tibet. In October 1950 the People's Liberation Army had captured Chamdo and gained control of eastern Tibet, so it seems likely that *Spring Comes to Tibet* was executed from studies made in the comparatively accessible eastern areas of Kham or Amdo. (By the time this picture was displayed in Beijing the first motorable highway to Lhasa had been completed.)[7] The paths of artists retraced those of the PLA following Mao's entreaty at Yan'an that they should travel and document the lives of their fellow workers. When these workers were Tibetans, their images also had the effect of placing the colonized within the national frame.

Although *Spring Comes to Tibet* is undoubtedly 'realist', and 'Socialist' or rather 'Maoist' in ideology, it is not drawn in the harsh-edged style of Soviet influence. The picture refers back to the roots of Socialist Realism which are to be found in history painting (as defined by Sir Joshua Reynolds in eighteenth-century England) as well as the works of French Realists such as Millet and Courbet. Ironically, Dong Xiwen's style is particularly reminiscent of the French nineteenth-century landscape painter Corot, whose gentle evocations of the French countryside punctuated by the occasional cluster of peasants toiling on the land ultimately became popular among the urban bourgeoisie. The use of a more lyrical Socialist Realism for a Tibetan scene reflects a Han notion of Tibetan ethnic identity as somehow bound to the land on which they work. During the 1950s Han Chinese artists were commandeered to assist in the effort to increase agricultural production all over China by depicting happy farm labourers. Feeding the People's Republic was not an easy task and mobilizing the workforce required a shift in the ideological positioning of landscape on the part of artists and politicians. Where in pre-Maoist Chinese painting nature had provided a relatively neutral backdrop to the human narrative or had been enjoyed for its aesthetic appeal, as in 'bird-and-flower' genre painting, under the new regime nature was to be shown as a force to be reckoned with and preferably defeated. The traditional theme of the cycle of the seasons was replaced by more prosaic images of the sequence of the Socialist

55 Dong Xiwen, *Spring Comes to Tibet*, 1954.

farming year. In Chao Mei's print *Spring Returns* (illus. 56) of 1964, a traditional motif from the natural world of cranes flying east (symbolizing longevity) is retained but superimposed on a modern agricultural scene in which two tractors carve up fields in preparation for spring planting. The drivers are anonymous workers unified with the machinery which makes the Maoist dream possible. Nor is their ethnicity at issue, since they are Han Chinese members of a commune of the Motherland, whereas in Dong Xiwen's image the 'ethnic minority' (nationality) status of the Tibetan women is emphasized in their dress and simple tools. Clearly when spring came to Tibet in 1955, it had yet to become fully modernized and Maoist.

Spring Comes to Tibet presents a vision of a relaxed, even languid life in Maoist Tibet which conforms with the soft-focus Socialist Realism that Han Chinese artists assigned to 'minority' groups in general.[8] The minority nationalities were placed at the lower, but undoubtedly more picturesque, end of the civilizational scale and their closeness to nature inspired a romantic and exoticizing pictorial style. But this soft Socialist style masks the harsh reality of Chinese demands on Tibetan land and Tibetan labour. *Spring Comes to Tibet* celebrates the fertility of the newly conquered Tibetan plateau which was soon to become the

56 Chao Mei, *Spring Returns*, 1964, wood-block print.

'bread basket' of China, providing cereals for the millions of the Motherland. As a result, Tibet's natural resources were exploited at such a pace that only four years after the painting was exhibited (at the beginning of the Great Leap Forward in 1958), it was in the grip of famine. The land had been overstretched, crops had failed or were requisitioned to feed the People's Liberation Army and non-Tibetans elsewhere in the PRC. As a consequence thousands of Tibetans died of starvation. The Maoist project to bring such a 'minority' up to the standard of living of their Han Chinese superiors had clearly become a vicious farce. Hence *Spring Comes to Tibet* now stands as testimony to the acquisitiveness of expansionist China, for whom the projection of Tibetans as passive occupants of a fecund land readily commandeered by China was a useful propaganda tool. This pastorale presents Tibet as if it had slumbered through the events of the 1950s, when in fact it was invaded and despoiled.

'The Wrath of the Serfs'

With the disastrous events of the late 1950s in mind, it is no surprise that the landscape of Tibet once again provided the backdrop for Socialist Realist dramas during the Cultural Revolution (1966–76). A Beijing publication of 1976 described it as a 'beautiful place, rich in natural resources' and populated by an 'industrious and brave people' (in vocabulary eerily similar to that used by Warren Hastings two centuries earlier).[9] However it seems that the colonization of this 'beautiful' country and the Maoization of its 'brave' people needed to be depicted and demonstrated to the populace. In the early 1970s a team of artists from the College of Fine Arts of the Central May Seventh

Academy of Arts in Beijing were selected for this task. They travelled over five thousand kilometres to investigate the conditions within Tibet and '. . . listened to the angry condemnation of past sufferings by a hundred liberated serfs, asked for suggestions from former poor and lower-middle class peasants and herdsmen and improved their works on this basis'.[10] These 'works' consisted of over a hundred life-size clay figures and photorealistic painted backdrops which were assembled in an exhibition entitled 'The Wrath of the Serfs'. The show charted a sequence of events, set in locations such as the Potala Palace, a monastery (described as a 'lamasery'), the house of a government official and a 'feudal manor'. These *tableaux vivants* were designed to illustrate the sufferings of the Tibetans in pre-1959 Tibet in a highly theatrical realism (emulating the impact of revolutionary opera). Mao's *Talks at the Yan'an Forum* were cited by the artists as the source for their combination of 'revolutionary realism and revolutionary Romanticism'. The exhibition focused on the purported iniquities of two powerful male-dominated institutions, the monastic establishment and feudal landownership, but the greatest condemnation was reserved for monks, who were accused of hacking limbs or stripping flesh from the bodies of 'serfs'. Cannibalism was said to be one of their habits and photographic 'evidence' of thigh-bone trumpets ('removed from the bodies of live serfs') and what was claimed to be 'the mummified body of a female child' used as a sacrifice in a religious ceremony were included in the exhibition catalogue (illus. 57). In order to elicit empathy from the audience, 'The Wrath of the Serfs' emphasized the tribulations of children (put into boxes to be cannibalized) and women, who stoically stand by as their husbands struggle or their children starve. However, in later parts of the cycle, female figures appear as victors instead of victims. In their 'wrath' they lose all traces of Tibetan physiognomy, for they have become the anonymous heroines of Socialist Realism (illus. 58). For the producers of the 'Wrath of the Serfs' the deracination of Tibetans was a means by which they could be affirmed within the official imagery of the Republic. Tibetans were no longer picturesque pastoralists but Maoist protagonists in their fate.

The format of 'The Wrath of the Serfs' was by no means unique and had been tried and tested in a number of other ideological battles. Under the influence of Soviet Socialist Realist sculpture, life-size clay images had been produced in mainland China since the mid-1960s. In 1965 the 'Rent Collection Courtyard' was set up by a group of artists in the abandoned mansion of an ex-landlord. (Designed to be anti-elitist in style and location, this was not art for the gallery but a public statement for the masses.) In this case, the life stories of the Chinese masses who

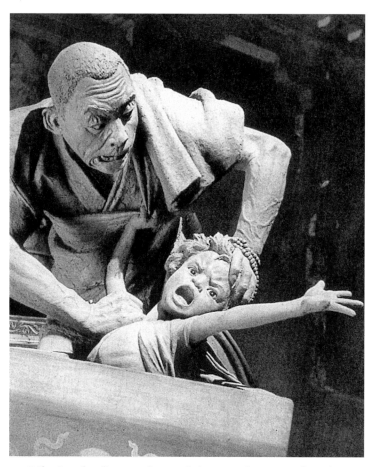

57 Life-size clay figures of a monk forcing a boy into a box, from 'The Wrath of the Serfs', 1976.

had experienced bonded labour before the Cultural Revolution were narrated. Pivotal events were portrayed in the style of high melodrama so beloved of propagandists aiming to enrage an audience. The 'Rent Collection Courtyard' (illus. 59) served as a reminder of the iniquities of the feudal system in which it was claimed that peasant farmers were forced to sell their daughters to the landlord and to mortgage their crops for 60 years in advance. Other topics chosen for such treatment were pre-Liberation conditions in sweat shops and a series which re-created 'The Air Force Man's Family History'. By comparing themselves with their clay compatriots, the members of Maoist communes were to have their faith in the Revolution bolstered, and the mimesis of Socialist Realism was the perfect tool for such a project. Such works were

intended to evoke agreement with the actions of the government and the People's Liberation Army. The fact that Tibet was the subject of such a cycle indicates that propaganda of this nature was still needed in the mid-1970s to convince both Tibetans and Chinese of the conclusiveness (and correctness) of the Chinese takeover.

'The Wrath of the Serfs' now appears rather like the diorama displays of 'dead' cultures in Victorian museums, but the original intention was to evoke an actuality which would appear very much alive to its viewers. Why should such a demonstration of Tibetans triumphantly freeing themselves from feudal shackles to become joyful and fearless members of the People's Republic still be needed twenty years after the annexation of Tibet into China? The exhibition was revealed to the public at a critical juncture in Chinese history. It appeared in Beijing and Lhasa in 1976, the year in which Mao Zedong died and the Cultural Revolution came to an end. The use of such a display in the Chinese and Tibetan capitals echoes the intentions of the Ming Tombs Reservoir project where images were deployed to boost the workers' commitment to the Socialist project and to create unity between centre and periphery. 'The Wrath of the Serfs' presents Tibet as if it too were a glorious construction project which, owing to the leadership of

58 Clay heroes and heroines of Socialist Realism, from 'The Wrath of the Serfs', 1976.

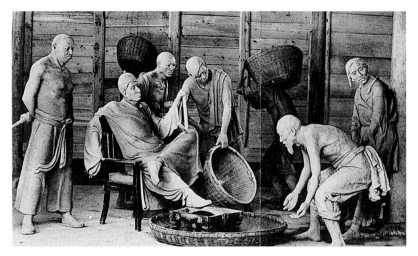

59 'Rent Collection Courtyard', 1965, life-size clay figures.

Chairman Mao, had been remodelled into a modern, Socialist utopia. It is difficult to establish how Beijing audiences responded to the exhibition: perhaps for them it provided a fitting tribute to the departed architect of China's success in territorial expansion. In Lhasa, the propagandistic intentions of the show were augmented by Tibetan attendants who provided a commentary for visitors at the 'Museum of the Revolution'. One of those guides described the

... displays of life size clay statues depicting the evils of the old, 'pre-liberation' society. There were dramatic portrayals of landlords exhorting landless peasants, beggars living in caves, and monks abusing the whole of society.[11]

Presumably many of the Tibetans who visited this house of horrors had, like one of the attendants, Gongkar Gyatso, been born after 1959 and had only known Tibet under Maoism. They had not experienced 'pre-liberation' Tibet and were ready fodder for Cultural Revolutionary indoctrination. Evidently the power of Maoist 'organized forgetting' was all pervasive, for it appears that the older generation who could have counteracted this reinvented history were silenced at this time. Gongkar Gyatso admits that he was impressed by the 'revolutionary realism' of the show and only later began to question the fabricated narrative which accompanied it. But during the Cultural Revolution he

... had to explain that when a new monastery was built, a child was put into a box and buried alive in the foundations. I completely fell for this and though I had no idea what religion was, I thought it must be a terrible thing.[12]

134

The 'Wrath of the Serfs' was presented to the Tibetan public at the close of a period when monasteries, temples and objects associated with the practice of Tibetan Buddhism had been systematically destroyed. The exhibition sought to justify these acts and to fill the void with a representation of a secular Tibet peopled by proud Socialist Realist heroes and heroines.

The Workers Weep Though the Harvest is Good

However inaccurate and propagandistic Chinese depictions of Tibet may now appear, they were clearly instrumental in transmitting ideas about the place to non-Tibetans elsewhere in the Motherland. In the 1960s a Han Chinese artist from Shanghai thought that Tibet could provide a safe haven from the persecution he was experiencing at home. At the start of the Cultural Revolution Chen Danqing's father had been labelled a reactionary and his family was purged for holding 'rightist' sentiments. When the family home was attacked by Red Guards in 1966, Danqing realized that his attempts to pursue a career as an artist would be continually aggravated by political obstacles. He was repeatedly refused access to art schools and for a time resigned himself to becoming a painter of coffins instead. However, during this period he met and married an art student, Huang Suning, and the two of them decided to weather the ravages of the Cultural Revolution in Tibet, where Suning had gained a place on a work unit. As a member of such a unit she was clearly required to toe the party line and produce images which reflected the approved Socialist Realist vision of Tibet. Hence her painting When the People Marched . . . (illus. 60) presents the colonization of Tibet as benign, with smiling Tibetans receiving the 'good news' of Communism. It depicts a re-education session wherein the history of China's move towards Communism was revisited and memories of events such as the 'Long March' of 1934–6 were revived. Suning's work also emphasizes the communion of a group of nomadic Tibetan women, enveloped in thick woollen garments and surrounded by yaks, and their acceptance of a female soldier (who is shown teaching a Tibetan woman to write 'PLA' in the earth). An interest in female dress and gender in general had been a favoured topic for Chinese artists working in Tibet (the picturesque workers of Spring Comes to Tibet were women) as it was a recurring theme of early Socialist Realist portrayals of all the 'nationalities' of the PRC. Portraiture was part of the wider project to record the ethnic types of the People's Republic in an effort to itemize and display their characteristics (similar to that used by the British Raj to document caste and ethnic types of the sub-continent for consumption

60 Huang Suning, *When the People Marched . . .*, c. 1970.

by the colonizers) and women were more frequently portrayed than men. Their depiction in local dress (in the case of Tibetans in the *chuba*) placed them in a generic 'ethnic' category and pointed to their 'innocence' of the civilized dress of mainstream Maoist society, i.e. the Mao suit worn by Han Chinese men and women. Occasionally Tibetan women were represented as the beneficiaries of Communist modernization – as was the case in a Socialist Realist print depicting a vet listening to a yak's heart through a stethoscope (though she still wears 'traditional' dress) (illus. 61). More commonly they are rendered in rather saccharine Socialist vein as in Zang Changgu's *Two Lambs* of 1954 (illus. 62). Here the exotic female minority 'other' is eroticized by the contrast drawn between her thick coat and exposed, bare feet. Clothing which protects Tibetans from the harshness of the environment appears in many Han Chinese paintings as a signifier of the wilderness aesthetic associated with Tibet. For Chinese colonialist artists an equation is drawn between Tibetan bodies and the Tibetan land, defining both as sensual, supine and eminently assailable.

Huang Suning's partner, Chen Danqing, also spent much of his time in Tibet making studies of the 'minority' people who surrounded him and which he later worked up into a series of oil paintings for which he became famous both within and beyond China. (His reputation as one of the foremost Chinese painters of the twentieth century had been

well established before he left the PRC in 1982 to live in the United States.) His fame was generated by portraits such as *Five Tibetan Cowboys* (illus. 63) and *Tibetan Mothers and Children* (1980), which were based on drawings made in Lhasa during the Cultural Revolution. It is difficult to place these paintings within the history of Chinese images of Tibet, for Chen Danqing's biography suggests that he was by no means a wholehearted supporter of Maoism. It therefore seems unlikely that he viewed Tibetans as mere marionettes in a theatre of propaganda. His style is neither that of the Sino-Socialist Realist nor of the saccharine, ethno-kitsch variety which was the norm among other Han Chinese painters. His *Five Tibetan Cowboys* (who are in fact a group of Khampa men) of 1980 is executed in a grimy realism which deflates romanticism. Four men face the viewer with an air of defiance, even hostility, while another presents his back to the audience focusing attention on a knife, an emblem of the Khampa reputation for strength and fighting prowess. Though it is difficult to establish Danqing's attitude

61 Anonymous Chinese artist, *The Vet*, wood-block print, *c.* 1970.

62 Zang Changgu, *Two Lambs*, 1954.

to his subjects, these paintings at least present a more robust vision of Tibetan life in the post-invasion period.

Chen Danqing's Tibetan paintings raise questions about the relationship between individual artistic intentionality and state control of art in a Communist state. Danqing has been revered as a unique individual with an exceptional style and distinctive subject matter. His Tibetan portraits appear in Western publications without any political contextualization, as if this Chinese Rembrandt operated at some remove from the ideological imperatives which beset others. But he was responsible for at least one image which appears to confirm the attitudes of the regime in Beijing. In 1978, with the Cultural Revolution over and the 'rightist' label removed from his family, Chen Danqing left Tibet and joined a post-graduate course at the Central Academy of Fine Arts in Beijing, where he later became a teacher and produced his famous paintings. However, at some point before this rehabilitation he produced *The Workers Weep though the Harvest is Good: 1976.9.9* (illus. 64). The title of the painting may at first appear cryptic. Why should the workers lament a successful harvest? The answer lies in the figures which designate the date of Chairman Mao's death at midnight on the ninth day of the ninth month of 1976. When reports of the

138

63 Chen Danqing, *Five Tibetan Cowboys*, 1980.

64 Chen Danqing and Nawang Choedrak, *The Workers Weep though the Harvest is Good: 1976.9.9*, 1976.

leader's demise were released to the nation, workers throughout China are said to have downed tools, bringing the country virtually to a state of shut-down. Chen Danqing's painting records the moment when a group of Tibetan labourers out in the fields received the news on their radio. This piece of modern apparatus, as well as the truck and combine harvester beyond, are critical components of the painting's symbolism. They function as expressions of Mao's policies in action: the tools by which the harvest is made possible and the medium through which the nation unites in communal joy or, in this case, grief. The colour range reiterates this point, for the image is saturated by the golden glow of the ripened crop waiting to be reaped by a combine harvester of deepest Maoist red. The Socialist Realist influence on this painting is also evident in the posture of the worker holding the radio, who could easily have been modelled on the statuesque heroes of Soviet sculpture. In fact, though the sequence of the agricultural year in the communes was a well established subject for artists in the PRC, *The Worker's Weep* shows greater affinities with a painting entitled *Corn* by Tatyana Yablonskaya which won the Stalin Prize in 1950. The Soviet artist gained official approval for her depiction of the success of Communist farming methods because she had spent some time labouring on a collective farm. (She had also denounced her earlier Impressionist

paintings as 'bourgeois'.)[13] Chen Danqing's direct experience of life in the TAR meant that he was also eminently well qualified to show Tibetans literally reaping the rewards of the new political system and devastated by the loss of its architect. *The Workers Weep* was undoubtedly commissioned for ideological purposes in order to demonstrate that minority communities such as the Tibetans grieved for Mao as much as other members of the People's Republic. Whether they did or not is a matter of dispute, but the historical record certainly suggests that Tibetans had little cause to thank Mao for his interest in their country. Hence this painting must be firmly placed within the category of Socialist Realist propaganda of the kind which blatantly manipulates history.

However, there is some evidence within *The Workers Weep* to suggest that Chen Danqing may not have embraced the role of mouthpiece of the State with alacrity and that not all Tibetans succumbed to the emotion of the national calamity. An almost invisible detail in the painting supports this idea. Attached to the *chuba* of a woman propped against a hoe is a badge. Its definition is indistinct but it appears to show a man's head, a flash of a yellow garment and a pair of black glasses. This is not the attire of the dead Chinese leader, but of the Dalai Lama. As we have noted before, the display of images of the exiled Tibetan leader was a punishable offence in the People's Republic and a sign of pro-independence sentiments on the part of the wearer. Should we read this as a clue to Chen Danqing's political affiliations? Do other elements of the composition (a clenched fist and sheathed knife) refer to the impotence of Tibetans as political and cultural subjects? As a member of a purged family who had escaped to live among Tibetans, perhaps it is not too far-fetched to suggest that Chen Danqing was at least sympathetic to the idea of greater independence for Tibetans. After all he had witnessed the conditions in which they lived during the terrible years of the Cultural Revolution and had experienced the oppressive force of Maoism in his own life. Finally, when *The Workers Weep* was published in a Chinese publication it was attributed to Chen Danqing and a Tibetan, Nawang Choedrak. The phenomenon of such Sino-Tibetan collaborations will be explored in the following chapter. In the meantime, we must note that back in Beijing Chen Danqing's success in producing an earthy, realist image of Tibet had a dramatic impact on both Tibetan and Chinese artists alike.

Anti-Revolutionary Romanticism

After the death of Mao in 1976 and the demise of the Gang of Four, the explicitly propagandistic drive behind art production throughout the

People's Republic began to wane and the need to convert Tibetans to the ideology of the Motherland was apparently less pressing. By 1985 the Beijing publication *Nationality Pictorial* could even include a picture entitled *Happiness Ballot* in which a Tibetan 'is portrayed as happily voting, as if Tibetans really did control their own destinies'.[14] However, a number of Han Chinese artists continued to visit Tibet. In the 1980s their journeys were no longer prompted by the need for 'study and investigation' to furnish propaganda, as it had been for the 'Wrath of the Serfs' collective. Instead artists reverted back to the romantic dream of the Tibetan landscape and its people. The enormous river valleys and plains of Tibet provided a tantalizingly different environment for urban Chinese painters and inspired changes in palette and style, just as Gauguin had felt released from the tyranny of European landscape traditions by the experience of the South Seas. As had been the case in the development of Western primitivism, the inhabitants of the Tibetan plateau continued to be perceived as alluring and exotic to increasing numbers of artists and the explicitly revolutionary aspect of 'revolutionary romanticism' began to diminish.

Those who had trained in Chinese art schools in the late 1970s had been exposed (through publications, exhibitions and lectures) to recent paintings from North America and another manifestation of realism, this time of what might be called a 'pastoralist' variety. The work of the American painter Andrew Wyeth, which celebrates the sparsely populated landscapes of the United States, became particularly popular in cities such as Beijing and Shanghai. The accuracy of his brushwork, creating a mess of fine lines, may have appealed to Chinese artists with a residual penchant for traditional calligraphy. But it was Wyeth's treatment of the human form, in which his subjects appear as if illuminated by a crisp, even daylight that Chinese artists most admired. A historian of Chinese art, Michael Sullivan, argues that it was the fact that this 'cool realism' was 'free of ideology' which appealed.[15] However, though Han Chinese artists of the 1980s had firmly abandoned Soviet-style Socialist Realism, their works may still be deemed ideological. Sullivan (in very Enlightenment empiricist mode) appears to believe that a Western mimetic style is somehow automatically a tool of democracy and reason, irrespective of who uses it and on whom. By describing a number of Chinese paintings of Tibetans purely in terms of their proximity to Western styles, Sullivan ignores the politics of such representations. In 1983 Ai Hsuan (b. 1947), a product of the post-Revolution realist school of Sichuan, produced *A Not Too Distant Memory* (illus. 65). Undoubtedly heavily influenced by Wyeth, the painting depicts a Tibetan girl standing alone in snowy wastes with a glimpse of a

mountain (perhaps Kailash) in the distance. Though the treatment is not explicitly Socialist Realist, this image refers to a familiar theme in Chinese artists' conceptions of Tibet: the romance of a colonized and yet still not fully modernized Tibet. If there had been a change of approach between the images of the 1950s and those of the 1980s, the image and title of Ai Hsuan's work suggest that Han Chinese artists now suffered from a sense of loss and had begun to envy the natural, simpler life of their 'minority' neighbours.

In fact, realism can rarely escape connections with ideology, as its 'cool' veneer seems to reflect the position of its viewers. When faced with realist images of the human form, Western authors often subconsciously resort to the concept of the 'pathetic fallacy' in which the natural world is seen to reveal and reflect emotion. On the other hand some Chinese viewers trained in Socialist Realist aesthetics see only actors in a political drama. Comparing the comments of an American and a Chinese critic who both describe what they believe to be the thoughts and emotions of a painted Tibetan woman reveals the mutability of readings of the 'real'. In *Earthline* (illus. 66) by Yuan Min (b. 1963) a young Tibetan woman is examined through the purportedly non-ideological lens of realism. The painting, once again influenced by Wyeth, with a dramatic landscape setting framing a near life-size face in the front plane of the picture, was extremely popular when exhibited in the Sichuan Artists Exhibition at the National Art Gallery in Beijing in 1984. Joan Cohen, an American who helped to bring exhibitions of Western art to China and then published a book, *The New Chinese Painting*, describes the image as depicting a 'nubile young Tibetan herdswoman' who is 'windblown and glamorous, standing on the high plateau, which appears convex in the clear distance, she is as beautiful as a movie-magazine star'.[16] For Cohen the exoticism of the girl is accentuated by the overpowering landscape, emphasizing her vulnerability in terms of the stereotypic inhospitable, 'roof-of-the-world' Tibet. By contrast the comments of Cai Zhenhui, Associate Dean of the Sichuan Art Academy, are (for Cohen) blatantly political:

The poor herd girl is happy because the day has gone well. Her dreamy expression suggests her vision of a new China; she is thinking about China's development and prosperity and how herders like herself will have a better life.[17]

Since, as we have established, there is a history in which Tibetans and their landscape have been envisaged ideologically by Maoist viewers, Cai Zhenhui's comment is an unsurprising variant on the 'Wrath of the

65 Ai Hsuan, *A Not Too Distant Memory*, 1983.

Serfs' theme. For him the painting confirms the stereotype of a liber-
ated serf while Cohen, an urban American writer and art dealer, enjoys
the wilderness aesthetic, in which a harsh environment can only
enhance a girl's looks. The 'cool realism' of this image is an empty
vessel into which commentators, both Western and Chinese, pour their
respective idealizations of Tibetans.

But is it possible to reconstruct the intentions of the artist Yuan Min?
Given the relatively relaxed political conditions of the 1980s and Yuan
Min's rejection of an explicitly Socialist Realist style, Cai Zhenhui's
emphasis on a 'happy' and 'dreamy' view of Chinese-controlled Tibet is
rather outdated and unhelpful. The social and political conditions in
which artists like Yuan Min worked had moved on. Harrell identifies
the emergence of 'non-revolutionary' art in Chengdu in the late 1970s
and notes that one of the most popular genres had been 'portraits of
pretty Tibetan women'.[18] He suggests that their appeal as subjects
derived from the notion that minority women were less constrained by
the sexual morals that Han Chinese women observed.[19] (However, I
have yet to come across similar representations of naked Tibetan
women.) In *Earthline*, the Tibetan landscape engulfs its occupants and
appears to push the woman closer to the viewer, as if encouraging a
Pygmalion-like dream to touch and animate her. But Yuan Min encour-
ages the viewer to be both repelled and drawn to the female on the
canvas, for though she may well be an object of desire for an urban Han
Chinese male artist, she also arouses feelings of loss. As Gladney

concludes, the beauty and nobility of minority 'savages' became an important theme for Chinese artists in the mid-1980s owing to the fact that these people were 'unsullied by Chinese political machinations and the degradations of modern society'.[20] This is the spirit which informs the baldly entitled *Tibetan* (1983) by Sun Jingbo (b. 1949) (illus. 67). This portrait was based on photographs taken by the artist during excursions to Tibet from his home in Kunming. There Sun Jingbo lived among a variety of minority peoples and painted them, according to Cohen, because they were 'colourfully costumed and officially approved of'. However, her comments reflect the old Socialist Realist agenda. By the 1980s some Han Chinese artists had cause to envy what they saw as the less rigid and state-controlled lifestyles of the 'nationalities'. In this context, the depiction of Tibet and the bodies of its men and women had become the vehicles for a muted and nostalgic critique of the totalizing state: an anti-Revolutionary romanticism.

66 Yuan Min, *Earthline*, 1984.

67 Sun Jingbo, *Tibetan*, 1983.

68 Anonymous Chinese artist, *The Excellent Doctrine of Tibet*, c. 1988.

In the late 1980s a different type of imagery inspired by Tibetan material culture came into vogue among Han Chinese artists, some of whom had taken up permanent residence in Tibet. Their works were still labelled according to some of the stereotypes of old, in which Tibet was the 'Extreme Land' of harsh environmental conditions, but the titles of other images refer to a new subject: Tibetan Buddhism. The mid-1980s had seen some relaxation of governmental controls on religion in Tibet and Chinese artists responded to this novelty. Clearly they were not privy to the practice and meaning of Buddhism in Tibetan lives for *The Excellent Doctrine of Tibet* (illus. 68) is represented in one image by a kind of cabinet of curiosities: a multi-armed statue of Avalokitesvara, the head of an ibex, a piece of Tibetan cloth and a bowl with two of the eight auspicious symbols of Tibetan Buddhism. Chinese artists began to collect the paraphernalia of Tibetan Buddhism to make their art in a similar manner to the appropriation of ethnographic 'specimens' by European artists at the turn of the century. Similarly, it could be argued that Tibetan Buddhist objects acquired the same kind of cultural currency which attached to African 'fetish' figures when they were transferred to the art markets of Paris and New York. That is, the incomprehensibility of their original cultural context only added to their exotic appeal. The 'aesthetics of decontextualisation'

(Appadurai[21]) are by no means limited to the Western cultural sphere.

The process by which Chinese artists began to consume Tibet as a treasure trove of beautiful objects was largely inspired by a Chinese teacher based in Lhasa. During the 1980s Han Huu Li taught painting at the Lhasa University art school and produced a series of works full of quotations from Tibetan Buddhist imagery. In the early 1980s urban Chinese artists had begun to research the history of art in China and travelled to examine sites such as Dunhuang, where an extraordinary set of early Buddhist paintings had been preserved. Han Huu Li was rather atypical in that he focused his studies on the architecture and painting of the Himalayas and Tibet, though much of his knowledge must have come from photographic reproductions in books. He could not, for example, have visited the thirteenth-century monastery of Alchi in the north-west of India, but in *Blessing* he included direct copies of scenes painted on the massive figure of Avalokitesvara there (illus. 69). Decorated with references to Alchi and surrounded by a cloud-like halo of soft grey wash, Han Huu Li's Buddha image is clearly intended to reflect a hybrid of Chinese painterly techniques (such as washed ink) with citations from Himalayan Buddhist visual culture. Though he could clearly be accused of appropriation, other works by Han Huu Li suggest that he respected and admired the cultural heritage of Tibetan Buddhists and encouraged his students, both Tibetan and Han Chinese, to share this approach. As an art teacher, he was a pivotal figure in the Lhasa art world, since he taught several Tibetans for whom (as we shall see in the next chapter) the rediscovery of their heritage was both an artistic and a political revelation.

From 1950 onwards the exoticism and 'otherness' of Tibet was documented and depicted for consumption by the masses in cities at the centre of the Maoist state. Such objectification of Tibet and Tibetans was one of the means by which the People's Republic defined itself as a nation and could be said to have 'more to do with majority discourse, than it does with the minorities themselves'.[22] Though the power to represent the TAR has remained firmly in Chinese hands (in art schools, work units, publications and exhibitions), shifts of approach over the decades of colonization are evident. As this brief survey demonstrates, Chinese images of Tibet reflect the political climate of their day; hence the Socialist Realism of the Mao period and blatant propagandistic projects such as the 'Wrath of the Serfs' arose at periods of crisis management when Tibet had to be forced into the fold of the Motherland. After the Cultural Revolution this type of image-making was gradually replaced by exoticizing and aestheticizing depictions of Tibet and Tibetans which proved eminently suitable for reproduction

as prints and which could be sold to decorate Chinese living rooms. In the 1980s the erotic 'minority' Tibetan girl became a popular staple of the consumerist spirit of the PRC under Premier Deng Xiaoping. At the more elite end of the scale, artists such as Han Huu Li and Chen Danqing owed their success to the remarkable subject matter they encountered in Tibet. Their debt was partially repaid when they helped Tibetan artists to take up the reins of representation and begin to depict Tibet in their own image.

69 Han Huu Li, *Blessing, c.* 1988.

5 The Tibetan Image of the Tibet Autonomous Region

As we have seen, the image of Tibet conjured up by Chinese artists has little to recommend it to exiled Tibetans and very probably is equally objectionable to the four million Tibetans who remain in the Tibet Autonomous Region (TAR). The exilic community believes that should a Tibetan born after 1959 in the TAR decide to become an artist, he or she has little choice but to become a mouthpiece of the State and a hand-maiden of Socialist Realism. These artists stand accused of treachery. However, the brute fact remains that Tibetans born after the invasion by Maoist China have experienced heavily controlled and radically different social, political and cultural conditions to those of their pre-1959 or exiled compatriots. Just as all TAR Tibetans have been educated in the language of the colonizers, Chinese, so artists have had to learn aesthetic vocabularies totally new to Tibet, such as Socialist Realism. This process begins in childhood, as Tibetan children learn to draw by copying portraits of Chairman Mao into their school books. It could be argued that the imposition of alien art forms is yet another facet of the technologies by which Communist China sought to gain cultural ascendancy and hegemony over Tibetans and that, like the images described in the previous chapter, these new styles further enabled an appropriation of their cultural space. In this climate a Tibetan who wished to become an artist had little choice but to attend Chinese-style art schools and then join an artists' work unit, since all labour in the PRC was organized in this way. Refugee commentators suggest that in the 1960s and 1970s, Tibetan artists were sent to Beijing simply to be trained as propagandists in the Socialist Realist vein. (Though, as we have seen, Jampa Tseten's story provides some evidence to contradict this judgement.) However, in the 1980s, institutions such as the Lhasa University art school employed Chinese lecturers whose teaching reflected the diversified art practice which had come into being throughout the People's Republic, with strands ranging from Socialist Realism, through traditional Chinese painting, to art influenced by Western modernisms. Hence, once again we need to historicize and particularize the situation in which Tibetans produced art under Chinese rule. This chapter considers the evolution of a Tibetan-made image of the TAR, from oppressive beginnings during the Cultural Revolution to attempts to escape the shackles of Chinese cultural control.

The questions which need to be raised when this material is taken into account are these. Is all art produced since the Chinese takeover of Tibet inevitably ideological, and do artists, be they Chinese or Tibetan, automatically concur with the ideology of the State when they employ its styles? Must we assume that all painters are blind followers of political dicta? Is it not possible that Tibetan artists could, in tune with twentieth-century artists worldwide, engage in the formulation of a modern or modernist discourse which includes the capacity for a critique of the political and cultural environment in which they find themselves? While it is reasonable enough to assume that Tibetan artists had no choice but to echo the values of Maoism during the Cultural Revolution and its immediate aftermath (for reasons of expediency and survival), the following decades seem to have presented some opportunities for self-expression.

Sino-Tibetan Socialist Realism

As we have seen, Tibetans quite literally came into the picture during the reign of Socialist Realism. Chinese artists depicted the process by which they became Maoist heroes and heroines battling the combined forces of the elements and feudalism. But they also became producers of images, as when Nawang Choedrak worked with Chen Danqing on the eulogy to the dead leader of the People's Republic. A collaborative method of making images was common in the PRC and has its roots in the Communist ideal of workers' solidarity, in which individuals subsume their distinctiveness for the sake of the common cause. This in itself contrasts heavily with Tibetan artistic practice prior to 1959, where painters were organized according to a hierarchy of junior and senior 'masters' and paid accordingly. Many of the famous figures of Tibetan painting came from a lineage of such master painters, keeping the 'trade secrets' and the status within the family. Also, as a result of their close involvement with religion, prior to 1959 Tibetan visual arts (unlike drama or literature) had rarely been used to narrate or comment upon political events. However, in the 1970s some TAR Tibetans adopted the style and ideology of their Chinese comrades and worked together to produce what is in effect Sino-Tibetan Socialist Realism, a type of painting which is eminently well suited to carrying political messages.

The 'Kanze school' was the joint project of Mis Ting Kha'e (this is the Tibetanized spelling of his name as published by Per Kvaerne), a Han Chinese artist, and Rigzin Namgyal, a Tibetan, founded with the explicit aim of establishing a 'new Tibetan art'. The propagandistic

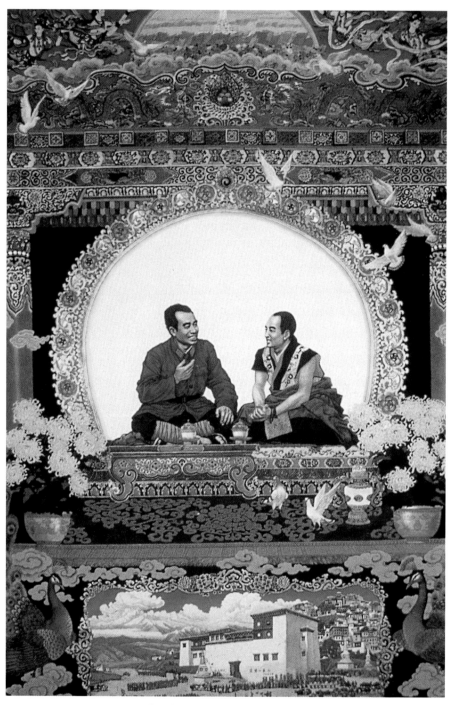

70 Rigzin Namgyal and Mis Ting Kha'e, *The Meeting of the General and the Monk in Kanze in 1936*, 1980.

intention behind this new style of painting is clear in a depiction of the meeting of a Tibetan monk, Getag Tulku, and the Chinese general Chu Teh at Beri monastery in Kanze in 1936 (completed in 1980) (illus. 70).[1] This is a Socialist Realist 'history' painting celebrating the hospitality and assistance provided by Getag Tulku to the general and his troops as they took part in the Long March. It also records the beginnings of a relationship between two powerful figures who were later instigative in the Maoist takeover of eastern Tibet. (Getag Tulku died in Lhasa in 1950 whilst on a mission to facilitate the 'peaceful liberation' of the rest of Tibet.) The painting was displayed along with two others, *King Gesar of Ling* and *Tashi Delek*, at an exhibition of the art of national minorities in Beijing in 1981, demonstrating that this new 'Tibetan' style swiftly gained a positive reception in official quarters. But in what sense were the works of the Kanze school 'Tibetan'?

In many ways the determination of 'Tibetan' in this context relies on the fact of the ethnicity of one of the painters. As we have seen, there had been a concerted campaign since the 1950s to bring 'minorities' into the superstructure of the People's Republic. In the case of Tibetans this had been effected through territorial and ideological incursions. As a result of the actions of such figures as Getag Tulku, Kanze in the east of Tibet was one of the first places to be invaded by China, hence Rigzin Namgyal was one of a new generation of Tibetans who became adults in a place and period of Maoist control. His artistic training was therefore also dominated by the aesthetics of Chinese-run art schools. The Kanze school, which he co-founded, was supported by the Sichuan branch of the Artists' Association of China.[2] At the time of Namgyal's studies the associate dean of this institution was Cai Zhenhui, who promoted depictions of Tibetans which emphasized their assimilation into the 'new China' (as we saw in Chapter 4). Rigzin Namgyal's ethnicity therefore signifies an endorsement of the political agenda which insisted that Tibetans could become fully assimilated into every aspect of Chinese culture – including Socialist Realism.

From a stylistic point of view *The Meeting of the General and the Monk* combines an almost photographic Socialist Realism with motifs borrowed from Tibetan religious painting. Socialist Realist techniques for recording actual landscapes are brought to bear in the lower portion of the painting where the artists demonstrate that Getag Tulku's monastery not only welcomed a PLA general but several hundred of his troops as well, memorializing the accommodation of Chinese troops into the Tibetan sphere. The central figures are also drawn in the distinctive manner of Socialist Realist portraiture of the Cultural Revolutionary period but are framed by a halo/niche of the type used in

Tibetan *thangka* painting such as we see in a fifteenth-century Sakyapa painting where the head monks of a lineage are reproduced in mirror-image symmetry (illus. 71). In the 1980 painting, the throne, comparable scale of the two figures and halo are retained as unifying devices. These elements transposed from religious painting undoubtedly still function for the Tibetan viewer as iconic markers of significance, even sanctity. The general and monk face each other while Chu Teh makes a modernized *mudra*. In that one hand gesture, as he appears to explain something to the attentive, even supplicant monk on his left, the power balance in their relationship is clear and the political eclipses the residue of religion. As Norwegian Tibetologist Per Kvaerne suggests, artists like Rigzin Namgyal must stand accused of cynically exploiting 'structural and semantic elements' from traditional Tibetan imagery in order 'to render new messages acceptable'. Other Tibetan-style elements of the painting, the portico with the pillars and multi-layered crossbeams of monastic verandas are so accurate that they might have been derived from a *thangka* painter's copy book. Hence Rigzin Namgyal has most likely also performed the function of an ethnographer's informant: providing culture-specific details which were unavailable to a non-Tibetan. Kvaerne concludes that Kanze school paintings such as this one exploit 'mythic' resonances to create a parable of political power. Ultimately they only serve to illustrate the 'paternalistic attitudes of the Chinese towards the "national minorities", the recipients of guidance which is benevolent but firm'.[3]

The choice of subject matter in Sino-Socialist Realism inevitably reflects the national agenda of the PRC. Certain topics which conformed with the Chinese view of Tibet gained far greater currency than others. This was the case with depictions of King Gesar. (The Kanze school produced a Gesar image which was reproduced as a print.) The story of the Tibetan hero was revived for popular consumption in the TAR because it could be presented as an essentially secular tale. However in pre-1959 Tibet this epic (which originated in the court of the small north-eastern Tibetan kingdom of Gling in the fourteenth century) had been a favourite of itinerant storytellers who embellished it with religious subplots over centuries of retelling. But in the TAR of the 1970s, Tibet's Buddhist heritage was to be erased in preference for non-religious themes. As Kvaerne complains:

This world of Tibetan kings and heroes is, however, a gaudy one dimensional, fairy-tale distortion of history, from which the great saints and ecclesiastical figures who have dominated Tibetan civilisation and played a decisive role in Tibet's history are conspicuously absent.[4]

71 A 15th-century Sakyapa lineage painting. Los Angeles County Museum of Art.

Narratives of the lives of yogic adepts and Buddhist saints, such as Padmasambhava or Milarepa, had been a staple of pre-1959 *thangka* but were now banished from the young TAR artist's repertoire. On the rare occasion that a religious figure from Tibetan history appears in a Socialist Realist work it is usually in order to illustrate Tibet's inferiority and deference to the rulers of neighbouring countries. Two Tibetan painters, Yeshi Sherab and Lobsang Sherab, imagined the meeting of the Mongolian ruler Godan Khan and the Tibetan monk Sakya Pandita in the fairy-tale Socialist Realist style of the 1970s (illus. 72). As in *The Meeting of the General and the Monk*, Tibetan and Chinese styles feature and the central scene is enacted on a perspectival stage surrounded by a huge, ornate *mandorla* functioning as a proscenium arch. All this pomp and circumstance is lavished on reminding the viewer of the moment in 1247 when Sakya Pandita surrendered Tibet to Mongol rule. In the preceding years Godan's Mongolian forces had looted and murdered their way almost as far as Lhasa, leaving the Tibetans with little choice but to succumb to their demands for tribute and religious instruction. Tibetan monks were to be called upon to perform rites, provide divination and proffer flattering titles to Godan

72 Yeshi Sherab and Lobsang Sherab, *Meeting of the Mongolian Godan Khan and Sakya Pandita, c.* 1980.

such as 'protector of religion', thus beginning the 'priest–patron' relationship in which Sakya Pandita became the regent of Tibet, answering to Mongol overlordship. Clearly PRC leaders desired to capitalize on the parallels between these events and their own rise to power in Tibet. The two Tibetan painters have thus added another tale to the genre in which historic affiliations between Tibetans and others were revived in order to deny Tibet any claim to independence. Pre-1959 Tibetan images portraying the first Tibetan king, Songtsen Gampo, with his Chinese wife Wencheng or high lamas meeting Chinese emperors were reproduced in Chinese propaganda publications and captioned to imply that China had long-standing claims on Tibet. Clearly this tactic had proved effective and the two Sherabs had embraced the Maoist revision of Tibetan history.

However, it is not only the subject matter of Sino-Tibetan Socialist Realism which makes it offensive to exiles and others who lament the fate of Tibetan culture in the TAR. During the 1970s Jampa Sang, a Tibetan, based an entire composition portraying contemporary secular life in the TAR around the form of a highly important Tibetan Buddhist diagram: the mandala (illus. 73). When painted, reproduced in fine

156

particles (sand mandala) or imagined, the mandala is the abode of a deity. Jampa Sang's composition takes the fundamental features of the mandala, the square ground plan of a palace with gateways facing the cardinal points, and turns them into a compound for humans and animals. (A device which has metaphoric resonance with the way in which a highly sacred mandalic building, the Jokhang, was converted into a shed for animals during the Cultural Revolution.) He commits further sacrilege (from the point of view of a Buddhist practitioner) by placing a Tibetan woman milking a yak at the epicentre of the 'mandala', in the place traditionally reserved for the representation of

73 Jampa Sang, *Prosperity* (Chinese title) or *The Increase of the Three: Grace, Glory and Wealth* (Tibetan title), 1970s.

74 Hong Chang Krung, *Weaving*, 1970s.

the presiding deity. This Communist 'goddess' is then encircled by other Tibetan women churning butter tea and striking attractive poses in the style of Chinese prints of eroticized 'minority' women. At the four gateways artisans are shown plying the trades of weaver, painter, potter and metalworker. The mandala is no longer a palace for a deity but a diagram used to display the interconnectedness and value of such pursuits for the economy of the TAR. Like many Tibetan painters, Jampa Sang may well have been influenced by the work of a Chinese artist in this respect. Hong Chang Krung's *Weaving* (illus. 74) (the title is clearly erroneous), depicting the final phase of Tibetan carpet production with women trimming and shaping the wool with large scissors, also has a loosely mandalic format. (The theme of cheerful 'minorities' working in a folk idiom which signifies their ethnicity had been the subject of early Soviet Socialist paintings such as Mariam Aslamazyan's 1950 *Carpet Weavers of Armenia Weaving a Carpet with a Portrait of Comrade Stalin*.) Jampa Sang's 'mandala' also depicts Tibetans happily enacting their ethnicity and embracing the stereotypes of a 'minority': making tea in the Tibetan style, designing handicrafts of Tibetan style and making paintings, like this one, in a new, improved 'Tibetan' style.

158

The image is in keeping with the spirit of earlier Socialist Realist morale-boosting imagery and, like many Han Chinese images of Tibetans, was intended to show the success of Chinese modernization policies in Tibet. When published in 1991, it appeared with the Chinese title *Prosperity*. Interestingly, the same publication gave a different rendering in Tibetan, *The Increase of the Three: Grace, Glory and Wealth*, a version which emphasizes the eclipse of the Buddhist triad of speech, body and mind by the forces of Communism and consumerism in the TAR.

Under the tutelage of Chinese painters in the 1970s, TAR Tibetans had little choice but to observe the stylistic strictures of Socialist Realism, however a question mark must remain over any statement about the political self-positioning of TAR artists. As we observed in the discussion of *The Workers Weep though the Harvest is Good*, there are problems inherent in the interpretation of painting produced under strictly controlled political conditions. Style in itself cannot be used as a determinant of the ideology of the artist except in the most extreme cases, such as 'The Wrath of the Serfs' or in the mass-produced images of Chairman Mao where form and content are indelibly fused. When a Tibetan artist worked in collaboration with a Han Chinese painter the matter becomes even more complex. As assistant to Chen Danqing for *The Workers Weep*, Nawang Choedrak had to master the same type of Socialist Realism as his co-worker. As a result it is impossible to differentiate between his contributions to the canvas and those of Chen Danqing. Was he simply a Tibetan set-dresser cynically providing the culture-specific details for Chen Danqing's Socialist Realist drama? Independent paintings by Chen Danqing demonstrate that the realistic portrayal of Tibetans, their dress and customs, was his speciality, hence the Han Chinese artist did not need to rely on a Tibetan painter. In solo works by Choedrak we see the same detailed mimetic observation, but his choice of subject matter suggests a different relationship to the depiction of his fellow Tibetans. In *The Wedding* (illus. 75) Choedrak avoids portraying the newly-weds themselves. Instead two eastern Tibetan hats placed on a white crumpled fabric (reminiscent of the *kathak* (scarves) that denote blessing on the bride and groom when presented at a Tibetan marriage) stand in for them. The absence of the protagonists suggests that Choedrak continued to balk at the idea of portraiture of his compatriots. His forensically accurate recording of the outer effects of Tibetanness allows some escape from the strict messages of Socialist Realism and should perhaps be read as a demonstration of a modern TAR Tibetan sensibility which on occasion quietly asserts itself in the face of hostile conditions.

This is also the case in Tashi Tsering's *Son of a Serf* (illus. 76), one of the few examples where a Tibetan artist turned the mirror of Chen Danqing-style realism directly onto themselves. Composed in thick oils and a monochrome colour scheme, Tashi Tsering's self-portrait presents a man who is clearly Tibetan (wearing a *chuba*) and an artist (holding his brushes and echoing the famous Kenwood House self-portrait by Rembrandt). Hence, at the very least, the image constitutes a statement about Tsering's ability to represent himself and could be read as confirmation of this freedom under Chinese rule. Geeta Kapur has argued that realism dominated the work of Indian modernists of the colonial period owing to its power to display identity and the categories from which identity is established such as nationhood, ethnicity, class, religion and gender. Tashi Tsering's self-portrait acknowledges this mimetic power, but without further information it is difficult to define the relationship between his identity as a male Tibetan artist and the ideology of the space in which he is located. He is by no means the hero of a 'Wrath of the Serfs'-style drama. Is he a convert to Communism who is thankful to have escaped the feudalism of his parents' generation, or does his rather pensive, but confident expression act as a

75 Nawang Choedrak, *The Wedding.*

76 Tashi Tsering, *Son of a Serf*, 1980s.

challenge to the viewer to receive him as more than a mere ex-serf? The title encapsulates the problem and could be translated from the Tibetan as either 'Son of a Serf' or 'Son of a Slave'. Either of these are rather unlikely ways for a Tibetan to describe himself, hence it may be an editorial invention for the purposes of a Chinese publication. For those who view this portrait through a Socialist Realist lens, Tashi Tsering may still only be the 'son of a serf' and a member of an inferior ethnic minority. On the other hand, for Tibetans the title can appear as an ironic label for a heroic image of a defiant Tibetan who controls his own destiny, as he controls his depiction.

The New Tibetan Painting

We must continue to ask how Tibetan artists have responded to the legacy of outsiders' representations, while acknowledging that the power of a colonizer's image-making techniques is difficult to overturn. During the later phases of British colonial rule in India, artists such as Raja Ravi Varma, Abanindranath Tagore, Jamini Roy, Nandalal Bose and Amrita Sher-Gill utilized the imported styles of European realism and modernism to make images for the urban elite, but we would be foolish to describe their works as merely weak imitations of the colonizers' designs.[5] Their images began the process of creating a new artistic modus operandi for an independent nation.[6] Tibetans have not yet achieved independence from their colonizers (and some, perhaps, do not desire it). Whilst they continue to live under the colonial yoke and gaze, are there any signs of a new type of image-making which, as in the Indian case, posits an independent and consciously Tibetan point of view? If so, what does it look like? Does style dictate the perceived 'Tibetanness' of an image? That is, can only 'thangka' styles be considered authentically Tibetan, or is it possible that a different artistic vocabulary, derived from non-Tibetan sources, could define Tibetan aspirations?

We should not prejudge the response of Tibetan artists to their situation. Though the majority became close followers of the styles of painting imported by Chinese art school teachers, some did not succumb to the experience of cultural colonization in a passive manner. The works described above and below may shock connoisseurs of 'Tibetan art', for they display radical departures from 'tradition', but political and historical facts must be taken into account in order to show that this is not simply a case of the importation of an 'inappropriate' style or of a feeble attempt to re-create an 'alien' aesthetic. Rather than assuming that recent art produced by Tibetans in the TAR can only reiterate a (Euro–

American) sense of loss at the destruction of Tibet, we should attempt to read the images for signs of a markedly different sense of self-perception and projection among their producers. In some cases this sense developed into a combative interrogation of their situation.

At present, source material for such a project is limited, making it dangerous to draw extensive conclusions. It is difficult to carry out research in the TAR with prohibitions against photography and limitations on the amount of time that can be spent in the country, hence my comments are admittedly circumscribed. However, the sale of art is an unmissable feature of any visitor's experience in the TAR capital, Lhasa. The fact that painting has played a key role in the marketing of Tibet as a tourist destination is also evident in retail outlets, such as the shop housed in a room next to the Dalai Lama's (vacated) private quarters in the Potala Palace. Here Chinese or Tibetan visitors could purchase a bi-lingual illustrated book entitled *Tibetan Contemporary Art*. The 1991 publication contains a survey of painting by Han Chinese and Tibetan artists from the 1950s to the 1980s in a wide range of styles, including Sino-Tibetan Socialist Realism. However, since the 1980s it has clearly been just one of a number of styles from which artists can choose to make their representations. This book is a crucial document for the process of reconstructing what happened to visual culture in the TAR after 1959, but it is by no means comprehensive. As will become apparent, a vital part of the story which did not appear in textual form or in the galleries of Lhasa was relayed to me by an artist living in exile in Dharamsala.[7]

Tibetan Contemporary Art

The existence of a book called *Tibetan Contemporary Art* produced under the auspices of a publishing house of the People's Republic inevitably begs the question: what is 'Tibetan' about it? The 169 illustrations are introduced with a statement by the Deputy Chairman of the Communist Party in Lhasa (the highest ranking Tibetan official in the People's Republic), confirming the official status of the publication. Each painting is labelled with the artist's name (if known) and an indication of ethnic background (for Tibetans and Han Chinese) or status as part of a religious 'minority' (Tibetan Muslims) alongside it.[8] Thus, according to the book's editors, it is the fact of an artist's presence in the TAR, not Tibetan ethnicity, that qualifies him (or her) for inclusion. These designations reflect government policies of the 1980s in which the minorities of the Motherland were to be acknowledged as cultural producers. Moreover there is an implicit understanding in that all

artist/workers featured in the publication are equal partners in a collaborative project to depict their shared subject: the Tibet Autonomous Region. Of nearly a hundred artists featured, approximately half are ethnic Tibetans, whose works are intermingled with those of Han Chinese artists as if there were a happy coalescence of approach. Given that this book was published only two years after the 1989 demonstrations against Chinese rule in Lhasa and that it was sold at a tourist location, where 'outsiders' such as Chinese tourists from other parts of the Motherland and foreigners from further afield were its most likely purchasers, we must assume that the publication constitutes another attempt to project the idea that Tibetans were fully assimilated members of the PRC. The work of Tibetan painters who have absorbed the aesthetic of Chinese representation has been co-opted to this cause, while the book makes the presence of Chinese artists, living in and depicting colonized Tibet, a demonstrable fact. Taken as a whole, *Tibetan Contemporary Art* constitutes an assertion of PRC hegemony and control of Tibet and presents the acceptable face of what the government construes to be 'Tibetan' culture.

Though the book appears to give equivalent status to all producers of images of the TAR, closer examination reveals the careful plotting of an overarching narrative of representational supremacism. The range of styles at first appears highly diverse and undifferentiated, but the underlying organizational principles are chronological and evolutionary, moving from 'simple', indigenous beginnings towards a complex hybrid end where the introduction of Chinese styles of depiction has gained unassailable ascendancy. In the opening pages the editors have included eleven '*thangka*' paintings by Tibetans of popular religious subjects such as White Tara, Padmasambhava, Tsongkhapa and so on. A surprising inclusion when *thangka* painting is said to have died out in the TAR. Some of these paintings conform to the New Menri or Lhasa style and are decent examples of the work of the few elderly *thangka* painters who remained in Lhasa. As we have seen, many of the foremost exponents of 'traditional' (i.e. religious) Tibetan painting left their homes to follow the Dalai Lama into exile in the early 1960s, but the Dalai Lama was able to call upon the services of an excellent painter based in Lhasa for the first stage of the Kalachakra Assembly Hall murals in Dharamsala in the 1980s. He was one of the generation with pre-1959 training who remained in the Tibet Autonomous Region but whose work had certainly been threatened with extinction during the campaigns against religion of the Cultural Revolution. However, with a shift in Chinese policy in the 1980s, they and their students found themselves in demand for the reconstruction and repainting of monastic

77 Jampa Tseten, *The Fourteenth Dalai Lama and His Tutor*, 1950s.

institutions which had been damaged in the preceding decades. In theory the revival of Tibetan monasteries was part of a liberalization policy which allowed Buddhist practice to reoccur. But another reading of these events would have to acknowledge that the rebuilding process began in advance of the opening of Tibet for tourism in 1985. Hence it is no surprise that the sites which received greatest attention from the authorities were those in Lhasa, such as the Jokhang or nearby at Nechung. Further afield, the fact that a monastic establishment such as Samye was 'conserved' reflects its status as the first Buddhist building in Tibet. The historic significance of such a place meant that it had to be preserved, if only as a monument for the tourist gaze. To demonstrate

the supposedly free atmosphere in the TAR of the 1980s these 'traditionalist' projects have been documented and advertised in publications of the Nationalities Publishing House and distributed worldwide. A lavishly illustrated tome showing the quality of recent painting at the Panchen Lama's monastery, for example, was released as *The Hidden Tradition: Life inside the Great Tibetan Monastery Tashilunpo* in 1993. The few Tibetan artists who could produce images of some quality were in high demand. However, the majority of *thangka* in *Tibetan Contemporary Art* are badly drawn and show little knowledge of the correct components of, say, a mandala. (They are also published upside down, suggesting an equivalent lack of knowledge on the part of the publishers.) For viewers who know the quality of painting prior to 1959, these works only reiterate the difficulties faced by TAR students who wish to learn the old styles. Within this publication they perform a tokenistic function, merely registering a style of image-making of the past which has been outnumbered and eclipsed by other types of painting in the Maoist and post-Maoist vein.

The inclusion of works by another artist of the pre-1959 generation, Jampa Tseten, further demonstrates the degree to which the art of Tibetan painters has been commandeered to suit editorial and ideological purposes. In fact *Tibetan Contemporary Art* begins with three images in his trademark photo-realist style: a portrait of the tenth Panchen Lama (see illus. 19), the Buddha teaching at the deer park in Sarnath and a scene showing the Dalai Lama with his tutor (illus. 77). All three are executed in the realist style which had been appreciated by the Dalai Lama when he was still in Tibet and which gained Jampa Tseten the commission for the Norbulingka murals. But here they function as if to celebrate the conversion of a Tibetan to the representational codes of China, placed as they are alongside more 'traditional' Tibetan images. Tseten's paintings allow the editors to suggest that, even in pre-Revolutionary days, Tibetans were at liberty to portray their leaders in a positive and visually impressive light, as if Chinese realism had, like Maoism, allowed them to throw off the shackles of pre-1959 aesthetics and enter the brave new world of portraiture and landscape studies. This is a theme which recurs throughout *Tibetan Contemporary Art*. Unsurprisingly the volume omits any clear evidence that Tibetans were forced to paint celebrations of the triumphs of the People's Liberation Army, memorials to the Long March or images of the Dalai Lama in chains. Instead Jampa Tseten's positive portrayals of Tibetan leaders have been deployed as if to suggest that Tibetans were always at liberty to imagine their leaders in that way. Little wonder that exiled Tibetans were ill at ease with

Jampa's realism. As *Tibetan Contemporary Art* makes clear, once such images came into the public domain in the TAR, their authors had little control over the messages attached to them.

Though we cannot be sure of the nature of images omitted from an official and ideologically loaded publication such as this, some statements can be made based on observations of those that did make the grade. Han Chinese paintings with an explicitly Socialist Realist agenda such as *Chairman Mao Sends his Emissaries*, *The Workers Weep* and *When the People Marched* all feature. By contrast there are no similar images by Tibetan artists: no depictions of Chinese leaders or PLA generals. In fact almost nothing to suggest that Tibetans had become Maoist propagandists, an editorial tactic which denies exilic claims that such a process had taken place. Instead, many of the Tibetan-made images are devoted to secular subjects in the mimetic styles which had been imported to Tibet by Chinese artists such as Chen Danqing. By comparison with truly Socialist Realist works their 'cool realism' appears less ideologically charged, reflecting the new values of art schools both in the TAR and other parts of the PRC during the 1980s. For the first time in Tibetan history large numbers of artists concentrated on the portrayal of their fellow Tibetans at work in the fields and in other domestic and non-elite contexts. By contrast to pre-1959 painting, in which portraiture had generally been reserved for high-ranking dignitaries and monks, this constitutes a break with the past which must be assigned to the influence of Socialist Realist aesthetics. But Tibetan images of the 1980s lack the triumphalism of Han Chinese depictions of Communist Tibet. Instead a high degree of romanticism and nostalgia characterizes works such as Tsang Chos's *Separation* (illus. 78). Here a father prepares to take leave of his family in order to guide a train of heavily laden yak to a trading centre. Such activities have been a feature of Tibetan life for many centuries, with male members of families frequently absent for long periods of the year as they traversed the Tibetan plateau providing porterage for goods or moving herds to fresh pasture. In some Tibetan communities polyandrous relationships ensured that other males remained at home to support women and children. However Tsang Chos iconizes the nuclear family unit of husband, wife and one child prescribed by the PRC. No longer forced to evoke the Socialist Realist dream of heroic workers, artists like Tsang Chos turned instead to presenting a romance of subsistence on the Tibetan plateau under Chinese dominion and embraced the realisms of their Chinese colleagues in a self-exoticizing mode.

Alongside the Tibetan followers of Chen Danqing, another variant of

78 Tsang Chos, *Separation*, 1980s.

the image of Tibet was led by Han Huu Li, who had been inspired by the 'exoticism' of Tibetan culture when he moved to the TAR. Some reminders of the artefactual riches of Tibetan Buddhism were still visible in the streets and back-alleys of conurbations such as Lhasa, and as a teacher at the university art school Han Huu Li directed a generation of both Han Chinese and Tibetan students towards these fragments of Tibetan heritage which had survived the onslaught of the Cultural Revolution (illus. 79). More importantly, the 1980s had begun with a directive from central government which heralded a new political climate in the TAR. In 1979, the PRC had allowed the Dalai Lama to send a fact-finding mission to the TAR, assuming that the visit would confirm the benefits of modernization and development instituted by China. This policy rather back-fired, as the mission found evidence of poverty, minimal economic improvement and the massive scale of destruction which had been wrought on monasteries. Even more worryingly for the PRC regime, thousands of Tibetans demonstrated their continuing respect for the Dalai Lama and support for Tibetan

nationalism in their rapturous reception of the fact-finding committee. The PRC rapidly set up a new policy for Tibet in order to counteract these signs of dissent. Point five of Party Secretary Hu Yaobang's six-point reform programme (released in 1980) stated that:

So long as the Socialist orientation is upheld, vigorous efforts must be made to revive and develop Tibetan culture, education and science. The Tibetan people have a long history and a rich culture. The world renowned ancient Tibetan culture included fine Buddhism, graceful music and dance as well as medicine and opera, all of which are worthy of serious study and development. [. . .] Cherishing the people of minority nationalities is not empty talk. The Tibetan people's habits, customs, history and culture must be respected.[9]

As a result of this decree, the TAR began to see a resurgence of Buddhist practice among both lay people and monks. This in turn ignited an explosion of works by both Tibetan and Han Chinese artists which made reference to an image of a 'religious' Tibet that would have been impossible to record a decade earlier. Portraits of lay people who were once again free to make prostrations and offerings at sacred sites were prevalent. Monks and their monasteries provided an equally

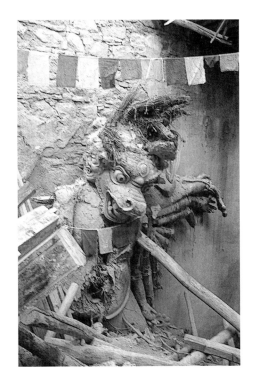

79 Damaged sculpture of a wrathful deity, Lhasa, 1993.

compelling subject for artists. Among them Jampa Sang, the author of the neo-mandala *Prosperity*, produced a study of a Geluk monk taking a meditational stroll in a monastic courtyard, very likely based on Drepung or Sera on the outskirts of Lhasa. Hence even Tibetan painters who had veered towards Socialist Realism reinvented themselves and abandoned the old Maoist styles and subjects in preference to the newly sanctioned imagery of Tibetan Buddhism. However, though one of the key definers of Tibetan cultural identity, Tibetan Buddhism, was now a visible feature of life in the TAR, it was primarily represented in non-Tibetan style. Significantly, Hu Yaobang's decree had not mentioned traditional painting as an area for 'serious study and development' and *thangka* painting only achieved a limited level of revival.

We should also note that, though the new governmental policy on Tibet reinstated Buddhism as a key component of Tibetan culture, it did not extend the same rapprochement towards other religious groups. As a minority within a 'minority nationality', Tibetan followers of Islam did not receive the same kind of attention as their Buddhist neighbours, despite the fact that Tibeto-Muslim culture was also targeted for extinction by the PLA and Tibetan Muslims had attended 'struggle' sessions where they had also been forced to denounce their faith during the Cultural Revolution.[10] However the work of a Muslim artist was included in *Tibetan Contemporary Art*. A painting by Abu depicts the hustle and bustle of the Barkhor, the street around the Jokhang which is both part of a Buddhist circumambulation route and a trading area which has been home to Muslim businessmen and their families since the seventeenth century (illus. 80). But the artist only hints at a Muslim presence in the figure of a woman with her head covered by a floral scarf and gives greater prominence to a monk and a Buddhist woman with a prayer wheel. In another image, Abu concentrates entirely on Buddhist culture, with a scene set near Mount Kailash in which a solitary woman prays beneath a string of Buddhist prayer flags. But why has he avoided depicting the outer effects of his own religion, such as the mosque which is located only yards away from the Barkhor? Given that these are the only works by a Muslim artist featured in *Tibetan Contemporary Art* (perhaps there are others which the editors chose to omit), it seems clear that whilst Buddhist subject matter gained some acceptance in the period of relaxation, other minority groups in the TAR remain unrepresented and undepicted. The inclusion of two Buddhistic images by a Muslim gives further weight to the argument that what makes an image eligible for publication as 'Tibetan' art is neither the ethnicity nor the religion of its maker, but the representation of the place, the TAR, according to an officially sanctioned vision.

80 Abu, *The Market*, 1980s.

As we have noted, Hu Yaobang's call to members of the PRC to recognize the value of Tibetan history and culture led to some improvements in social and political lives of Tibetans in the 1980s, but it did not encourage a revival of traditional Tibetan painting. Just as the 'Socialist orientation' of the TAR had to be upheld, so the Socialist Realist orientation of Chinese images of Tibet was not entirely abandoned. In fact, realism in various forms continued to provide the model by which Tibetans and Han Chinese artists followed Hu Yaobang's other requirement to observe the 'customs and habits' of Tibetans. Where photographs of exoticized 'others' have been a stimulus to 'ethnotourism' worldwide, so the supposed veracity of realist portrayals of Tibet and Tibetans also proved extremely useful in the promotion and commodification of a carefully tailored image of the TAR when it was opened up for tourism in the mid-1980s. The rise of this new service industry created a financial imperative that artists could not ignore and which they answered with romantic visions of a Tibet replete with the practices and paraphernalia of Buddhism.

Selling an Image of Tibet

The rise to power of Premier Deng Xiaoping in 1978 had heralded the arrival of a new economic and ideological era throughout the PRC. While still fundamentally Communist, Deng's philosophy also

incorporated some of the lessons of capitalism and led the country towards what has been termed 'Deng-style consumerism'. The TAR was not exempt from these developments, if anything it became a zone of entrepreneurship, with thousands of Han Chinese arriving in the region to set up small businesses. The new Tibetan painting of the 1980s, which appeared in the pages of Tibetan Contemporary Art, proved to be highly suitable for the process of commodifying an acceptable vision of the TAR in this period. Works which did not stray from the realist paradigms established since the 1950s fulfilled the needs of the new art consumers, Han Chinese business people, cadres and foreign visitors, who sought to collect impressions of the region they had arrived in. Expressionistic views of the Potala Palace, the soulful countenances of monks and Tibetan women in 'minority' dress were subjects which reified the concept of the newly liberated, but still exotic, Tibet.

The focal point for the sale of art was Shöl, an area just beneath the Potala Palace in Lhasa. Prior to 1959, Shöl had been occupied by buildings of the Tibetan government, granaries and the premises of craftspeople such as printers. Major public events, such as the New Year ceremony and the Golden Rosary ritual which marked the sacred space around the Potala, took place there.[11] Since the Chinese takeover, particularly under the 'modernization of the minorities' offensive, the area has been gutted. Pre-1959 structures have been torn down and replaced by shopping arcades and new public institutions such as the 'Museum of the People' (where 'The Wrath of the Serfs' was displayed). This phenomenon was by no means unique to the TAR as throughout the PRC all 'minority areas have boutiques, open markets, tourist stores, and even "cultural stations" where minority goods are collected, displayed, sold and modelled'.[12] These outlets were designed to cater to the needs of tourists from other parts of the PRC, who no longer needed to rely on exhibitions in Beijing or Chengdu for a glimpse of the peripheral 'minorities', as well as for migrant workers who had settled in Tibet. From 1985 the TAR was also opened up to non-Chinese visitors, though their ease of passage was later disrupted by political clampdowns.[13] With the Potala Palace as a backdrop (the most popular sight on a visitor's itinerary), Shöl has become a tourist's dream, though the process of rededicating the space to the spirit of commerce, rather than religion or Tibetan political power, should clearly give pause for thought. The display and sale of art (particularly easel painting) has been officially encouraged in the area, with a number of galleries and studios complementing the cultural tour to the Potala. By 1993, visitors to the Potala were assaulted by a sign announcing the presence of the

'Potala Palace Art Gallery' and claiming (in English) that it was 'The Biggest Tibetan Art Museum'. This statement has rather depressing implications, for it was the Potala that could most accurately claim to have been the greatest repository of 'Tibetan art' up until the Chinese takeover. Many of its treasures have been removed and only a fraction of the rooms in which the Dalai Lama's collection of religious art was housed are open to the public. Much of the original wall-painting has been erased and guides provide a bowdlerized version of Tibetan history for those who want to hear it. Tourists can indulge their fantasies in this building, which has now become a backdrop for a mock-up 'Tibet' in which Han Chinese play the characters of Tibetans by donning various different regional styles of Tibetan dress. Meanwhile, 'real' Tibetans play the role of 'minority' workers of the Republic, reciting traditional labourers' songs as they stamp mud for new roofs as tourists enter the building. These Tibetans appear to dance to the tune of a choreographed Communism in which they must assert their ethnicity for the enjoyment of others. The familiar refrain of Tibeto-exotica was also evident at 'The Chinese Artists' Association (Tibet Branch) Gallery' in Shöl.

Any worker in the People's Republic – be he (or she) artist or agricultural labourer – is required to join a work unit. The notion of an independent artist living by the sale of his own wares is thus inconceivable in China. Irrespective of ethnic background, once they have completed their training in a Chinese-run art school, TAR artists are required to join a work unit affiliated to a larger body such as the Chinese Artists' Association. During the 1980s the association provided facilities in which their art was displayed for sale. Nevertheless, the question of state control of culture remains germane when training and exhibiting is strictly controlled. Hence the gallery of the Tibet Branch of the Chinese Artists' Association presented a selection of works with officially approved subjects and styles by Tibetan and Chinese artists. In a small ill-lit room there in 1993 around thirty paintings covered the walls. About half of these used thick oils to define empty valleys and snow-capped mountains in the 'Pastoralist Realist' style of Andrew Wyeth which had been imported to Tibet in the mid-1980s. The remainder followed the example of Chen Danqing by focusing on the inhabitants of the land, though few of them were drawn from life. Photography had clearly been the source for images of men and women in aristocratic dress, since such people were no longer visible or present in Lhasa. These paintings are most likely to have been based on pre-1959 studio portraits, that is, from the period before the implementation of Mao

suits and less ostentatious traditional dress. Nostalgic images such as these are part of the same tourist culture in which visitors to the Potala temporarily adopt the dress of an Amdo Tibetan or a Lhasa noblewoman. Soviet-style Socialist Realism was completely absent, suggesting that a romantic photorealism had been considered more palatable for tourist tastes and in commodifying a vision of the old Tibet no longer visible in actuality.

However, the official imagery of the Chinese Artists' Association at the tourist area of Shöl masks another side of the story of painting by Tibetans in the TAR. During the mid-1980s Shöl had also been a zone of dissent. A tea shop there had been converted into a temporary exhibition space by a group of artists who tried to overturn some of the implications of Chinese image-making and commercialization. Earlier, we wondered if it were possible to identify signs of defiance in the work of Tibetan painters or to glean examples with a modernist sensibility. The 'tea-house' artists provide the clearest evidence of this, but their story is not revealed in the galleries of Lhasa. For obvious reasons, Tibetan artists whose work posits a critique of the state and system in which they were educated and who dare to imagine an independent Tibet are hardly celebrated. However, often the message behind their work is deliberately difficult to decipher, and as a result a couple of radical images slipped through the net and were published in *Tibetan Contemporary Art*.

An Image of Tibet With No Name

During the mid-1980s the relaxation policy of Deng Xiaoping and Hu Yaobang started to have adverse consequences from those desired by Beijing. The monasteries had begun to increase in strength and numbers, and monks and their lay supporters pushed for greater freedom of expression for religious and political sentiments. In the meantime, in 1986–7 the Dalai Lama and his Dharamsala officials launched an international campaign to bring outside weight to bear on the PRC and to push for a different political system, if not independence, for Tibet. Tibetans in the TAR listened to their radios for news of this initiative and in 1987 they heard that the Dalai Lama had spoken in the capital of the USA.

Many average Tibetans in Lhasa, therefore, believed that the Dalai Lama's speech to the Human Rights Caucus of the Congress was a turning point in Tibetan history, and that the United States, in their eyes the world's greatest military power, would soon force China to 'free' Tibet.[14]

These developments, coupled with the influx of Han Chinese into the TAR, led to a tense atmosphere, particularly in Lhasa, which between 1987 and 1989 erupted into demonstrations and sometimes riots led by Tibetan monks. The authorities responded violently and several Tibetans were killed. Artists in the city could hardly ignore these events, though to depict them would have been suicidal. However, at least one painter has stated that his work altered dramatically at the time of the riots and that he tried to use his canvases as a way to present the passion for independence in an elliptical manner.[15] In a political climate such as this, only the brave and the talented could attempt to express these feelings on canvas.

One such figure was a man who took the name of a Tibetan saint renowned for his magical powers and generally rather eccentric behaviour, Milarepa. Although they appear in *Tibetan Contemporary Art*, the works of Nawang Respa subvert the ideological intentions of its editors and posit a subtle political critique of the PRC. One of these is entitled *ming med*, literally 'without a name'. It is no coincidence that this untitled image is also the most impenetrable to official interpretation. By omitting a title Respa prevents a simple reading of his work and challenges his audience to decipher the buried semantics of his visual code. We will return to this image later.

The meaning of Respa's *White Moon; Red Banner* (illus. 81) is less difficult to ascertain given a little culture-specific contextualization. It presents a harrowing portrait of a woman seated in a forbidding rocky landscape. There can be little doubt of the discomfort of this Tibetan woman, whose expression is echoed by the aridity and desolation of the hinterland which surrounds her. The recent history of Tibet is literally etched into this environment, with the Buddhist mantra '*Om Mani Padme Hum*' carved into a boulder overshadowed by the red banner of the title. Nawang Respa has clearly used the colour red within the symbolic context of Communism and hence it is the Maoist Red Flag (not just a banner) which falls like a pall over the countryside of Tibet. The white moon of the title, on the other hand, is associated with the purity of Tibet. For Tibetan Buddhists, the full moon is aligned with auspicious events, such as the Buddha's birth and *parinirvana* (final achievement of nirvana). In pre-1959 Tibet, entire communities would participate in ritual circumambulation of sacred sites by the light of the full moon. However, in Respa's image a pale red cloud partially obliterates the lunar disc and the mantra which should sanctify the landscape has been plunged into deep shadow. The source of the woman's distress has evidently been the eclipse of Buddhism under Chinese Communism. It seems extraordinary that this message

81 Nawang Respa, *White Moon; Red Banner*, 1980s.

82 Nawang Respa, *Untitled*, 1980s.

escaped the attention and, perhaps, the comprehension of Respa's publishers.

The unnamed painting, *ming med*, also contains a submerged political allegory, but again the publishers must have assumed that a work showing a crowd of Tibetans clutching prayer wheels and rosary beads was simply a 1980s' revisitation of the style and subject matter of Chen Danqing (illus. 82). They ignored the fact that Respa's Tibetans crouch beneath a disc which is at once sun, moon, globe and clock. This unique reference to a Western-style timepiece in a painting by a Tibetan suggests a precursor in the famous image by the Spanish Surrealist, Salvador Dali. In fact Respa may be deliberately quoting from Dali's *The Persistence of Memory* (1931, now in the Museum of Modern Art, New York), in which a drooping, molten clock evokes the impact of the passing of time in the individual subconscious. In *ming med* the globe/clock functions as a symbol of the collective consciousness of history among the Tibetan people, since it is surrounded by scenes from life in pre-1959 Tibet: a stupa with prayer flags, rocks engraved with mantras and Buddha images, yaks ploughing fields and an undamaged

monastery. These visions emerge in a sunset orange coloured non-naturalistic space, the illogicality of which suggests a shared memory or dream. As the group of huddled figures gaze gloomily forwards, one of them looks towards the clock/globe as if expecting it to move on. Unfortunately, it is in the nature of painting for time to stand still, and Respa's clock is stuck at half past three, just as the prayer wheel held by a Khampa below is also in a state of suspended animation. The Tibetans seem to expect that both the clock and the prayer wheel will at some point be reanimated, enabling the memory of pre-1959 Tibetan practices to metamorphose from hallucination back into lived reality. Respa implies that it is only the faith of Tibetan Buddhists which can truly reactivate their stupas and monasteries, rather than the cynical relaxation policies of their Communist rulers. Meanwhile an independent Tibet at least survives in their imagination, whilst the rest of the globe is castigated for allowing time to stand still. This image with no name reconstructs the period after the Dalai Lama's speech to the US Congress, when Tibetans could only hope that the outside world would take heed and take action.

Moving Towards Modernism

The editors of *Tibetan Contemporary Art* had certainly not intended to publish complaints about the current state of Tibet. So how had Respa's work slipped through the net? Just as the PRC authorities had mistakenly assumed that their modernization of the TAR had been effective and embraced by Tibetans, so they imagined that the various forms of imported realism had effected a visual hegemony which could not be breached. Respa had managed to twist post-Socialist Realism's figurative code to suit his own ends, but alongside him a group of Tibetans were experimenting with another stylistic vocabulary that would prevent the authorities from identifying their true meaning and define a distinctively Tibetan aesthetic. These artists rejected Sino-Socialist Realism in preference for a pared down abstraction from the real which enabled a more 'independent' and identity-conscious Tibetan art to emerge. A crucial component of this new Tibetan painting is a critique which is muted, subtle and, for some, incomprehensible.

This truly novel Tibetan style was inspired by the formal lessons of Modernism. Ironically Tibetan painters first heard of this global phenomenon in the classrooms of their Chinese teachers, who knew the history of twentieth-century European and American painting from exhibitions held in Beijing since the 1960s. These shows had included work by Matisse, Picasso, Braque and later generations of painters who

followed in the footsteps of such key Modernist figures. Publications based on these displays were owned by teachers such as Han Huu Li and consulted by his students. The impact of the Modernist dissection of the human form, most evident in Cubism, led one Tibetan painter to pursue a dramatic representational shift in his treatment of a subject he had previously painted figuratively. Jigme Thinley had initially painted his fellow Tibetans at work or in the home carrying out traditional activities, for example *Preparing Barley* (not illustrated), his technique and choice of subject matter was clearly indebted to the Chen Danqing vision of Tibet. In *Preparing Barley* a woman breast-feeding her baby is drawn in utterly Realist mode. But in a later work, *Nurture* (illus. 83), a Tibetan woman and child have been transposed into a composition almost entirely composed of flat, Cubistic planes, their bodies modelled in a style distinctly reminiscent of Picasso. Hence in the working career of one Tibetan artist we see the history of European Modernism in microcosm, abandoning the realism of Courbet and Manet and replacing it with the formal values of Picasso and Braque.

During the mid-1980s a number of Tibetan artists left the TAR to complete their training in art schools at institutions such as the Beijing 'University of the Minorities'. Here they were able to see Western modernist and post-modern painting at first hand or in the bookshops frequented by the Beijing avant-garde. However, on the streets of the capital of the PRC, members of 'inferior' minorities such as Tibetans often experienced abuse and insult at the hands of their more 'civilized' Han Chinese comrades. The trauma of such events led to a heightened sense of their ethnicity and of the distinctiveness of their cultural identity. For some, the process of moving between the centre and the periphery focused their minds on difference, as Gongkar Gyatso recalled.[16] He experienced a kind of epiphany on a flight back to Lhasa from the PRC capital. Having spent a number of years in Beijing, where among other things he had been sent to study nature in Chinese gardens, he was overawed by the view of the Tibetan landscape from the air. Everything about it – the strong colours, clear air and empty valleys – contrasted with China. But he realized that he 'felt like a Chinese looking at Tibet' and that what he had learnt under Chinese tutors did not do justice to Tibet. 'Chinese artists had made the Tibetan landscape pretty – but it's actually hard and stark', he noted. Gyatso resolved to try to re-train his vision, removing the Sinicization of his aesthetic sensibilities, and to 'find the real Tibet'. For him, and a handful of others, the 'real' Tibetan art emerged from a fusion of an ethnopoliticized aesthetics and the liberating example of Western modernism.

83 Jigme
Thinley,
Nurture,
1980s.

Gongkar Gyatso's involvement with these issues is evident in many of his paintings, which undoubtedly explains why, despite the fact that he was a key figure in Lhasa art circles, only two of his works feature in *Tibetan Contemporary Art*. The mislabelling of a highly abstract work by Gyatso in this book enables us to recapitulate the problematics of representation in a totalitarian cultural environment. After his airborne epiphany, Gyatso decided to portray a place in the 'real' Tibet, *Lhamo Latso* (illus. 84). This lake to the south of Lhasa has particular significance for Tibetan Buddhists, as it is named after Palden Lhamo, the wrathful protector goddess of the Dalai Lama and the Tibetan state. Thus for a Tibetan artist and his Tibetan viewers the lake is no mere

84 Gongkar Gyatso, *Lhamo Latso*, 1980s.

'pretty' landscape detail. Gyatso has distilled the starkness of the lake, mountains and sky of southern Tibet into essences of pure colour reminiscent of American Colorfield painting. For those who read Tibetan, the specificity of the place is revealed in an inscription at the bottom left of the image stating 'Lhamo Latso'. But in the publication the painting has been captioned as *Extreme Land*, the expression used to label Han Chinese outsiders' impressions of Tibet, with all the associations of Sino-primitivism that this implies. But Gyatso's understated painting was part of a concerted attempt to counteract the 'Extreme Land' preoccupations of Han Chinese artists with resonances which were meaningful for those who knew the cultural history of the Tibetan landscape. In the 1980s, Gyatso was one of a group of Tibetan artists who began to use the idea of the land as a way of re-engaging with their Tibetan identity. These artists sought to develop a new image of Tibet which would overturn thirty years of Chinese realist visions that had demarcated their country as a rare domain, ripe for observation and invasion. The conspicuously non-figurative and modernist style of their new Tibetan art was also designed to be a closed book for those accustomed to Maoist ideological readings.

The Creation of a Tibetan Modernist

The biography of Gongkar Gyatso, who was born in Lhasa in 1962, inscribes a narrative of the aesthetic and ideological imperatives of life in the TAR after 1959. Gyatso describes himself as 'a product of occupied Tibet'[17] and his paintings are also the products of an invaded space.

His life and work reveal how being Tibetan in the TAR involves negotiating between conflicting representational fields. In the course of Gyatso's career he was both the first Tibetan to paint a mural for the Tibet Reception Room in the Great Hall of the People in Beijing (entitled *The Yarlung River* and completed in 1985) and a founder member of the 'Sweet Tea Painting Association' (*Cha ngarbo rimo tsokpa*), the first independent Tibetan artists' association with an agenda that was by no means supportive of the Chinese regime. The evolution of his art practice parallels a political conversion from Maoist ideologue to refugee follower of the Dalai Lama.

As a child, Gyatso grew up under the totalitarian ubiquity of Maoist ideology and imagery. 'Everything in our home was Chinese and the entire family strictly adhered to party guidelines'.[18] The son of government employees (his mother was a clerk in a government office and his father a soldier in the PLA), he was educated in schools reserved for the offspring of such workers, where the PRC vision of 'minority' Tibet held sway. Students were drilled in reverence for Mao Zedong and the heroes of the Cultural Revolution and trained to despise the Dalai Lama and the religious system he embodied. At the age of seventeen, Gyatso took a job as a tour guide at the 'Museum of the Revolution' built on the site of the demolished Nangtseshar (a pre-1959 court house and prison) in Shöl. As we have seen, the museum contained a display of 'the evils of the old, "preliberation" society', such as the practice of Tibetan Buddhism. With an extensive background in party propaganda, Gyatso had little difficulty in adopting the Communist view that religion was a wasteful, oppressive system that had led to the iniquities of 'feudalism' in pre-1959 Tibet. His job at the museum began in the year after the death of Mao, hence he became part of the campaign to remind Tibetans of how bad their lives might have been without Maoist intervention. At this time Gyatso's education had left him unable to imagine anything other than the PRC's representation of Tibet, past and present.

However, in 1978 his pro-Maoist world view received an abrupt jolt, partly as a result of his interest in art. During his time at the museum, Gyatso met some of the Lhasa University art teachers and was invited to accompany them on a project to make drawings and 'give ideological advice' to 'peasants' in Chamdo in Kham. The 'peasants' turned out to be his fellow Tibetans living in poverty as a result of government policies which demanded that Tibetan farmers donate half their yield to the Motherland, whilst the rest could be claimed by government employees. This experience raised some doubts in Gyatso's mind, and he began to question some of the assumptions he had held since child-

hood. When the opportunity to study art at the Minority School in Beijing arose in 1979 he found himself surrounded by students from 'forty to fifty' different 'minorities' and was again shocked by this experience. Of his 'minority' classmates, he and two other Tibetans were the only ones who retained some knowledge of their mother tongue and its script. Hence during four years of tuition in two styles of Chinese painting and the 'strict guidelines as to what art should be like'[19] Gyatso instead became highly conscious of the distinctiveness of his own 'minority' heritage. On visits to museums and libraries in the capital of the PRC he also discovered the culture of places further afield. He read Nietzsche and Sartre, books on Millet and Van Gogh and was introduced to Western Modernist art among the Beijing avant-garde. The son of Tibetan Communists decided that 'all these Western ideas flowing into China were the fruits of free societies with free markets, freedom of expression and concepts of democracy'.[20]

The lessons learnt during Gyatso's time in Beijing can be revisited in paintings which display an evolving fascination with the work of Braque and Picasso (especially in their Synthetic Cubist period). In one study, the colour range (browns, blacks and creams) echoes their palette, though where Braque and Picasso developed Cubism as a means of disassembling visible reality, Gyatso's pieces move straight to abstraction without the intermediate phase of the dissection of form. A similar composition, but with patches of more vivid pigment (red, blue and purple) occurring like disused shards of stained glass, owes its interplay of shape and colour to the experiments of Vasily Kandinsky (1866–1944), who in *Concerning the Spiritual in Art* famously compared his non-figurative painting to the abstract appeal of music (illus. 85).[21] The only specifically 'Tibetan' feature in these early works is the inclusion of the artist's signature in Ü-chen script. (What occurs here merely as an appropriate detail becomes a far more self-conscious statement in Gyatso's later works, such as *A Prayer* of 1993, where extracts from Tibetan religious texts predominate [illus. 87].)

In 1984 Gyatso returned to the TAR to continue his training at the fine art department at Lhasa University. His arrival coincided with the period of liberalization, when some restrictions on the practice of Tibetan Buddhism had been lifted. He therefore arrived in a rather different city from the one he had left: the Jokhang had been reopened and Tibetans (including his own grandmother) were once again reciting mantras, using rosaries and generally reviving popular religious practices. At a less visible level, cassettes with speeches made by the Dalai Lama in exile were in circulation. When Gyatso heard the Dalai Lama's account of Tibetan history and its status as an independent nation, it

85 Gongkar Gyatso, *Cubist Composition*, 1980s.

galvanized his resolve to try to create 'something Tibetan'. But how was this to be achieved? Gyatso had no knowledge of 'Tibetan techniques' (such as *thangka* painting) and had only ever learnt Western and Chinese styles of oil painting, so his first attempts to illustrate the special characteristics of the Tibetan environment were still forged in the stylistic mould of Sino-Realism.

Ironically his abilities in this type of representation meant that the process of devising 'something Tibetan' was interrupted in 1985 when Gyatso was required to return to Beijing to complete the *Yarlung River* mural for the Tibet Reception Hall (not illustrated). Although the subject enabled Gyatso to depict the Yarlung Valley where the first Tibetan kings had ruled, it was an official commission for a Han Chinese audience. On his return to Lhasa, Gyatso became even more painfully aware of the contradictions between his status as the son of party workers (and now also an artist to the state) and his growing consciousness of the distinctiveness of his Tibetan heritage. Around this time he tried to express his frustration:

. . . all my attempts to get at my Tibetan identity and cultural roots. The result was a feeling of depression and emptiness, which I tried to depict in a self portrait. I drew myself with half a face, reflecting the boredom and feeling of vacuousness I had felt during these idle days of senseless arguments.[22]

86 Gongkar Gyatso, *Cloud*, 1980s.

In these 'senseless' discussions with other art students Gyatso had at first continued to defend Maoism, but he gradually came to the realization that his personal crisis was shared by many other young Tibetans in Lhasa. They too suffered from a sense of split personality as a result of reaching adulthood in a version of Tibet constructed by China. A solidarity emerged between them which further inspired the search for a new 'medium of expression'.

These debates about politics and the future of Tibetan art had occurred in the tea houses of the Shöl district near Lhasa University. In 1985 the university authorities proposed that its students should exhibit at the World Youth Day festival in Lhasa, but Gyatso and his friends realized that they would only be allowed to exhibit work 'whose social connotations conformed to the regime's views'.[23] Thus, with the model of the Parisian Salon des Refusés in mind, they decided to show their work in the alternative spaces where their discussions had taken place and to name themselves 'The Sweet Tea Artists' Association'. The tea-houses provided an ideal venue for other young Tibetans to view and comment upon their work without official interference.

The primary motivation for these artists came from a growing sense of the need to reinstate their Tibetanness and to reject the styles and institutions of their Chinese masters. As Gyatso recalled: 'By taking inspiration from the shapes, elements and events in our own environment, I and a group of art students in my college were striving to create a form of specifically Tibetan modern art'.[24] The 'Sweet Tea House' identity and sensibility became heavily tied to nature and the physical

environment as they attempted to reclaim the landscape of Tibet and to populate it not with ethno-kitsch reflections of themselves but with Tibetan signifiers. Excursions were made to remote areas of the country, such as Changthang in western Tibet, in order to 'seek affirmation of their traditional spirit from the sky, the mountains and the rivers of Tibet'.[25] Gyatso's *Lhamo Latso* is a prime example of the new anti-realist approach which, instead of merely recording, sought to reattach Tibetan meanings to Tibetan places. As we established earlier, Tibetans believed the lake to be inhabited by the spirit of Palden Lhamo, the wrathful protector goddess, and it had therefore been a place of pilgrimage since at least the sixteenth century. In the twentieth century, a number of eminent religious figures are said to have experienced visions in its waters, as Reting Rinpoche did when he consulted Palden Lhamo during his search for the birthplace of the next incarnation of the Dalai Lama. The signs which appeared on the water led to the discovery of the current (fourteenth) Dalai Lama. Given the significance of the Dalai Lama, as the religious and political leader of Tibetans who seek an independent Tibet, and the Palden Lhamo, as the State Protector, a location such as Lhamo Latso has great potency for Tibetans both inside and outside the TAR. Gyatso's modernist evocation

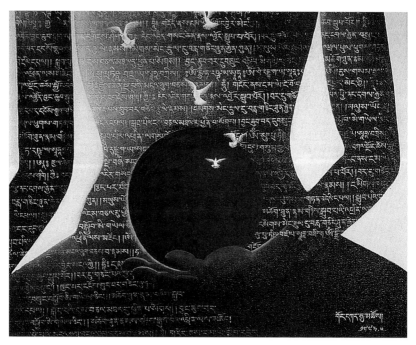

87 Gongkar Gyatso, *A Prayer*, 1993.

of it reanimates these historical, religious and political associations in an abstract, encrypted code.

As we have seen, the mid-1980s was a period of religious revivalism and Gyatso became interested in Tibetan Buddhism as a practice and philosophy as well as a source of aesthetic inspiration. He produced some studies of the monastic environment, but his 'Sweet Tea' colleagues complained that they were too realist. So he looked at the remaining paintings in the monasteries around Lhasa and tried to produce 'modern *thangka*' in which he quoted from traditional motifs. In one of these he expanded the traditional Tibetan style of painting clouds until it becomes a pattern of lines which play on the eyes like the Op Art of Bridget Riley (illus. 86). But, like the religious revival, the efflorescence of 'Sweet Tea' Tibetan modernism was not to last. In 1987, the year of the first of a series of demonstrations against Chinese rule, the group held an exhibition which was covered by Lhasa radio and television and attended by TAR dignitaries; shortly afterwards the authorities demanded that party-approved Han Chinese painters should be allowed to join. This was entirely contrary to the 'Sweet Tea' aim to produce an art form that was Tibetan in subject matter and style by artists who were ethnically Tibetan. Hence the group disbanded rather than adulterate this purity.

Following the dissolution of the association, Gyatso entered a period of retrenchment and a phase of rather nostalgic realism. His drawings of prostrating pilgrims at the Jokhang and men resting in the Barkhor became almost identical to portraits painted by Chen Danqing a decade earlier. But two years later, in 1989, demonstrations in Lhasa and the Tiananmen Square outrage shocked him into action again. With the knowledge of the brutal suppression going on in Lhasa and an increasing belief in the need for Tibet to regain its independence under the leadership of the Dalai Lama, Gyatso returned to modernist experimentation and produced a series of fiery red seated Buddha images in which the basic colours are stained into cotton cloth and then drenched with further layers of black ink (illus. 88). The resulting image can be rolled and transported in the same way as traditional *thangka*, though the delineation of the Buddha has been simplified, making it closer to early Indian rather than Tibetan models. Though informed by Buddhist art of the past, Gyatso's compositions also depart from history under the influence of modernism. His *Buddha and the White Lotus* (illus. 89) is divided into three sections with the central portion filled by a black void in which an elegantly sketched white lotus floats. Its roots drift into the left-hand segment where a cloudy mass of red and black pigment glows like a furnace of old but long burning coals. This flower,

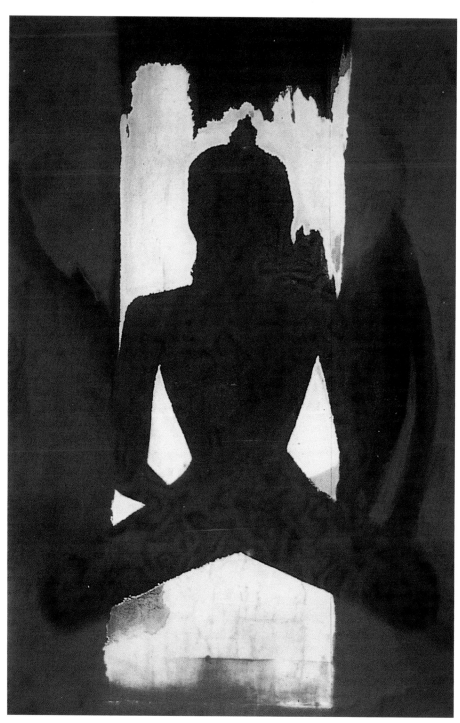

88 Gongkar Gyatso, *Red Buddha*.

which exceptionally grows in water and was a symbol of Buddhahood in *thangka* painting, now appears to be scorched by a red flame, while the Buddha is obfuscated, even obliterated, by the troubling black band in the centre. Expectations of frontality and symmetricality are confounded as the lotus appears at 90 degrees to the upright and the Buddha is depicted in half-silhouette. He is literally nebulous: more a ghost at the feast than a true presence. The artist has stated that at this time he believed that the Buddha 'could not look the Tibetans in the eyes',[26] hence the image is a statement about the facelessness and powerlessness of the Buddha whose teaching could not truly materialize in Chinese-run Tibet. Moreover, it is an essay on absence and mortality: the absence of the key representative of the Buddha in Tibet, the Dalai Lama.

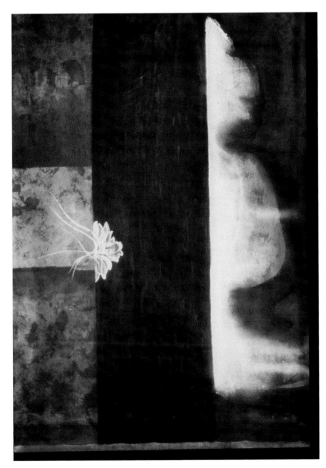

89 Gongkar Gyatso, *Buddha and the White Lotus.*

In works like this, Gongkar Gyatso and the 'Sweet Tea' artists peeled away the surface details of traditional Tibetan iconography to present a pared-down expression of Tibetan identity. Their reference to the 'essence' of the past and of a non-Sinicized Tibet was designed to defy Chinese essentializing of 'minority' Tibet and depicted in realist images. Fifty years after Gendun Chöpel's experiments, this new generation of Tibetan painters found an outlet for their anger and frustration through a modernist abstraction from the real. One of them even reinterpreted the 'wheel of existence' (as Chöpel had done in India) to create a commentary on life in the TAR. In it the elaborate symbolism of the twelve stages of the evolving consciousness, six realms of existence and three causes of delusion have been removed and replaced by a simpler, starker vision (illus. 90). The wheel is still held in the clawed hands of Shinge, the wrathful form of Avalokitesvara who is judge and lord of death, but a thin ring of skulls now encircles a naked corpse surrounded by vultures. This is a blunt depiction of the Tibetan method of burial which, as in the original wheel, requires the viewer to contemplate the end of existence. But this bleakness is relieved by a novel element in the composition. Whereas the mantric 'seed' syllables (Om, Ah, Hum) would have been inscribed on the reverse of a thangka canvas at the time of consecration, these redemptive letters are now part of the displayed image: a reminder of the possibility of a good Buddhist rebirth. As with many of the new Tibetan paintings, the political message of this image is by no means overt, but contextual information can help to elucidate it. During the 1987–90 'uprising' the practice of khorra (the ritual circumambulation of sacred sites) was reinvented for religio-political purposes. In September 1987 monks led a demonstration against Chinese rule which began with three circuits of the Barkhor (around the Jokhang). As Schwartz remarks, these 'could be seen as ritual preparation for a confrontation with the government'.[27] In the following month, following another demonstration, khorra accrued even more symbolic power when the bodies of those who had been shot dead by the Chinese police were carried around the Barkhor. Hence the wheel of existence described above must surely be read as another example of the politicized reinvention of Tibetan Buddhism of the 'uprising' period. The circle of skulls and the corpse within suggest that the ancient khorra routes had become zones of mortality, but that with Avalokitesvara, the protector of Tibet in wrathful form, to counteract the violence inflicted on Tibetan Buddhists there could be honourable death for the Tibetan cause. As Gendun Chöpel had used a wheel of existence to comment on the horrors of a world war, so TAR painters have reinvigorated ancient imagery in the service of their battle for an independent Tibet.

Gongkar Gyatso and his 'Sweet Tea' colleagues had succeeded in devising a specifically Tibetan type of painting by reinterpreting the Tibetan landscape and Tibetan Buddhist iconography through the lens of modernist aesthetics. By asserting an independent Tibetan spirit, their works implied a critique of cultural and political conditions in the TAR. Hence the first Tibetan artists' association quickly attracted the unwelcome attention of the authorities. By the time of protests against Chinese rule in Lhasa (1987–90), the atmosphere of 'liberalization' had clearly evaporated and making images which expressed Tibetan anger and frustration (as *Buddha and the White Lotus* does) became an underground activity. This imagery could not be displayed or marketed in the galleries of Lhasa and artists like Gyatso faced a serious challenge. Many returned to painting the safe, Sinicized portraits of Tibetans which could be sold in the tourist galleries of Shöl. Gyatso could not stomach this descent into commercialism and deference to Chinese rule and continued to produce images of decapitated and dissected Buddhas in private until, like thousands of others before him, he decided to leave Lhasa and the hollow mausoleum of the Potala Palace to go in search of its rightful incumbent on the refugee pilgrimage to Dharamsala.

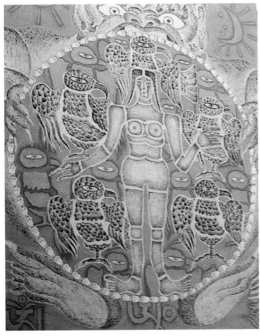

90 Wheel of Existence, from Potala Palace Art Gallery, Lhasa, 1993.

6 'Tibets' in Collision: Conclusions

The conflicts which Gongkar Gyatso experienced both in the TAR and in the refugee community allow us to recapitulate some of the themes of this book. His search for a Tibetan identity, both as individual and artist, has led him across borders of many kinds – national, political and stylistic – but the journey has left him caught in a no-man's-land between the imaginative territories which currently constitute 'Tibet'. The response to his work in Dharamsala illustrates what can occur when different versions of Tibetan culture come into collision.

In 1992 Gongkar Gyatso began a new life in the 'capital in exile' at Dharamsala in India. Initially the move was a source of inspiration. He found the Dalai Lama, a library and a group of people who made him feel 'at home', but as an artist who had formulated a new style in the TAR, he soon realized that no one knew where he was coming from. In Dharamsala, the values of the guardians of Tibetan cultural identity impacted upon him in a graphic sense, as his products entered a world of antagonistic codes of interpretation. Both fresh-faced foreigners on the Dharma tour and his fellow exiled Tibetans constantly exclaimed 'What, no *thangka* painting?' for, as we have seen, Gyatso's work presented a radical departure from pre-1959 painterly norms. For the Dharamsala art world such images as *Buddha and the White Lotus* appeared sacrilegious owing to their lack of iconometric measurement and splitting of the Buddha body. From a religious point of view, as another artist (Thaye) had warned, such 'erroneous' images were thought to lead both producer and viewer to hell. The rejection of Jampa Tseten's non-*thangka*-style *Three Kings* and the fixing process by which the Lhasa Menri has been reified as the appropriate style for the Dharamsala vision of exilic Tibet further contextualize Gyatso's difficulties. His work could not be understood, as it was not even '*thangka*', let alone New Menri, and Dharamsala viewers were unprepared for the shock of the new Tibetan painting from the TAR. The tensions between modern or modernist styles generated in the TAR and the demand for 'traditionalism' of a very specific kind was as palpable as it had been in Jampa Tseten's time.

In the hostile conditions of the TAR the fusion of a modernist formal vocabulary with a Tibetan sensibility had been sporadically effective as a survival tactic for the 'Sweet Tea' artists and their followers, but in exile the same style has proved unmarketable and one of its adherents

experienced a sense of marginalization and rejection. We have asked what Tibetan art in the disrupted conditions of post-1959 era looks like and whether style dictates the perceived 'Tibetanness' of an image. Gyatso and his friends had produced what they believed to be distinctively Tibetan kind of imagery, but the response to such modernist work in Dharamsala confirmed the power of the 'traditionalist' line and that only '*thangka*' styles are considered authentically Tibetan by those who control the exilic vision of Tibet. Dharamsala viewers appeared to suffer from a problem, identified by Clifford, that 'it is

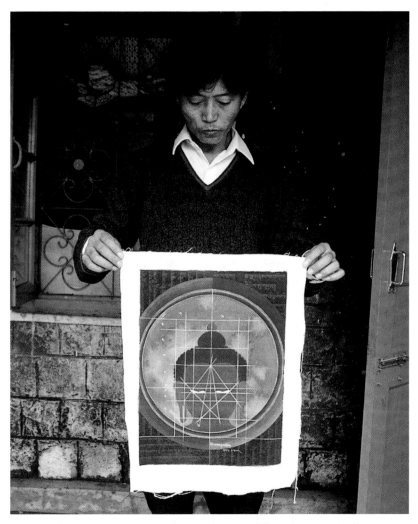

91 Gongkar Gyatso with a painting of the Buddha, photographed in Dharamsala in 1995.

easier to register the loss of traditional orders of difference than to perceive the emergence of new ones'.[1] Though Clifford directs this statement towards Occidental interpreters, it could equally well be applied to the members of the Dharamsala art world. Tied as they are to a project defined by a sense of loss of tradition, the radically different vision of Tibet presented in 'Sweet Tea' modernism could not be accommodated into exilic representational schemes. Once again style was a determinant in their judgement, since, as Gyatso claims, 'Tibetans are not interested in modern art'.[2] But as we saw, novelty and difference from the Tibetan past are not readily embraced by powerful figures in Dharamsala owing to the prevailing view that the abandonment of *thangka* styles is a dereliction of a Tibetan artist's religious and political duty. This perception is only exacerbated when the source of such deviation from tradition is connected to the People's Republic of China.

So how does an artist such as Gyatso, acculturated in the TAR and educated in art schools in Lhasa and Beijing, continue to function in exile? In response to the constant querying of the 'authenticity' of his non-*thangka* paintings he took up classes with the Library Art School teacher Sangay Yeshi and began to produce dozens of iconometric studies of the seated Buddha in the Lhasa Menri style, like every other *thangka* painting student in Dharamsala. As a draftsman he hardly needed training. Studying with Sangay Yeshi was much more a process of accommodation into a cultural system to which he had no access in Tibet. But Gyatso's appreciation of that heritage was inevitably filtered through a different aesthetic. In works produced outside the classroom, the traditionalist iconometry of the Buddha became not only a technical or sanctifying device but a signifier of style left for the viewer to examine in the finished works (illus. 91). Gyatso's emphasis on these linear structures was informed both by a modernist preference for form over content but also, perhaps more significantly, by his ambivalent position as both insider and outsider to this cultural vocabulary. While iconometric grids are perceived by *thangka* artists as the building blocks of their trade, to be learnt and assimilated over years of training and then subsumed in the final product, for Gyatso these structures must remain visible, precisely because they had come to represent the codified memories of Tibet, re-created in exile by painters who no longer live in the cultural landscape for which they were originally designed. When the art historian Erwin Panofsky analysed medieval European and ancient Egyptian painting, he claimed that iconometric codes, rather than content or attached narratives, revealed far more about the aesthetics of a particular cultural group. Like Panofsky,

Gyatso is also primarily an 'outsider' observing Tibetan culture from a distance and has come to similar conclusions, deciding that he is 'more interested in iconometry, than in *thangka* painting itself'.[3] For him, line and measurement are of greater value in understanding fundamental artistic and philosophic principles than the details of deities and demons, but it is exactly this logic which makes his work virtually incomprehensible to traditionalist Tibetan refugees.

Gyatso has found himself in the ironic position that outside of his country of birth he feels more 'at home' in political and spiritual terms, but his involvement in the recent history of image-making in the Tibet Autonomous Region has meant that he remains culturally displaced. His solution has been to keep moving and, just as distant regions of Tibet had provided inspiration for the 'Sweet Tea' artists, so Gyatso has travelled within India in search of an artistic home. One place which provided him with a refuge was the monastic enclave of Alchi, in Ladakh. Unlike his teacher in Lhasa, Han Huu Li, Gyatso's refugee status has allowed him to view the Alchi murals *in situ* and to revel in early Tibetan Buddhist painting in a style which is distinctly unlike the Lhasa Menri of Dharamsala. His search for different ways of representing Tibetanness has since led him even further afield, to an art school in London and most recently to the United States, where he became the first ex-TAR artist to exhibit in a North American gallery.

Gyatso's departure from Dharamsala, a place which should have been his spiritual and political home, brings us back to the question of who makes 'Tibetan' art. It appears that modernism, even when produced by artists of Tibetan parentage, is unacceptable in Dharamsala. It cannot be 'Tibetan' art, for it is viewed as yet another alien art style inspired by China and indicating a treacherous bent on the part of its producers. As Gyatso discovered, there is no easy or transparent relationship between being a Tibetan and being an authentic maker of Tibetan products. On the other hand, those who were not born into Tibetan ethnicity, such as the British artist Robert Beer, the Japanese Kenji Babasaki and the Canadian Andy Weber, have been accommodated and recognized as producers of Tibetan art in Dharamsala. Their works have been published in books which explain 'Tibet' to outsiders such as tour guides and introductions to Tibetan Buddhism. Tenpa Choepel (the neo-Norbulingka painting teacher) explains how this is possible when describing the way in which *thangka* styles alter slightly from one artist to another:

If you are a native speaker of English you always notice the way that other people speak the language when it is not theirs by birth. They have an

accent or a particular way of using elements of the language which is distinctive. So it is with the styles of Tibetan art. The image reflects the background of the artist in a particular way, even though the story he is telling is the same.[4]

Choepel's definition emphasizes two key notions: that the style of 'Tibetan art' is a fixed entity with rules and a structure comparable to a language which can be learnt by anyone, and that the story it relates must remain the same. For an exiled artist such as Choepel that story must be a Tibetan Buddhist one. The Dharamsala art world can accept those who are not 'native' speakers of Tibetan (i.e. not ethnically Tibetan) if they learn the language of *thangka* painting and adopt the practices of the religio-cultural definers of Tibetan exilic identity. Firstly they must follow and practise Tibetan Buddhism, taking the well trodden path for *ingis* (foreigners) established since the creation of the exile community in India and Nepal in the 1960s and take part in the oral transmission of Tibetan Buddhism, sitting at the feet of *rinpoches* (precious teachers) and passing through various stages of initiation.[5] Secondly, they must involve themselves in a similar guru–disciple relationship with a painter and emulate his example by copying and studying for many years.[6] These two types of experience are of course interconnected. In keeping with the openness the Dalai Lama has engendered towards foreign adherents to his faith (including the acceptance of Caucasian incarnations of *rinpoches*), so long as foreign practitioners of Tibetan-style painting have also absorbed something of Tibetan-style religion they can be accommodated and even allowed to push against the boundaries of Tibetan tradition. Thus an English *thangka* painter can be so confident of his assimilation of *thangka* painting methods that he can assert his freedom to reinvent it.

That this sacred art form finds new expression through the perception of Western artists is a consequence both of the times in which we live and the eternal spirit of the human imagination. Perhaps more than anyone I myself am most responsible for innovations in colour, perspective, atmospheric landscape elements and the use of the airbrush in painting.[7]

Sadly, the times in which Tibetans live has meant that modernist innovation by TAR artists such as Gongkar Gyatso cannot be so confidently celebrated.

Since the advent of 'primitivism', Western *aficionados* of cultures other than their own have convinced themselves of their understanding of 'indigenous' art and made objects which pay homage to non-Western aesthetics. However this kind of purportedly benevolent appropriation

is no longer stomached by the majority of communities in the post-colonial world. It is now highly unusual for a person who is ethnically an 'outsider' to be allowed to produce images which determine a marginalized group's identity, a fact confirmed by the uproar which recently greeted the discovery that the works of an acclaimed male aboriginal painter (Eddie Burrup) had actually been made by an 82-year-old white woman called Elizabeth Durack.[8] Given the popularity and saleability of Native Australian painting it is perhaps no surprise that Ms Durack concealed her racial origin to become part of a burgeoning market. White artists who wear the mantle of Tibetanness, however, need not fear such exposure. As long as Dharamsala favours aesthetic and cultural conformity over 'race' they are welcome to contribute to the 'preservation in practice' ethos of exilic Tibet. To paraphrase Charles Ramble's comments on the revival of Tibetan culture in the Himalayas, foreigners becoming good Buddhist artists may be 'a matter of people becoming something they look as though they might have been but never actually were'.[9] Divorced from its roots on the Tibetan plateau, exilic 'Tibet' is itself in a constant state of 'becoming', hence anyone who shares the vision of this imagined nation can contribute to its realization. However, as the opening chapter of this book high-lighted, we need to be wary of well intentioned but ultimately Orientalist attitudes to displaced Tibetans. If exilic 'Tibet' is only remade in terms which appeal to the dream of Shangri-La, it could remain on a life-support system in perpetuity and the romantic and timeless vision of its culture could destroy any chances it has of self-regeneration. The crux of Gongkar Gyatso's predicament lay in the fact that he could not share the ethos of Tibetan exilic culture since it is dedicated to the representation of what Tibet once was. Equally, his Dharamsala audience could not comprehend his images of 'Tibet'. He had experienced the TAR, a domain where history had been erased, leaving Tibetans like himself entirely reliant on the power of their imagination to make the 'real' Tibet come into being in art, if not in reality.

Conclusions

In both a Chinese-sponsored publication from the TAR and in Dharamsala, an artist's ethnicity is by no means the determinant of what constitutes contemporary Tibetan painting. So what makes recent 'Tibetan' art authentically Tibetan? As Tibetan authenticity is currently 'staged' (Clifford) in relation to a number of 'external domi-nating' realities, it is no surprise that in the life of an artist such as

Gyatso the 'cultural inventions' of the TAR and exilic Tibet came into collision. In the TAR he was part of an invention of Tibetan identity which was forged within and against the colonialism of Maoist China. In Dharamsala this invention was at odds with an authenticity determined by *nangpa* confirmations of the 'old', pre-1959 Tibet, aided and abetted by outsider (Western) desires for the fixing and placing of that Tibet in exile. Tibetan refugee culture is frequently defined (by Tibetans) in relation to the perceived requirements of their immediate Asian neighbours (demonstrated in the use of English and Hindi language placards at rallies) in India and Nepal, or those of more distant others, as when monks from Namgyal monastery travel the world making particle mandalas in museums in the West. In these conditions the delineation of a distinctive, 'authentic' Tibetan style in the visual arts (as in so much else) is essential for self-determination, but this, as we have seen, was also the case for the 'Sweet Tea' artists in the TAR.

In fact, both TAR and exilic Tibetans have constructed their cultural authenticity in response to the same brute fact of history; the Chinese takeover of the 'aboriginal' Tibet and all its 'fixtures and fittings' (to borrow Waddell's phrase). This fact denies them the 'mapping' of the space which Connerton tells us produces the context for collective memory and a social framework which supports the illusion of unchanging stability. In such a stable environment, the presence of familiar objects in daily life helps to trigger the human capacity to rediscover the past in the present. In the images of the artists of both groups discussed here, reference to the past (i.e. with quotation from paintings and objects of the past) involves a major leap of imagination and is always a reconstruction, since the objects which held their history are no longer part of daily experience. (Hence the importance of photography and film as a way of re-creating past objects, places and lives.) These memories of that past are to some extent shared, but what varies markedly is the way in which the past is used.

Dharamsala accords privileged status to the 'purity' of the oral lineage tradition by emphasizing the role of the 'precious' artists whose memory is based on actual experience of pre-1959 Tibet. (The younger generation, on the other hand, have no access to this authentic memory. History and politics have denied them the experience of living in a Tibet in which the past can be revisited with ease.) *Thangka* painting, in a variant of the Menri style (and dedicated to the memory of Menla Dhondrup embedded in a text) is the preferred vehicle for staging the authenticity of *nangpa* solidarity, and it signifies Tibetan Buddhism as the key definer of Tibetan culture. On the other hand, although TAR

artists, like the 'Sweet Tea' painters and Nawang Respa, are equally conscious of the history of the vacated space which they inhabit (the territory which is no longer truly 'Tibet' owing to the absence of the Dalai Lama), their recollection of the past is more fluid and has been interwoven with non-Tibetan influences. For them Tibetan Buddhism is something which has to be reinvented to suit the political conditions of the TAR. They have returned to first principles in the search for the essence of what Tibetan religion and culture might mean after 1959. As has been noted on a number of occasions in this book, the label 'Tibet' has powerful resonances, as a marketing tool and a sign of a memory (which is globally shared) of the pre-1959 place. The reappearance of 'Tibet' in post-1959 images is filtered through a series of lenses, which has meant that for some, even Tibetans, the subject ('Tibet') has become unrecognizable. Jampa Tseten, Gendun Chöpel and Gongkar Gyatso's visions of how Tibet could be re-presented were all incomprehensible for Dharamsala viewers because of the perception that 'external' influences (i.e. of China, India and the West) were predominant in their work and that 'Tibetan' style had been extinguished. We could therefore conclude that since 1959 there has been no such thing as 'Tibetan' art, only art produced by Tibetans, and sometimes even non-Tibetans, in which the idea of 'Tibet' is staged.

Perhaps this explains the lack of studies similar to this one. The loss of historic Tibet has meant that 'Tibetan' culture cannot be presented as an entity determined by a relationship to a place. Documenting the image-making of a period when Tibet was invaded, despoiled and colonized, and when its people were slaughtered, starved and dispersed, has meant that Tibetans could not be presented as a homogenous group with a single mode of self-representation. Their identity as political and cultural agents was in a state of fracture and flux, whereas, as we saw in Chapter 1, Orientalist authors and collectors of the nineteenth and early twentieth centuries could confidently describe Tibetan culture within the static parameters of geography and religion. Such essentializing remains common in Western literature, including and perhaps especially in publications on Tibetan art where a predilection for the stereotypes of Tibet established in museums and publications well over a hundred years ago remains powerful. Tibetan modernist paintings and images that are actually in use among ordinary Tibetans such as photo-icons, book covers, market stall prints and so on have been ignored because they fail to fulfil Orientalist expectations of Tibet. One of the ways in which such Orientalist fixing can be counteracted is by acknowledging that a homogenous 'Tibet' does not exist and did not even prior to 1959. As Said remarks:

The notion that there are geographical spaces with indigenous, radically 'different' inhabitants who can be defined on the basis of some religion, culture, or racial essence proper to that geographical space is [. . .] a highly debatable idea.[10]

The existence of 'Tibetan art' before 1959, as anything other than an object constructed in the paradigms of Western knowledge, is therefore also debatable.

There is one other issue which demands attention. It concerns what Hallisey (1995) calls 'intercultural mimesis'. In an analysis of the history of Western writing about Buddhism, Hallisey asks us to acknowledge the links between knowledge and power (which Said had so effectively analysed) but also to look for relationships between 'the West' and 'the Orient' that are not characterized by negation or inversion. One way of proceeding is of course to accommodate the voices and accounts of people of 'the East' (and I have made some attempt to do that here) but also to demonstrate the interconnectedness of 'East' and 'West'. I interpret this notion to refer, not to a kind of universalism in which what differentiates the actions and ideas of different people can actually be put down to a series of interconnected and mutually influencing themes, but to the extent to which we are all producers and receivers of various staged authenticities. Thus when Hallisey asks us to be transparent and to admit 'where it seems that aspects of a culture of a subjectified people influenced the investigator to represent that culture in a certain manner',[11] I will not demur. My relationship with the subject matter of this book is inevitably the result of 'intercultural mimesis' and, in producing a representation of Tibetan culture myself, I have bowed to the appropriate form of academic literary 'mimesis' (and photography) in order to record my impressions.

Equally I cannot escape an entanglement with colonial history (particularly of Britain) nor of some of the memories of 'Tibet' and Tibetans which impinged on my consciousness, beginning at the age of eleven, when I saw Powell and Pressburger's film *Black Narcissus* (an Orientalist exploitation of Indian and Tibetan representations if ever there was one), before I ever ventured to 'Tibet' or met a Tibetan. However, when I did begin to engage with Tibetans and listened to their experiences as refugees or as subjects of the PRC, their narratives clearly conflicted with the image of Tibet that had been presented in the West. Tibetans themselves highlighted 'aspects of a culture of a subjectified people' which they felt had been ignored by non-Tibetans. They complained that they had become 'like rare pandas in a zoo', specimens of exotica who were seen but not heard. It was Tibetans who

suggested that admiration for their religion and culture created an expectation that they must all be spiritual beings who had no interest in the material world beyond their doorstep. They wanted to be acknowledged as more than this: as producers of their own cultural identity.

If 'intercultural mimesis' affects Western writers, then does it not also affect Tibetans? Many of them are well aware of the representational dynamics in which their culture is entangled. We have seen in this book a number of moments at which Tibetan artists responded positively to the interconnectedness of cultures (Tibetan, Indian, Chinese, European, American, Soviet Russian etc.) and other times where they sought to overturn negative representations of Tibet produced by outsiders. Tibetans must be credited with the power by which they have imagined themselves and reflected upon their history and which they utilize in difficult conditions both inside and outside the TAR. It is up to others to look and listen.

Epilogue

The problems inherent in negotiating a secular nationalist agenda on the political front and a religious cultural project on the other hand are currently being approached by a small number of individuals and institutions in the 'capital in exile' in Dharamsala. It is therefore no surprise that the newly formed Amnye Machen Institute (AMI),[12] a radical organization which, among other things, focuses on secular aspects of Tibetan arts, curated the only exhibition of Gongkar Gyatso's work in exile.[13] Among its aims is the acknowledgement of the non-religious aspects of culture in pre-1959 Tibet:

A.M.I. is established along liberal and humanist lines. Its focus is on lay and folk subjects, with emphasis on contemporary and neglected aspects of Tibetan culture and history. The Institute is not just concerned with preservation; it studies the past in order to help Tibetans understand the present and prepare for the future.[14]

The AMI recognizes that not all painting by Tibetans has been produced in the service of religion, counteracting one of the dominant 'Shangri-La-ist' assumptions that a 'Tibetan' painting must be a *thangka*. It also sponsors and publishes new forms of Tibetan literature both from the TAR and the exile community and thus tries to move into the space of the virtual Tibet, where cultural production is not fixed within the rigid categories of nation states, geographic boundaries

or religious and political ideologies. The AMI is thus already trying to negotiate a vision of the future 'Tibet' and is facing up to a problem which the Dharamsala government has yet to fully grapple with. For if, as they hope, the exiles and TAR Tibetans one day recombine in an independent Tibetan nation, the story of Gongkar Gyatso's experience of the collision of cultural representations and identities could be repeated on the grand scale.

References

Introduction

1 See Y. Bentorn, 'Tibetan Tourist Thangkas in the Kathmandu Valley', *Annals of Tourism Research*, xx (1993), pp. 107–37

1 The Image of Tibet in the West

1 P. H. Pott, *Introduction to the Tibetan Collection of the National Museum of Ethnology, Leiden* (Leiden, 1951), p. 36.
2 See P. Bishop, *The Myth of Shangri-La* (London, 1989).
3 Johannes Fabian, *Time and the Other: How Anthropology Makes Its Object* (New York, 1983).
4 D. Snellgrove and H. Richardson, *A Cultural Heritage of Tibet* (London, 1986), p. 277.
5 See N. Thomas, *Entangled Objects: Exchange, Material Culture and Colonialism in the Pacific* (Cambridge, MA, 1991), on colonialism and Melanesia.
6 B. Anderson, *Imagined Communities* (London, 1983), p. 171.
7 As do D. Lopez and contributors to *Curators of the Buddha: The Study of Buddhism under Colonialism* (Chicago, 1995).
8 P. Pal, *Lamaist Art: The Aesthetics of Harmony* (New York, 1969).
9 *Wisdom and Compassion: The Sacred Art of Tibet*, exh. cat., ed. M. Rhie and R. Thurman; Royal Academy, London (London, 1991).
10 F. Sierskma, *Tibet's Terrifying Deities: Sex and Aggression in Religious Acculturation* (London, 1966).
11 F. Maraini, *Secret Tibet* (London, 1952).
12 *Much Maligned Monsters: A History of European Reactions to Indian Art* (Chicago and London, 1992) – has been published by P. Mitter. No equivalent text currently exists for Tibetan art, though D. Lopez includes a chapter on the Western reception of Tibetan art in *Prisoners of Shangri-La* (Chicago, 1998).
13 Cited in Bishop, *The Myth of Shangri-La*, p. 29.
14 *Ibid.*
15 The British also feared that 'the Northern Tartars', i.e. the Russians, might gain political and economic ascendancy in Tibet if they did not intervene.
16 L. A. Waddell, *Among the Himalayas* (London, 1899), p. viii.
17 *Ibid.*, p. 42.
18 L. A. Waddell, *The Buddhism of Tibet or Lamaism* (London, 1971), p. xxxvii.
19 D. Lopez, 'Foreigner at the Lama's Feet', in *Curators of the Buddha*, p. 259.
20 Waddell tells us (in *The Buddhism of Tibet*, p. xi):
 . . . it had been one of my first self-imposed tasks on entering the Indian Medical Service to pass the Higher Standard literary examinations in not only the universal Indian vernacular Hindustani, but also in Bengali and in Sanskrit, the dead language of Indian Buddhism and Brahmanism, corresponding to the Latin of Europe.
21 C. Breckenridge, 'The Aesthetics and Politics of Colonial Collecting', *Journal of the Society for the Comparative Study of Society and History*, xxxi (1989), p. 209.

22 H. H. Risley, *The Gazetteer of Sikkim* (Calcutta, 1894).

23 N. Thomas, in his *Entangled Objects: Exchange, Material Culture and Colonialism in the Pacific* (Cambridge, MA, 1991), pp. 133–7, notes a similar tendency in the illustrations to Captain Cook's (1777) *A Voyage to the South Pole*.

24 Waddell, *The Buddhism of Tibet*, p. xxxviii.

25 *Ibid.*, p. xi.

26 L. A. Waddell, quoted in H. H. Risley, *The People of India* (London, 1915).

27 Waddell, *The Buddhism of Tibet*, p. 571.

28 L. A. Waddell, *Lhasa and its Mysteries with a Record of the Expedition of 1903–4* (London, 1905), p. 1.

29 Waddell, *Lhasa and its Mysteries*, pp. 1–2. See the comment on this passage by Lopez in *Curators of the Buddha*.

30 H. Bhabha, *The Location of Culture* (London, 1994), p. 156, with reference to India.

31 Letter written by Hadow at Gyantse encampment dated 18 April 1904, held in the Norfolk and Norwich Regimental Museum collection. I am indebted to my student Sarah Whitewick for pointing out this source.

32 *Ibid.*

33 *Ibid.*

34 Snellgrove and Richardson (*A Cultural Heritage of Tibet*, p. 277) state: The collections in England began to be built up mainly as a result of the British expedition into Tibet in 1904 [. . .] The British Museum, where still today a very small part of the total collection is on display, and the Victoria & Albert Museum, were the main recipients.

35 S. Stewart, *On Longing: Narratives of the Miniature, the Gigantic, the Souvenir, the Collection* (London, 1993), p. 140.

36 Waddell, *The Buddhism of Tibet*, p. xxxiii.

37 *Ibid.*

38 Caption to the original from the Macdonald collection at the Pitt Rivers Museum, Oxford, cited in A. McKay, *Tibet and the British* (London, 1997), plate 2.

39 Snellgrove and Richardson, *A Cultural Heritage of Tibet*, p. 230.

40 G. Tucci, *Tibetan Painted Scrolls* (Rome, 1949), p. 13.

41 This journey is described by Tucci in *To Lhasa and Beyond: Diary of the Expedition to Tibet in the Year 1948* (Rome, 1956).

42 G. Benavides, 'Giuseppe Tucci, or Buddhology in the Age of Fascism', in *Curators of the Buddha*, ed. Lopez, p. 171.

43 P. Pott, *Art of the World: Burma, Korea, Tibet* (London, 1964), p. 210.

44 Further details of this dubious story appear in B. Lipton and N. Ragnubs, *Treasures of Tibetan Art: Collection of The Jacques Marchais Museum of Tibetan Art* (New York, 1996), p. 9.

45 Lipton and Ragnubs, *The Jacques Marchais Museum of Tibetan Art*, p. 17.

46 R. Handler, 'Consuming Culture Genuine and Spurious as Style', *Cultural Anthropology*, v (1990), pp. 346–7.

47 Snellgrove and Richardson, *A Cultural Heritage of Tibet*, p. 277.

48 Catalogues of these shows were published in 1965, 1966 and 1979.

49 The show was designed for the Asian Art Museum of San Francisco for display in 1991. It then toured to the Royal Academy in London in 1992 and the Kunsthalle in Bonn in 1996.

50 Richard Gere, in *Wisdom and Compassion: The Sacred Art of Tibet*, exh. cat., ed. Rhie and Thurman, p. 8.

51 Rand Castile, in *ibid.*, p. 9.

52 D. Norbu, *Red Star Over Tibet* (New Delhi, 1974), p. 9.

53 R. de Grey in the President's Foreword (no page number), in *Wisdom and Compassion: The Sacred Art of Tibet*, ed. Rhie and Thurman.

54 See the catalogue *Magiciens de la Terre* (Paris, 1989) with text by exhibition director Jean-Hubert Martin and critiques of the show in a special issue of *Third Text* (1989), vi.

55 P. Pal, *Tibetan Paintings* (New Delhi, 1988).

56 J. C. H. King, 'Tradition in Native American Art', in E. Wade, ed., *The Arts of the North American Indian: Native Traditions in Evolution* (New York, 1986), pp. 65–92.

2 The Image of Tibet in Exile

1 Gega Lama's *The Principles of Tibetan Art* was published in Darjeeling in 1983.

2 D. De Voe, 'The Refugee Problem', *Tibet Journal*, xx (1981), p. 32.

3 M. Goldstein, in 'Change, Conflict and Continuity among a Community of Nomadic Pastoralists', in *Resistance and Reform in Tibet*, ed. R. Barnett and S. Akiner (London, 1994), analyses the categories of 'ethnographic' and 'political' Tibet which have been in use after 1959, in which the political heartland of the Tibet Autonomous Region (TAR) of the People's Republic of China (PRC) is contrasted with the larger category of ethnic Tibetans who are located in the nearby Chinese provinces of Qinghai, Sichuan, Gansu, Yunnan and Xinjiang, and parts of neighbouring states such as India, Nepal and Bhutan.

4 Arthur Danto, 'The Art World', *Journal of Philosophy*, 61 (1964), pp. 571–84.

5 C. Von Furer-Haimendorf, *The Renaissance of Tibetan Civilisation* (Oracle, AZ, 1990), p. 61.

6 J. Avedon, *In Exile from the Land of Snows* (New York, 1986), p. 95.

7 Their regnal periods are AD 627–49, 755–99 and 815–38, respectively.

8 From a postcard of the rejected *Three Kings* image purchased in the bazaar in Dharamsala in 1992.

9 E. Lo Bue, 'Iconographic Sources and Iconometric Literature', in *Indo-Tibetan Studies*, vol. II (Tring, 1990), p. 187.

10 J. Norbu, *The Works of Gongkar Gyatso*, exhibition pamphlet (Dharamsala, 1993), p. 3.

11 Lo Bue, 'Iconographic Sources and Iconometric Literature', p. 181.

12 The Tibetan title is *bDe bar gshegs pa'i sku gzugs kyi tshad kyi rab tu byad pa'i yid bzhin gyi nor bu.*

13 P. Denwood's translation of Menla Dhondrup's text in 'The Artist's Manual of Menla Dhondrup', *Tibet Journal*, xxi/2 (1996), p. 29.

14 G. Tucci, 'aJig rten kyi bstan bcos dpyad don gsal bai sgron me – A Tibetan Classification of Buddhist Images According to their Style', *Artibus Asiae*, xxii (1959), p. 180.

15 Interview with Sangay Yeshi, Dharamsala, 1992.

16 Further details of Choepel's biography are included in K. Yeshi, 'Tenba Choepel's Story', *Chöyang, Year of Tibet Special Issue* (1991).

17 D. Jackson, in *A History of Tibetan Painting* (Vienna, 1996), p. 246, confirms that 'recent Lhasa artists', including Sangay Yeshi, 'consider themselves to be the modern direct successors of the Old sMan-ris'.

18 Interview with Sangay Yeshi in Dharamsala, 1992.

19 However, Jackson (again in *A History of Tibetan Painting*) has tentatively attributed a mural at the monastery of Tashilunpo in Shigatse to Menla.

20 Interview with Sangay Yeshi, Dharamsala, 1992.

21 See the chapter on the New Menri in Jackson, *A History of Tibetan Painting.*

22 Ibid., p. 243.
23 A point noted by a non-Dharamsala-based artist (Gega Lama, Principles of Tibetan Art, p. 46.): 'Some refer to his as the "southern style" (Lho.bris), since Mentang was a district of Lhodrak in southern Tibet; they assign the name on the basis of which major region of Tibet was the source of the tradition.'
24 Kalsang, interviewed in the Kalachakra Assembly Hall, Dharamsala, 1992.
25 J. Clifford, The Predicament of Culture (Cambridge, MA, 1988), pp. 11–12.
26 Interview with Sangay Yeshi, Dharamsala, 1992.
27 Von Furer-Haimendorf, The Renaissance of Tibetan Civilisation, pp. 1–2.
28 J. Losal, New Sun Self Learning Book on the Art of Tibetan Painting (New Delhi, 1982), p. 8.
29 D. Jackson and J. Jackson, Tibetan Thangka Painting (London, 1984), p. 3. In his more recent publication, A History of Tibetan Painting, David Jackson provides a wealth of hitherto unknown source material on Tibetan art but mentions only a handful of twentieth-century painters. He prefers to 'leave it to others to portray in more detail the still flourishing branches of the ancient tree of Tibetan painting', but in a footnote it becomes clear that he expects these studies to provide evidence of artistic 'pedigrees' through reference to 'conservative' traditions dating back at least to the eighteenth century.
30 Tashi Tsering, interviewed at the Library of Tibetan Works and Archives (LTWA) in 1992.
31 Tashi Tsering, interview at LTWA, 1992.
32 T. Philips, 'Finding Objects of Desire', Times Literary Supplement (24 January 1989).
33 Cited in M. Nowak, Tibetan Refugees: Youth and the New Generation of Meaning (New Brunswick, NJ, 1984), p. 135.
34 M. Kapsner and T. Wynniatt-Husey, 'Thangka Painting', Chöyang (1991), p. 298.
35 The dolls have been purchased by individuals and organizations such as the Tibet Society of the UK, The Foundation Alexandra David Neel, the Musée d'Ethnographie, Geneva, and even the Dean of Westminster Abbey, London.
36 K. Yeshi, 'The Losel Project', Chöyang, Year of Tibet Special Issue (1991), p. 338.
37 Ibid., p. 343.
38 Ibid., p. 338.
39 E. Hobsbawm, 'Introduction: Inventing Traditions', in The Invention of Tradition (Cambridge, 1983), p. 1.
40 See D. Snellgrove and H. Richardson, A Cultural Heritage of Tibet (London, 1986), as quoted in the introduction.

3 Beyond the Boundaries of Tradition

1 C. Dhondup, Life in the Red Flag People's Commune (Dharamsala, 1978), p. 64.
2 Ibid., p. 65.
3 D. Norbu, Red Star Over Tibet (New Delhi, 1987), p. 263.
4 Dhondup, Life in the Red Flag People's Commune, p. 30.
5 Though one exile told me that when Mao images were placed in Tibetan homes, many people slept with their feet facing them as a gesture of disrespect.
6 P. Thaye, Concise Tibetan Art Book (Kalimpong, 1987), p. 23.
7 Ibid., p. 183.
8 Roland Barthes, Camera Lucida: Reflections on Photography (London, 1993), p. 80.

9 Cardinal, in G. Clark, ed., *The Portrait in Photography* (London, 1992), p. 6.

10 Henri d'Orleans visited Tibet in the 1860s, but his photographs were first published in *De Paris au Tonkin à travers le Thibet inconnu* in 1892.

11 Walter Benjamin, 'The Work of Art in the Age of Mechanical Reproduction', in *Illuminations* (London, 1955, repr. 1992), p. 219.

12 C. Bell, *The People of Tibet* (London, 1928), p. 294: the quotation is taken from *The Biography of the Reverend Omniscient So-nam Gya-tso, like a Chariot in the Ocean*.

13 C. Bell, *Portrait of the Dalai Lama* (London, 1946), p. 383.

14 *Ibid.*, p. 114.

15 As quoted in J. Avedon, *In Exile from the Land of Snows* (New York, 1986), p. 3, in August 1932 the thirteenth Dalai Lama wrote at his room in the Norbulingka:
It may happen that here, in the centre of Tibet, religion and government will be attacked both from without and within. Unless we can guard our own country, it will happen that the Dalai and Panchen Lamas, the Father and Son, and all the revered holders of the faith, will disappear and become nameless. Monks and their monasteries will be destroyed. The rule of Law will be weakened. The lands and the property of government officials will be seized. They themselves will be forced to serve their enemies or wander the country like beggars. All beings will be sunk in great hardship and over-powering fear; the days and nights will drag on in slow suffering.

16 M. Nowak, *Tibetan Refugees: Youth and the New Generation of Meaning* (New Brunswick, NJ, 1984), p. 133.

17 Tashi Tsering: personal communication, Dharamsala, 1995.

18 E. Tarlo, 'Competing Identities: The Problem of What to Wear in Late Colonial and Contemporary India', PhD, School of Oriental and African Studies, University of London, 1992, p. 426.

19 P. Denwood, 'Landscape in the Painting of Nepal, Tibet and Mongolia', *Landscape Style in Asia: Percival David Foundation Colloquies*, ed. W. Watson, vol. IX (London, 1979), pp. 176–7.

20 *Ibid.*, p. 176.

21 Charles Baudelaire, *The Painter of Modern Life and Other Essays* (New York, 1964; repr. 1986).

22 J. Losal, *New Sun Self Learning Book on the Art of Tibetan Painting* (New Delhi, 1982), p. 8. It is also rather amazing to note the similarity between these anecdotes and the famous account of verisimilitude in Pliny in which Zeuxis produced such a realistic image of some grapes that birds came to eat them.

23 H. Stoddard (Karmay), *Le Mendiant de l'Amdo* (Paris, 1985), p. 168: my translation from the French.

24 H. Karmay, 'dGe-'dun Chos-'phel, the Artist', in *Tibetan Studies in Honour of Hugh Richardson: Proceedings of the International Seminar on Tibetan Studies* (Warminster, 1980), p. 148.

25 *Ibid.*

26 *Ibid.*

27 E. Lo Bue, 'Iconographic Sources and Iconometric Literature', in *Indo-Tibetan Studies*, vol. II (Tring, 1990), p. 190.

28 P. Bilimoria, 'The Enigma of Modernism in Early Twentieth Century Indian Art: "Schools of Indian Art"', in *Modernity in Asian Art*, ed. J. Clark (Sydney, 1986), p. 39.

29 T. Guha Thakurta, *The Making of a New Indian Art* (Cambridge, 1992), p. 316.

30 Stoddard, *Le Mendiant de l'Amdo*, p. 173.

31 *Ibid.*, pp. 202–3.

32 For copies of these drawings, see Stoddard, *Le Mendiant de l'Amdo*.

4 The Chinese Image of Tibet

1 Exceptions are articles by P. Kvaerne, 'The Ideological Impact on Tibetan Art', in *Resistance and Reform in Tibet*, ed. R. Barnett and S. Akiner (London, 1994), and C. Harris, 'Struggling with Shangri-La: The Works of Gongkar Gyatso', in *Constructing Tibetan Culture: Contemporary Perspectives*, ed. F. Korom (Quebec, 1997), pp. 160–77.
2 T. Clark, *Art and Propaganda* (London, 1997), p. 85.
3 E. J. Laing, *The Winking Owl* (Los Angeles, 1988), p. 15.
4 C. Yang, 'Mao Tse Tung's Teachings on Contemporary Art and Literature', in *People's China* (Beijing, 1951), p. 7.
5 See Laing, *The Winking Owl.*
6 S. Harrell, ed., *Cultural Encounters on China's Ethnic Frontiers* (Seattle and London, 1995), p. 9.
7 See P. Karan, *The Changing Face of Tibet* (Kentucky, 1976), p. 47.
8 This continues to be the case in more recent Chinese depictions such as those from *Chinese Nationalities*, a publication discussed by D. Gladney in 'Representing Nationality in China: Refiguring Majority/Minority Identities', *Journal of Asian Studies*, LIII/1 (1994), p. 97, where he states: 'The minorities are almost always portrayed in natural, romantic settings, surrounded by flora and fauna'.
9 *Wrath of the Serfs*, exhibition catalogue, published by Foreign Languages Press (Beijing, 1976).
10 From the introduction to *Wrath of the Serfs*, p. 5.
11 Gongkar Gyatso, quoted in K. Yeshi, 'Gongkar Gyatso: Creation of a Painter in Contemporary Tibet', *Chöyang*, VII (1996), p. 76.
12 *Ibid.*
13 See Clark, *Art and Propaganda.*
14 Gladney, *'Representing Nationality in China'*, pp. 96–7.
15 '. . . Wyeth's realism appears to be totally free of ideology, being visual and psychological'. M. Sullivan, *The Meeting of Eastern and Western Art* (Los Angeles, 1989), p. 191.
16 Joan L. Cohen, *The New Chinese Painting 1949–1986* (New York, 1987), p. 108.
17 *Ibid.*
18 S. Harrell, ed., *Cultural Encounters on China's Ethnic Frontiers* (Seattle and London, 1995), p. 11.
19 Gladney ('*Representing Nationality in China*', p. 103) also notes that by the 1970s,
The image of Dai (Thai) and other minority women bathing in a river has become a leit-motiv for ethnic sensuality and often appears in stylized images throughout China, particularly on large murals in restaurants and public spaces.
20 *Ibid.*, p. 109.
21 Arjun Appadurai, ed., *The Social Life of Things: Commodities in Cultural Perspective* (Cambridge, 1986), p. 28.
22 Gladney, 'Representing Nationality in China', p. 94.

5 The Tibetan Image of the Tibet Autonomous Region

1 Published and discussed by P. Kvaerne in 'The Ideological Impact on Tibetan Art', *Resistance and Reform in Tibet*, ed. R. Barnett and S. Akiner (London, 1994). His source was *The New Tibetan Painting of Kanze*, published in Chengdu in 1987.

2 Kvaerne, 'The Ideological Impact', p. 168.

3 *Ibid.*, p. 173.

4 *Ibid.*

5 For a discussion of this problem see J. Clarke, 'Open and Closed Discourses of Modernity', in his *Modernity in Asian Art* (Sydney, 1986).

6 See P. Mitter, *Much Maligned Monsters: A History of European Reactions to Indian Art* (Chicago and London, 1977, repr. 1992) and T. Guha Thakurta, *The Making of a New Indian Art* (Cambridge, 1992) for the full account of this period.

7 With the able assistance of the writer Jamyang Norbu (of the Amnye Machen Institute) and the historian Tsering Shakya.

8 Names and titles of paintings were translated from the Tibetan and compared with the Chinese equivalent with the help of Dr Wang Tao (from the School of Oriental and African Studies, London University). We found that the Tibetan and Chinese often did not tally. The spelling of Tibetan artists' names may also appear odd. This is due to the Chinese editors' bizarre Sinicization of Tibetan names.

9 Summary of World Broadcasts, 30 May 1980, quoted in M. Goldstein, *The Snow Lion and the Dragon: China, Tibet and the Dalai Lama* (Los Angeles, 1997), pp. 64–5.

10 One elderly woman who lived on the Barkhor in Lhasa told me (in 1993) how she removed copies of the Koran from the flames of the Revolutionary fires which consumed hundreds of Islamic as well as Buddhist texts.

11 H. Richardson discusses this ceremony, along with others that take place in Lhasa over the course of a year, in *Ceremonies of the Lhasa Year* (London, 1993), p. 74.

12 D. Gladney, 'Representing Nationality in China: Refiguring Majority/Minority Identities', *Journal of Asian Studies*, LIII/1 (1994), p. 97.

13 As Western tourists found during the period of demonstrations in Lhasa between 1987 and 1992. Documented in R. Schwartz, 'Travelers Under Fire', *Annals of Tourism Research*, XVIII/4 (1991).

14 Goldstein, *The Snow Lion and the Dragon*, p. 83.

15 Gongkar Gyatso, speaking at the Tibet Foundation, London, on 27 October 1997.

16 *Ibid.*

17 K. Yeshi, 'Gongkar Gyatso: Creation of a Painter in Contemporary Tibet', *Chöyang*, VII (1996), p. 73.

18 *Ibid.*, p. 74.

19 *Ibid.*, p. 78.

20 *Ibid.*, p. 79.

21 Wassily Kandinsky, *Concerning the Spiritual in Art* (1914; repr. New York, 1977).

22 Yeshi, 'Creation of a Painter', p. 81.

23 *Ibid.*, p. 82.

24 *Ibid.*, p. 80.

25 J. Norbu, *The Works of Gongkar Gyatso* (Dharamsala, 1993), p. 5.

26 Gongkar Gyatso speaking at the Tibet Foundation, London, 1997.

27 See R. Schwartz, *Circle of Protest: Political Ritual in the Tibetan Uprising.*

6 'Tibets' in Collision: Conclusions

1 Clifford, *The Predicament of Culture*, p. 15.

2 Interview with Gongkar Gyatso, Dharamsala, 1995.

3 Interview with Gongkar Gyatso, Dharamsala, 1995.

4 Tenpa Choepel, interviewed at the Norbulingka, 1991.

5 See Lopez, 'Foreigner at the Lama's Feet'.

6 Robert Beer, for example, studied with Oleshey in Solu Kumbu, Nepal, and with the eighth Khamtrul Rinpoche in Tashijong, Himachal Pradesh. See R. Beer, 'Tibetan Art Transposed', in *Eastern Art Report* (1991), pp. 11–14.

7 *Ibid.*, p. 13.

8 Reported in *The Guardian* (8 March 1997).

9 C. Ramble, 'Whither the Tsampa Eaters Indeed?', *Himal*, vi/5 (Lalitpur, 1993), p. 23.

10 E. Said, *Orientalism* (London, 1995), pp. 322–3.

11 C. Hallisey, 'Roads Taken and Not Taken in the Study of Theravada Buddhism', *Curators of the Buddha*, ed. Lopez, p. 33.

12 The Amnye Machen Institute (AMI) was formally launched on 28 June 1992 in Dharamsala, India.

13 The exhibition 'Works of Gongkar Gyatso of Lhasa' was held in Dharamsala in June 1993.

14 Norbu, *The Works of Gongkar Gyatso*, p. 38.

Select Bibliography

Anderson, B., *Imagined Communities: Reflections on the Origin and Spread of Nationalism* (London, 1983)

Avedon, J. F., *In Exile from the Land of Snows* (New York, 1986)

Babb, L. 'Glancing: Visual Interaction in Hinduism', *Journal of Anthropological Research*, xxxvii (1981)

Barthes, R., *Camera Lucida: Reflections on Photography* (London, 1993)

Beer, R., 'Tibetan Art Transposed', *Eastern Art Report* (1991), pp. 11–14

Bell, C., *Portrait of the Dalai Lama* (London, 1946)

——, *The People of Tibet* (London, 1928)

——, *The Religion of Tibet* (Oxford, 1931)

Benavides, G., 'Giuseppe Tucci, or Buddhology in the Age of Facism', in *Curators of the Buddha*, ed. D. Lopez (Chicago and London, 1995)

Benjamin, W., 'The Work of Art in the Age of Mechanical Reproduction', in *Illuminations* (London, 1955, repr. 1992)

Bentorn, Y., 'Tibetan Tourist Thangkas in the Kathmandu Valley', *Annals of Tourism Research*, xx (1993)

Bhabha, H., *The Location of Culture* (London, 1994)

Bilimoria, P., 'The Enigma of Modernism in Early Twentieth Century Indian Art: "Schools of Oriental Art"', in *Modernity in Asian Art*, ed. J. Clark (Sydney, 1986)

Bishop, P., *The Myth of Shangri-La: Tibet, Travel Writing and the Western Creation of Sacred Landscape* (London, 1989)

Bourdieu, Pierre, *Distinction: A Social Critique of the Judgement of Taste* (London, 1989)

Breckenridge, C., 'The Aesthetics and Politics of Colonial Collecting', *Journal of the Society for the Comparative Study of Society and History*, xxxi (1989)

Chandra, L., *Buddhist Iconography* (New Delhi, 1991)

Clark, J., 'Open and Closed Discourses of Modernity', in *Modernity in Asian Art* (Sydney, 1986)

——, *Modern Asian Art* (Sydney, 1998)

Clifford, J., *The Predicament of Culture* (Cambridge, MA, 1988)

Cohen, J. L., *The New Chinese Painting 1949–1986* (New York, 1987)

Connerton, P., *How Societies Remember* (Cambridge, 1989)

De Voe, D., 'The Refugee Question', *The Tibet Journal* (1981)

Denwood, P., 'Landscape in the Painting of Nepal, Tibet and Mongolia', in *Landscape Style in Asia: Percival David Foundation Colloquies*, no. 9, ed. W. Watson (London, 1979)

——, 'The Artist's Manual of Menla Dhondrup', *The Tibet Journal* xxi/2 (1996)

Dhondup, C., *Life in the Red Flag People's Commune* (Dharamsala: Information Office of H. H. Dalai Lama, 1978)

Foreign Languages Press, *The Wrath of the Serfs* (Peking, 1976)

Gladney, D., 'Representing Nationality in China: Refiguring Majority/Minority Identities', *The Journal of Asian Studies*, liii/1 (1994)

Goldstein, M., 'Change, Conflict and Continuity among a Community of Nomadic Pastoralists: A Case Study from Western Tibet, 1950–1990', in R. Barnett and S. Akiner, eds, *Resistance and Reform in Tibet* (London, 1994)

——, *The Snow Lion and the Dragon: China, Tibet and the Dalai Lama* (Los Angeles, 1997)

Greenough, P., 'Nation Economy and Tradition Displayed: The Indian Crafts Museum New Delhi', in C. Breckenridge, ed., *Consuming Modernity: Public Culture in a South Asian World* (Minneapolis and London, 1995)

Guha-Thakurta, T., *The Making of a New Indian Art* (Cambridge, 1992)

Gusheng, Y., *Monuments historiques du Tibet* (Beijing, 1992)

Hallisey, C., 'Roads Taken and Not Taken in the Study of Theravada Buddhism', in D. Lopez, ed., *Curators of the Buddha: The Study of Buddhism under Colonialism* (Chicago, 1995)

Harrell, S., *Cultural Encounters on China's Ethnic Frontiers* (Seattle and London, 1995)

Harris, C., 'Struggling with Shangri-La: The Works of Gongkar Gyatso', in *Constructing Tibetan Culture: Contemporary Perspectives*, ed. F. Korom (Quebec, 1997)

Hicks, R., and N. Chogyam, *Great Ocean: An Authorised Biography of the Buddhist Monk Tenzin Gyatso, His Holiness the 14th Dalai Lama* (Longmead, 1984)

Hobsbawm, E., 'Introduction: Inventing Traditions', in *The Invention of Tradition*, ed. E. Hobsbawm and T. Ranger (Cambridge, 1983)

Hsia, A., *The Chinese Cultural Revolution* (London, 1972)

Jackson, D., *A History of Tibetan Painting* (Vienna, 1996)

Jackson, D., and J. Jackson, *Tibetan Thangka Painting: Methods and Materials* (London, 1984)

Kapsner, M., and T. Wynniatt-Husey, `'Thanka Painting', *Chöyang, Year of Tibet Special Edition* (1991)

Karan, P. P., *The Changing Face of Tibet: The Impact of Chinese Communist Ideology on the Landscape* (Kentucky, 1976)

Karmay, H. (Stoddard), 'dGe-'dun Chos-'phel, the Artist', in *Tibetan Studies in Honour of Hugh Richardson: Proceedings of the International Seminar on Tibetan Studies*, ed. M. Aris and A. S. Suu Kyi (Warminster, 1980)

Kvaerne, P., 'The Ideological Impact on Tibetan Art', in *Resistance and Reform in Tibet*, ed. R. Barnett and S. Akiner (London, 1994)

Laing, E. J., *The Winking Owl: Art in the Peoples' Republic of China* (Los Angeles, 1988)

Lama, Gega, *Principles of Tibetan Art*, 2 vols (Darjeeling, 1983)

Lauf, D. I., *Eine Ikonographie des tibetischen Buddhismus* (Graz, 1979)

Lhalungpa, L. P., *Jewel of Humanity: Life of Mahatma Gandhi and Light of Truth of His Teachings: Rendered in Tibetan Prose and Verse with Illustrations by "Master Topgay" of the Tibetan Craft Community* (Palumpur, Delhi, 1970)

Lo Bue, E., 'Iconographic Sources and Iconometric Literature', in *Indo-Tibetan Studies*, ed. T. Skorupski, vol. II (Tring, 1990)

Lopez, D., 'New Age Orientalism: The Case of Tibet', *Tibetan Review*, XXIX/5 (1994)

——, *Prisoners of Shangri-La: Tibetan Buddhism and the West* (Chicago, 1998)

Lopez, D., ed., *Curators of the Buddha: The Study of Buddhism under Colonialism* (Chicago, 1995)

Lopez, D. S., 'Foreigner at the Lama's Feet', in *Curators of the Buddha* (Chicago, 1995)

Losal, J., *New Sun Self Learning Book on the Art of Tibetan Painting* (New Delhi, 1982)

Makley, C., 'Gendered Practices and the Inner Sanctum: The Reconstruction of Tibetan Sacred Space in "China's Tibet"', *Tibet Journal*, XIX/2 (1994)

Mitter, P., *Much Maligned Monsters: A History of European Reactions to Indian*

Art (Chicago and London, 1977, repr. 1992)

Norbu, D., *Red Star Over Tibet* (New Delhi, 1974, repr. 1987)

Norbu, J., *The Works of Gongkar Gyatso*, exhibition pamphlet (Dharamsala, 1993)

——, ed., *Lung-ta: Journal of the Amnye Machen Institute*, 8 (1994)

Nowak, M., *Tibetan Refugees: Youth and the New Generation of Meaning* (New Brunswick, NJ, 1984)

Pal, P., *Tibetan Paintings: A Study of Tibetan Thangkas Eleventh to Nineteenth Centuries* (New Delhi, 1988)

Panofsky, E., 'The History of the Theory of Human Proportions as a Reflection of the History of Styles', in *Meaning in the Visual Arts* (London, 1955)

Peljor, R., *Illustrations and Explanations of Buddhist Iconography and Iconometry according to the Old Menri School of Central Tibet (Zi-khro rab-'byams rgyal-ba'i gzugs-sku las cha-tsad glu-dbyangs sgro-pa)*, with introduction by Tashi Tsering (Dharamsala, 1987)

Pinney, C., *Camera Indica: The Social Life of Indian Photographs* (London, 1997)

Pott, P. H., *Art of the World: Burma, Korea, Tibet* (London, 1964)

——, *Introduction to the Tibetan Collection of the National Museum of Ethnology, Leiden* (Leiden, 1951)

Ramble, C., 'Whither the Tsampa Eaters indeed?', *Himal*, vi/5 (1993)

Ranopanza, T., *The Hidden Tradition: Life inside the Great Tibetan Monastery Tashilunpo* (Nationalities Publishing House, Beijing, 1993)

Richardson, H., *Ceremonies of the Lhasa Year* (London, 1993)

Risley, H. H., ed., *Gazetteer of Sikkim* (Calcutta, 1894)

Schwartz, R. D., *Circle of Protest: Political Ritual in the Tibetan Uprising* (London, 1994)

——, 'Travelers Under Fire: Tourists in the Tibetan Uprising', *Annals of Tourism Research*, xviii/4 (1991)

Shakya, T., 'Whither the Tsampa Eaters?', *Himal*, vi/5 (1993)

Snellgrove, D. and Richardson, H., *A Cultural History of Tibet* (London, 1968, repr. 1986)

Stewart, S., *On Longing: Narratives of the Miniature, the Gigantic, the Souvenir, the Collection* (London, 1993)

Stoddard, H., *Le Mendiant de l'Amdo* (Paris, 1985)

Sullivan, M., *The Meeting of Eastern and Western Art: From the Sixteenth Century to the Present Day* (Los Angeles, 1973, repr. 1989)

Tarlo, E., 'Competing Identities: The Problem of What to Wear in Late Colonial and Contemporary India', PhD thesis, School of Oriental and African Studies, University of London, 1992 (published as *Clothing Matters: Dress and Identity in India* [London, 1996])

Thaye, P. N., *Concise Tibetan Art Book* (Kalimpong, 1987)

Thomas, N., *Entangled Objects: Exchange, Material Culture and Colonialism in the Pacific* (Cambridge, MA, 1991)

Tibetan Contemporary Art (Lhasa, 1991)

Tucci, G. 'aJig rten kyi bstan bcos dpyad don gsal bai sgron me – A Tibetan Classification of Buddhist Images according to Their Style', *Artibus Asiae*, xx (1959)

——, *The Theory and Practice of the Mandala: with Special Reference to the Modern Psychology of the Subconscious* (London, 1961)

——, *Tibet* (London, 1967)

——, *Tibetan Painted Scrolls* (Rome, 1949)

——, *To Lhasa and Beyond: Diary of the Expedition to Tibet in the Year 1948* (Rome, 1956, repr. Ithaca, New York, 1987)

Von Furer-Haimendorf, C., *The Renaissance of Tibetan Civilisation* (Oracle, AZ, 1990)

Waddell, L. A. *Among the Himalayas* (London, 1899)
——, *Lhasa and its Mysteries with a Record of the Expedition of 1903–4* (London, 1905)
——, *The Buddhism of Tibet or Lamaism* (Cambridge, 1894, repr. 1971)
Wisdom and Compassion: The Sacred Art of Tibet, exh. cat., ed. M. Rhie and R. Thurman; Royal Academy, London (London, 1991)
The Wrath of the Serfs (Beijing, 1976)
Yang, C., 'Mao Tse Tung's Teachings and Contemporary Art', *People's China*, September issue (1951)
Yeshi, K., 'Gongkar Gyatso: Creation of a Painter in Contemporary Tibet', *Chöyang*, VII (1996)
——, 'The Losel Project', *Chöyang, Year of Tibet Special Issue* (1991)
——, 'Tenpa Choepel's Story', *Chöyang, Year of Tibet Special Issue* (1991)

Index

Photographic Acknowledgements

The author and publishers wish to express their thanks to the sources listed below for illustrative material and/or permission to reproduce it. In a substantial number of cases, it has not been possible to trace the locations, sources or copyright holders for particular images.

Courtesy of the author: 1–3, 10, 12, 14–16, 20, 22–6, 29–31, 35, 41, 48, 51, 53, 79, 91; courtesy of Gongkar Gyatso: 85–9; courtesy of Per Kvaerne: 70; courtesy of Faith Spencer-Chapman: 39; Kim Yeshi: 28.